THE BOY
WHO CRIED
FREEBIRD

THE BOY WHO CRIED FREEBIRD

*Rock & Roll Fables
and Sonic Storytelling*

MITCH MYERS

HarperEntertainment
An Imprint of HarperCollins*Publishers*

Pages 301–309 constitute an extension of this copyright page.

THE BOY WHO CRIED FREEBIRD. Copyright © 2007 by Mitch Myers. All rights reserved. Printed in the United States of America. No part of this book may be used or reproduced in any manner whatsoever without written permission except in the case of brief quotations embodied in critical articles and reviews. For information address HarperCollins Publishers, 10 East 53rd Street, New York, NY 10022.

HarperCollins books may be purchased for educational, business, or sales promotional use. For information please write: Special Markets Department, HarperCollins Publishers, 10 East 53rd Street, New York, NY 10022.

FIRST EDITION

Library of Congress Cataloging-in-Publication Data has been applied for.

ISBN: 978-0-06-113901-7
ISBN-10:0-06-113901-7

07 08 09 10 11 WBC/RRD 10 9 8 7 6 5 4 3 2 1

FOR

Peg and Chuck

Contents

This collection has been carefully crafted for your reading enjoyment. The writing incorporates the use of fables, straight reportage, metaphorical criticism, yellow journalism, red herrings, shaggy dogs, serious artist profiles, the reworking of myths and the updating of legends, first-person narratives, comedic spritzing, fanatic pop humor, and odd social commentary—tales of history and imagination, if you will.

All of which adds up to the elements of contemporary literature, I think.

In my further estimation, this is an extension of the oral storytelling tradition here in America, a fact first illuminated when my producer at *All Things Considered*, Bob Boilen, gave me a platform on *National Public Radio*.

Clearly, this book is a love letter to the music and popular culture of the twentieth century. Any attempt at embellishing these stories with more modern accoutrement would not change the fact that I'm a child of the '70s, pure and simple.

My father, Chuck Myers, was in the record business when I was young, and my life was shaped by a chaotic collision of cultural influences. My uncle, Shel Silverstein, was a personal inspiration, as

was his friend Charles Bukowski. Later, while earning my doctorate in psychology, the teaching tales of hypnotherapist Milton Erickson factored into the mix, as did the theories of my mentor, Dr. Bob Roth.

This was originally intended to be a collection of "reviews as fiction," a concept inspired by certain record reviews in the early issues of *Rolling Stone*, written by critics like Lester Bangs, Nick Tosches, and most important, J. R. Young. Those fantasias manifested the idea of allegorical commentary via playful, music-oriented vignettes.

Some of my fables have become urban legends, passed on by word of mouth and through the Internet. These works often touch on rock artifacts, when music was universally experienced through vinyl albums (later CDs), concerts, and underground radio. While new digital formats are supplanting older listening modes, there's still something to be said for the tangible experiences celebrated (and spoofed) in this collection.

It is a rare pleasure to reinterpret old American folklore. But, in addition to the murder mysteries, ghostly tales, and science fiction, vehicles for some of these tales came in the unlikely form of glockenspiels, cowbells, borrowed combs, car songs, circle jerks, and subway stations. The song "Freebird" remains an exceedingly familiar allusion to rock mentality in the twentieth century—hence the title of this book.

The sardonic power of these stories is revealed by the uncomplicated observation that some folks seem to think that I'm telling the truth when I'm jiving—and think that I'm jiving when I'm telling the truth. Go figure. While I'd like to think that there is some complexity and eclecticism within this book, my persistent theme is the simple joy of discovery, musical and otherwise.

The potential impact of myths and fables cannot be underestimated, however, and as a result I must reaffirm that some of the characters here are fictitious and are not intended to resemble anyone,

living or dead. A few of the more famous living characters (and the scenes in which they are placed) have been utilized in fictional scenerios for satirical purposes only, as the humor or dramatic import would have been diminished without their iconic presence in these (imaginary) settings.

Certainly, art that was once on the fringe has been absorbed into the mainstream. Still, these stories define what is perennially cool. They are pop tales for brothers and sisters in arms, and for parents to pass on to their children.

For the record, there are some recurring subject matters; these include time travel, pot and drug use, youthful protagonists, damned and devilish things, steel-string guitars, and my ubiquitous hero, Adam Coil.

Ultimately, this book asks the musical question, "Do You Believe in Magic?" If the answer is yes, these stories—the shorter humorous interludes and the longer, more elegiac pieces—will speak directly to you. So, as John Sebastian of the Lovin' Spoonful once sang . . .

> *I'll tell you about the magic, and it'll free your soul,*
> *but it's like trying to tell a stranger about rock and roll.*

And that's what I'm trying to do here.

—*Mitch Myers*

A ROCK & ROLL FABLE

Once upon a time, not so very long ago, Adam Coil was home changing clothes, preparing to go out for an evening of musical entertainment. He was almost giddy with anticipation—he hadn't been to a concert in over a month and was eager to catch the show.

For Adam Coil was no ordinary spectator. He'd carved out a special role for himself in the late 1970s—concerts were his sole outlet for personal expression. It was one brief moment when Adam discovered his calling, but since then his behavior had grown into a lifestyle that he was reluctant to abandon.

Concertgoers encountered Adam frequently over the years, but his appearances had a Zelig-type quality, and people rarely realized that it was the same person. Different times, different cities— it was always Adam. Most folks just took him for granted without knowing who he was or what his purpose might have been. His exploits were recounted until they became embedded in our collective unconscious. In a way, Adam had discovered his own version of immortality.

You see—Adam Coil is the guy who always yells "Freebird!" at a concert.

Yes, no matter what kind of show, Adam is the smart-ass shouting Freebird. And he takes his prank seriously, too. He doesn't just blurt out the old familiar standby—he waits and measures every performance until he finds just the right moment. Timing is everything— he'd learned that lesson early on.

He first shouted Freebird in 1979 at a punk-rock club in Cleveland, Ohio. Pere Ubu was performing, and there was a lull between songs. Adam was drinking with his college pals when he impulsively called out for the southern rock rave-out.

The club exploded with laughter and Adam's buddies slapped his back in support, complimenting his sarcastic genius.

That was all it took. Adam was filled with a grand sense of confidence and from that point on, he made sure to holler for the Lynyrd Skynyrd song whenever he could.

Initially, his friends encouraged him and sometimes joined in on the game. But years passed, and his college pals all went their separate ways. More recent acquaintances tired of Adam's conduct and declined to attend concerts with him. He lost two girlfriends because of his "hobby" and took to going to shows by himself. Adam was the lonely purveyor of his ironic little sport.

Despite the alienation, Adam clung to his strange pursuit and took pride in his behavior. He even had a few accomplishments that he bragged about.

One such incident occurred during a Keith Jarrett recital in Philadelphia. The pianist had just received a thunderous ovation from an appreciative audience intent on an encore. Jarrett bowed before quieting the crowd and sitting at the piano.

Hidden in the darkened auditorium, Adam yelled "Freebird!" just before Jarrett's fingers touched the keys.

The pianist froze, then stood up, and walked offstage without saying

a word—refusing to return. The following day, Adam found mention of the event in the daily paper. He clipped out the article and envisioned compiling a scrapbook of similar achievements.

By the late '80s, Adam had his concertgoing down to a science and avoided any show where the musicians might actually perform "Freebird." Naturally, country-rock gigs were out of the question.

Adam had other concerns as well. Sometimes he'd be poised, ready to shout out his request, and someone would beat him to it. This irked Adam to no end. There were implicit dangers, too. One night, at Red Rocks outside Denver, Colorado, three zealous Iron Maiden fans cornered Adam and threatened to thrash him within an inch of his life if he opened his mouth again.

All this embittered and emboldened Adam Coil. Obsessed, he kept a list of every concert he'd attended since that night in Cleveland. Sometimes his cry was received with complete indifference, but he'd persevere until another response was finally elicited. Feedback could come from anyone—audience or performers—Adam didn't care as long as he was noticed.

He'd been living in San Francisco for about a year and had only visited Yoshi's jazz club once before. It was a Thursday, and the Sex Mob—a group from Manhattan—was performing. Adam took the BART out to Oakland and arrived around 7:30, where he managed to get a table near the front of the stage. He'd never seen the Sex Mob, but he knew that they were talented players. Adam had also heard that the band's trumpeter talked a lot when he was onstage.

Adam could feel it in his bones—this night would provide him with a perfect opportunity to do his Freebird thing.

By the end of the first set, Adam was ready. The band was quite good and their leader, trumpeter Steven Bernstein, kept yammering between tunes. Adam could hardly contain himself. They had just

finished playing an old James Bond movie theme and Bernstein was giving another long spiel when suddenly, Adam shouted . . . "Freebird!!!!"

A few people tittered, but the crowd was mostly unresponsive to Adam's quip. Onstage, the band did not look amused. The trumpeter stared directly at Adam as the quartet huddled near the back of the stage. A moment later, they resumed their positions and Bernstein counted off the next tune.

It took Adam a minute to realize that the brooding introduction was actually the melody from "Freebird." He listened in amazement as the song took shape and built in intensity. The saxophonist took hold of the second verse, and his solo was sad, gently urging and poignant.

The group kept increasing the song's tempo until they burst into a rousing, free-jazz interpretation of the song's climactic guitar flourish. People in the audience were going wild. Many of them had their lighters out and they were standing and cheering while the band played faster and faster.

Meanwhile, there at the foot of the stage, Adam Coil was crying. He didn't know if he was happy or sad, but the one thing he did know was that he would never call out for "Freebird" again.

The song ended and there was a big round of applause. The trumpeter thanked the crowd for coming out and encouraged everyone to stick around for the second set.

But for Adam, the night was over. He made his way back home on the BART and went to sleep round about midnight.

It had been a long day.

RIVER DEEP

A few years ago, I was in Los Angeles and found myself at a quiet bar in the middle of the afternoon. There were just two guys shooting pool and an older fellow drinking by himself.

The older fellow had long sideburns and wore a fringed leather jacket. He told me that he was a studio musician who'd played on a lot of recording sessions during the 1960s.

"Wow," I said. "That sounds exciting. What instrument do you play?"

"Glockenspiel," he answered.

"Glockenspiel?" I barely contained my sarcasm. "Man, you must have sat in on some pretty heavy sessions."

The musician became stern, "Listen kid, you think you're smart? Let me tell you something, I worked on one of the greatest recording sessions of all time. Have you ever heard the song 'River Deep, Mountain High,' produced by Phil Spector?"

"Sure," I said. "Ike and Tina Turner recorded that one in 1966."

The old guy laughed, "You're half right, son. Now let me tell you the *real* story."

With that, he strolled over to the old-fashioned jukebox in the

corner, dropped in some quarters, pushed a few buttons, and returned to his seat. He said that his friends called him Harvey the K.

Then Harvey leaned back on his barstool and explained a few things, "Phil Spector was a young hotshot when he first saw Ike and Tina Turner perform in L.A. at the TAMI Show in 1964," he said. "But two years later, at the age of twenty-six, Phil was a hugely successful record producer. He had a string of hit singles with all these different girl groups—like the Crystals singing 'He's a Rebel' and 'Be My Baby' by the Ronettes.

"It hardly mattered who was singing when Phil was in charge. He picked the groups, gave them their songs, and directed their every move in the studio. Before Spector, record producers rarely got any press, but Tom Wolfe wrote this big article about Phil in 1965 calling him 'The First Tycoon of Teen.'

"Anyway," Harvey said—talking faster as his tale progressed, "Phil had started his own record label, but the hits weren't coming like they used to. His last big record had been with the Righteous Brothers and even though he produced their number one hit, 'You've Lost That Lovin' Feeling' a year earlier, the Righteous Brothers stopped working with Phil.

"Yeah, Spector was slipping, but he still had a few tricks up his sleeve. So, he contacts this little label called Loma Records and offers to buy Ike and Tina's recording contract for $20,000! And get this—the entire offer is just so he can produce one song with Tina Turner. But there's a catch, part of the deal is that Ike isn't allowed anywhere near the recording session—PHIL JUST WANTS TINA!

"They finally make the deal, and Tina starts rehearsing at Phil's L.A. mansion, just the two of them with no Ike in sight. They were working on this disjointed love song about a little girl and her rag doll that Phil had written with a couple of his cronies from Manhattan—Ellie

Greenwich and Jeff Barry. Phil had even convinced Ellie and Jeff to come out to L.A. hoping to recapture the magic of their days together at the Brill Building, when they'd collaborated on hits like 'Da Doo Ron Ron' and 'Baby, I Love You.'

"In a way, Phil took a big risk working with Tina. She and Ike weren't stars at that point—just another hard-core rhythm-and-blues revue doing endless one-nighters. Ike fronted a nine-piece road band and had Tina singing along with three Ikettes. Ike called all the shots back then and if you think about it, Tina's work with Phil was her first step away from Ike's domination.

"Finally, Phil got everyone together for 'River Deep' and you had to see it to believe it—it was a huge scene with more than twenty musicians crammed into Studio A at Gold Star Sound in Hollywood. We're talking about the top session guys at the time, guitarists like Glen Campbell and Barney Kessel, Leon Russell on piano, even Sonny Bono was there working for Phil.

"And there were just as many people hanging out, too. I remember Brian Wilson of the Beach Boys was watching us the whole time and Mick Jagger kept walking in and out of the control booth. Would you believe Dennis Hopper was there, taking photos? It was a rock 'n' roll party, and Phil worked us harder than usual just to impress everyone.

"With so many musicians in the studio, Phil took his 'wall of sound' to a whole new level. It was positively orchestral with four guitarists, four bassists, and three keyboards, all going over this killer arrangement written by Jack Nitzsche. Nitzsche was always in the studio with Phil, and so was engineer Larry Levine. Jack, Larry, and Phil fussed endlessly with the sound that day—adjusting each microphone and cranking up the echo and reverb beyond anything that I had ever heard before.

"Phil used two drummers for the first time, as well as two percussionists. We were falling all over each other, but the sound was huge; there were saxophones, trumpets, and trombones. Phil threw them all together until the instruments reverberated into one giant roar. Later, he would add an entire string section and a battalion of backup singers.

"Of course, the whole thing was done in mono—and *nobody* made mono recordings like Phil Spector.

"Tina tried doing her vocals that day, but she just wasn't ready for the total Spector experience. So, Phil rehearsed Tina for another week before finally recording her vocal track. That day, there was hardly anyone in the studio—just Phil, Larry, and me. The lights were low and Tina was wearing headphones with Phil's tremendous sound booming in her ears.

"Spector was relentless, and he kept making Tina sing the song over and over until the sweat came right through her blouse. Finally, she said, 'Okay Phil, one more time.' Then she pulled off her shirt, stood there in her bra, and nailed it. She matched Phil's majestic production punch for punch. It was fantastic.

"We all figured 'River Deep' was headed straight for number one but a funny thing happened . . . the record bombed. Some said it was overproduced, others thought it was just too far ahead of its time. Besides, Phil had alienated a lot of people in the music industry and many of them were happy to see him fail.

"In any case, 'River Deep, Mountain High' flopped, and Phil took it real hard. He became reclusive and hardly made any records at all for about three years. Of course, he rebounded in the '70s, producing albums like George Harrison's *All Things Must Pass* and John Lennon's *Imagine*.

When the song on the jukebox ended, Harvey the K stood up and

said that he had to get going. As we said good-bye, I noticed a button on his jacket that read, "Back to Mono." Then he was gone.

I was so intrigued by Harvey's story about Phil Spector that I contacted the American Federation of Musicians Local Union 47 on Vine Street in Hollywood. Sure enough, they had a contract listing for a recording session using twenty-three musicians on March 7, 1966, working on a song entitled "River Deep."

The funny thing is, no one named Harvey was listed on that recording session. Not only that, there was absolutely no mention of anyone playing a glockenspiel.

HELLHOUND ON MY TRAIL

It all started out innocently enough. I was trying to get some work done while listening to *Robert Johnson: The Complete Recordings*.

To tell the truth, I was well into the second CD before I started writing. I'd been unproductive that day and spent hours on the phone before typing a single word. By the time I'd finally gotten into a decent work groove the music on disc 2 had ended and I wrote in silence for about twenty minutes.

I'd forgotten all about the music when suddenly, Robert Johnson's blues-ridden wail started coming out of the speakers again. "That's funny," I thought. "The disc player isn't on auto-repeat and there aren't supposed to be any bonus cuts on this CD."

I went into the living room and looked at the digital display on my disc player. The machine read TRACK 30 but when I checked, the CD box listed only twenty-one tracks. The song ended, so I programmed the machine to play track 30 again. No such luck. The song seemed to have vanished.

I examined the entire CD, track by track, but it only went up to twenty-one. I went backward and forward, but there was nothing else

to be found. I even plugged the damned thing into my computer and read all the existing data. Still no go.

Feeling confused, I called some people who I thought might have the Robert Johnson collection. After a few conversations, I found an old friend who owned the two-disc set.

"Have you listened to disc 2 all the way through?" I asked him. "I think I've listened to it," he said. "Come on, Jim," I pressed. "You're no blues fanatic. Are you absolutely sure that you've listened to both CDs all the way through to the very end?"

"Well, actually," Jim confessed, "I only remember playing the song 'Crossroads' to see how it compared with the version by Cream with Eric Clapton."

"Well, don't put it on now!" I yelled. "Just wait for me to get over to your place and I'll tell you all about it. I'll be there in twenty minutes!"

I hustled over to Jim's house and explained the situation. After telling him what had happened, we agreed to play disc 2 in its entirety rather than searching for a phantom track. As a backup, I suggested that we use his old tape recorder to make a copy of the song if it appeared.

According to plan, we sat through all twenty-one tracks on disc 2 and then turned on the tape recorder. Sure enough, the CD kept going rather than stopping after track 21. Exactly sixteen minutes and thirty seconds later, track 30, the ghostly, angst-ridden blues that I'd heard in my apartment, was emanating from Jim's stereo.

I must admit that I was a little freaked out. It was definitely Robert Johnson, but neither Jim nor I recognized the song, and it wasn't listed *anywhere* on the CD package. As I predicted, the song ended and we couldn't get the disc to play track 30 again. Still, the meters on Jim's tape recorder had been moving while the tune played, so we were confident that we'd captured the elusive song.

When we tried to play it back, the tape came up blank. Then Jim started to get nervous. "I don't know, man," he whined. "It's just too weird, this whole legend about Robert Johnson having a hellhound on his trail and selling his soul to the devil at the crossroads? Think about it, the liner notes say that Johnson was only known to have recorded twenty-nine compositions in his short life. The rest of the tracks on these two discs are just alternate versions of those same songs. Twenty-nine songs . . . Track 30? Come on. This one piece of unidentified music *just happens* to disappear from two different compact discs on two different stereos and can't be recorded onto tape? It's just too weird!"

We fiddled with Jim's stereo a little more, but there was no trace of the song. It became clear that Jim was uncomfortable with our discovery, and he wanted me (and Robert Johnson) to get the hell out of his house. "Let it go, man, it's just too weird!" he shouted after me as I walked to my car.

The next day, I began my search for unopened copies of *Robert Johnson: The Complete Recordings*. I started by talking with some employees at Sony Records to see if I could get any information that would explain this phenomenon. The Sony folks seemed sympathetic, but I got the sense that they thought I was crazy.

I also got the impression that one guy I spoke to, one who actually participated in the production of *The Complete Recordings*, was hiding something. When I asked him about the existence of a track 30, he said that he'd have to call me back. I never heard from him or anyone else at Sony again.

Meanwhile, my search for unopened copies of *Robert Johnson: The Complete Recordings* was going poorly. None of the record stores I called had the box set in stock and neither did any of the online retailers. One friend in the music business told me that while the Johnson

collection was supposedly still in print, Sony had been showing the item on back order for the last eighteen months.

By this time I was convinced that there was some kind of cosmic blues conspiracy going on. No matter how hard I tried, I was unable to remember the slightest thing about the phantom Robert Johnson song. The lyrics and the melody were lost in my memory like a drunken dream. The song was hiding somewhere in my subconscious, but I was unable to summon it into my thoughts.

On top of that, my friend Jim stopped talking to me. Then, he moved out of town.

After more research, I determined that there *were* a few Johnson compositions that (supposedly) had never been recorded by the blues-man himself. Could the song have been "Little Boy Blue" or "Take a Little Walk with Me," both alleged Johnson compositions recorded by Robert Jr. Lockwood, a surrogate stepson to the legendary blues singer? No clue. The late Johnny Shines sang Johnson's little-known "Tell Me Mama" back in 1972, but the Shines version didn't jog my memory in the least.

There was only one answer: I had to hear that song again.

Desperate, I found a high-priced broker whose specialty was locating hard-to-find blues and jazz recordings. "Listen," I told him. "I'm looking for a double-CD box set called *Robert Johnson: The Complete Recordings* on Sony. I'm only looking for new copies but I'll pay top dollar for as many as you can find."

The broker laughed and said, "Kid, you're out of your league here and let me tell you why. I already have a standing order direct from Eric Clapton's business manager for every copy of *The Complete Recordings* that I can get my hands on. You don't even want to know how much he's paying; it would make you *sick*. Now, I don't know what it is about these Johnson discs that you guys are so hyped up

about and the more I hear, the less I want to know. I can tell you that I'm not the only one who's been contacted by people like Clapton—all of the guys in my business have had similar requests for two years running. Every once in a while somebody comes across a few of these box sets and makes enough money to buy a new house. My advice is to just scour the record bins and leave the high-end dealing to folks who can afford it."

In the following months, I spent my time calling vintage record stores and noted blues historians. I even located an old Robert Johnson crony in Chicago, bluesman David "Honeyboy" Edwards. Edwards was nice enough, but as soon as I asked him about the chance recording of a thirtieth Robert Johnson song, he hung up the phone.

Music authorities like Greil Marcus and Peter Guralnick ignored my queries, perhaps unwilling to share such forbidding information with a stranger. I found one copy of *The Complete Recordings* in a suburban CD shop, but it had already been played and there were some strange markings carved onto the cover.

Then, one night, after spending hours looking through Internet auctions and other online music sites, I turned off my computer in a state of complete exhaustion. It was late, nearly midnight, and a wave of discouragement swept over me.

"Damn," I said out loud. "I'd do anything for another listen to that song."

Immediately, there was a knock at my front door. Startled, I went to see who could be stopping by at such a late hour. As I approached the doorway, I felt an extreme heat coming from the outer hall. The smell of sulfur filled the air.

At that exact moment, I realized that I had made a big mistake.

NUGGETS

The year is 1968 and it's a quiet Tuesday afternoon in Cleveland, Ohio. Sid Garfinkle is on the phone with one of his more friendly business associates. Sid's office is a mess. Stacks of papers are everywhere, remnants of Chinese takeout litter the room, and the ashtrays are all filled with half-smoked butts. The shades are drawn and Sid is doodling on a yellowed invoice for an entire season's worth of secretarial services.

"I don't know, Manny," Sid groans into the phone. "It was a hell of a lot easier when I was promoting comedians like Morey Amsterdam and Shecky Green."

Sid crumples the unpaid invoice and tosses it toward an overflowing garbage can where it bounces off the rim and lands on the floor. He pauses for a quick slurp of hot coffee and burns the roof of his mouth.

"Shit," he mutters. "I'm telling you, Manny, all I can do nowadays is book these crazy rock-and-roll acts for a living. I don't even know where half of them come from. Every single region of the United States has more Beatles and Stones imitations than you can shake a stick at. These pimply-faced kids, most of them aren't twenty years old and

never even been laid! They think they're so frigging clever with their 'secret' drug lingo—one look at them and you know they're smoking more reefer than all of the jazzmen in Harlem. And the clothes! One group came onstage wearing electric suits, no less. Most don't bother wearing matching outfits—except for the ones dressed up like colonial soldiers. And I've never seen so much long hair since Flossie and I drove Bobby to college out in Berkeley, California."

Sid moves an empty pizza box from his desk and spreads out the mail.

"You wouldn't believe some of their gimmicks," he laughs. "I swear, one group has a kid that blows an electric jug, and another bunch wear capes just like Dracula. They all look completely ridiculous! I've booked two different bands that actually had a guy with a hook for a hand."

Sid plops back in his chair and says, "At least some of the kids have a sense of humor, or their managers do. I got one bunch an entire week in Boston on the strength of their single, 'Are You a Boy or Are You a Girl?' These groups each have one hit single and then fade back into the suburban garage oblivion from whence they came. Honestly, most of them should stick to teen dances and stay away from the big time; they're just not ready. I canceled one tour because some parents decided that their kids needed to go to summer school! Can you imagine?

"Yep, three weeks of music lessons and they all think they're going to be stars. Of course, some get so scared when they first see an audience that they piss themselves. Occasionally, I'll recognize one or two kids from the last big dance craze—they think that just because they're wearing bangs now or singing with English accents that no one will remember what snotty punks they were."

Sid Garfinkle counts the cash in his wallet and places a bank deposit

slip in his breast pocket. "All this talk about psychedelic music doesn't mean anything to me—it all sounds pretty much the same. Well, at least somebody's buying something. I'd be totally screwed without these bands.

"You know," Sid says. "The funny thing is that almost every rock concert I've been to has one moment that stands out from the rest. Most of these groups have the sense to wait until the end of their show before playing their hit song; otherwise, the crowds would go home long before they're finished. Anyway, the audience is there for the song they've heard on the radio, and when the band finally plays their hit single, the room goes wild. The band is so cocksure that they bear down on their instruments, and for one brief instant everything falls together. The crowd adores the band and the band gives every bit of intensity they've got right back to the audience. I hate to admit it, but the music sounds magical in a freaky, ominous kind of way. It feels like I'm being pulled into a strange cult ritual of a very secret society."

Sid Garfinkle rises slowly from his chair. "I have to head over to the bank, Manny. If I don't deposit some money quick, every check that I wrote this week will bounce from here to Akron. Hey, don't forget to say hi to Gladys for me and I'll catch you at the pinochle game next Thursday.

"You know," Sid adds. "As far as all those bands are concerned, nobody's going to remember them in six months. Any kid in America can make music like this. The only thing I would do is take each one of their best records and put them together in one big fancy package—maybe then you'd have something worth remembering."

— *For Lenny Kaye*

THE SOUND AND THE FURY

Since first released in 1975 Lou Reed's *Metal Machine Music* has been scrupulously analyzed by a number of pop culture journos. This includes serious analyses and not-so-serious prose. Reed himself has caused much of the confusion, but there have been so many details, myths, lies, half-truths, accusations, and discussions devoted to this radical piece of work that a more thorough investigation has long been in order.

So, consider these disparate bits of information if you will. *Metal Machine Music* was Lou Reed's seventh solo release after leaving the Velvet Underground. It was also his first double album, which affirmed RCA Corporation's faith in the marketability of their most notorious recording artist. Developed in Lou's west Long Island studio out near Pilgrim State Hospital, the sonic opus was created without the use of conventional instruments *or* the human voice.

Instead, Reed chose to stack multiple combinations of reverberating electronic sound to create a vast industrial howl. Derived from a process of manipulating aural frequencies and distorting both intensity and pitch, Reed's mechanized drones and harmonic buildups released

shifting waves of pulsing white noise and emitted squeals of pure feed-back into two separate (but equal) stereo channels.

Now, what's up with that?

On the back cover of the original album—above an incorrect chemical diagram of some unholy amphetamine—there was a specifi-cations list that included such things as ring modulators, tremolo units, high-filter microphones, and Jimi Hendrix's very own Arbitor distortion box. The spec list further asserted, "No Synthesizers No Arp No Instruments? No Panning No Phasing No."

In some way, that last lone "No" betrayed the true underpinning of *MMM*'s conception. Representing a diametric swing away from his then-popular identity as the androgynous rock 'n' roll poet laure-ate of Manhattan's mean streets, Reed's oppositional soundscape could hardly have been anticipated, even as an extension of the feed-back/noise/distortion found in Lou's early work with the Velvet Un-derground on their groundbreaking performance of "Sister Ray."

This new (metal machine) music, Reed contended, was "the per-fect soundtrack to the *Texas Chainsaw Massacre*." Lou also claimed to have inserted tiny snippets of classical music into the mix and that many of the sound frequencies were dangerous, even illegal to put on a phonograph record.

Yes, while successive generations of subversive DJs and electro-acoustic dronemeisters were still learning to crawl, Lou Reed had al-ready employed the studio as a sound instrument, resulting in an imposing approximation of sonic-electronic doom.

In interviews, Lou compared his work to those by avant-garde composers like (the late) Iannis Xenakis and La Monte Young (whose name is misspelled on the back cover). Although Reed's VU band-mate John Cale had actually been a member of La Monte Young's Theater of Eternal Music, Lou never really associated with Young

and his associates during their own (amphetamine-driven) marathons of minimal music making.

Rather, Lou insisted that he had been working on *MMM* by himself for six long years and earnestly discussed his esoteric sound maze in several major music magazines.

MMM was clearly an artistic gamble, but RCA Records backed Reed to the hilt, releasing the double album on stereo and quadraphonic vinyl, as well as on (quadraphonic) 8-track tape. Of course, none of these well-intentioned efforts saved the release from commercial disaster.

While *MMM* was reported to have initially shipped a hundred thousand copies, it was the most returned album in RCA's history. In its frantic effort at damage control, the record company pulled *MMM* from store shelves and rerouted it straight into the cutout bins. Before more damage was done, it canceled the disc's release in England.

Since that time *MMM* (subtitled *An Electronic Music Composition: The Amine ß Ring*) has become one of the most sought after 8-tracks of all time, right up there with vintage oddities like Yoko Ono's *Fly*. It was officially entered into the 8-Track Hall of Fame (yes, there is such a thing) on October 10, 1995.

It should not be forgotten that the late, legendary chronicler Lester Bangs waxed poetically, prolifically, and prophetically on *MMM*. In his classic *Creem Magazine* article, "The Greatest Album Ever Made" (later in the posthumous collection, *Psychotic Reactions and Carburetor Dung*), Lester provided seventeen lively reasons why *MMM* was superior to his number two choice, *Kiss Alive!*

Bangs and Reed jousted brutally when discussing *MMM*, which was documented in another Bangs's essay, "How to Succeed in Torture Without Really Trying." While Lester adored *MMM*, others disagreed.

Rolling Stone voted it "Worst Album of the Year." *Billboard Magazine* said simply, "Recommended Cuts: None." Most critics panned

it, although Robert "The Dean" Christgau was merciful in his *Consumer Guide*, giving it a respectable grade of C+. In the *Trouser Press Record Guide*, Ira Robbins described ". . . the truly deviant *Metal Machine Music*" as "four sides of unlistenable noise (a description, not a value judgment) that angered and disappointed all but the most devout Reed fans."

All true enough.

While dismissed as a scam that (simultaneously) took revenge on his manager, fulfilled a commitment to Reed's record company, and eliminated a growing congregation of unwanted admirers, *MMM* was undeniably guilty of deceptive packaging.

The album cover featured a leather-clad Reed, hair peroxide blond, wearing sunglasses and looking every inch the decadent glamhead. Lou used this same punk visage on his sexually ambiguous *Transformer* album (which included the hit single, "Walk on the Wild Side") and again on his twin-guitar/arena-rock concert recording, *Rock and Roll Animal*.

Imagine teenagers across the country rushing home with their brand-new Lou Reed album, only to conclude that something had gone terribly wrong with their stereo systems, or worse yet, that Reed had ripped them off with a bunch of irreverent white noise.

John Holmstrom, former editor of *Punk* (defunct) who interviewed Reed for the visionary fanzine's first issue in 1976, described the album's impact this way: "*MMM* is one of the greatest records of all time. It kicked off the whole punk movement. I mean—it nearly destroyed Lou's entire career. How much more punk can you get than that?"

So, *MMM*: a grand punk statement, an electronic composition of indecipherable depth, or both? Whatever the case, *Metal Machine Music* was one of the more controversial pop music products of the twentieth century. But looking at MMM as art, one must contemplate the artist.

Prior to the release of *MMM* Reed had gone through a divorce and was in a state of near exhaustion. He was cohabiting with a drag queen named Rachel and had been hit in the face with a brick while performing in Europe.

On *MMM*, Lou flagrantly trashed the boundaries of decorum with overt references to amphetamines, syringes, and pharmaceutical handbooks. In his bitter, rambling album notes, Reed made apocryphal drug comments—curtly dismissing "those for whom the needle is no more than a toothbrush."

Rumored (and then denied) to have been a candidate for RCA's classical music imprint, Red Seal, *MMM* was immediately and forever stuck between rock music and a hard place. Lou even made some faint apologies for not having a proper disclaimer on the album cover—only to angrily deny those regrets the next time he spoke to the press.

With Reed's uncompromising electronic maelstrom spread across four sides of vinyl, and each untitled side listed as exactly sixteen minutes and one second in length (this, too, proved to be untrue), *MMM* was unlike any other record released by a "rock" personality.

Consumer reactions to Reed's labor of love (and hate) were equally extreme. Musician/writer Richard Henderson recalled replacing all the tubes in his stereo amplifier before heading back to the record store to return his copy of *MMM*.

"I walked in and watched someone bring back an *MMM* 8-track they had obviously just bought," Henderson said. "Without a word they stood in front of the cash register and pulled all of the tape out of the cartridge onto the counter. Everyone in the store was watching while he spooled out the entire 8-track, dropped the cartridge on top of the pile of tape, and walked out without saying a word. I decided that if the record had that kind of effect on people, I was going to keep it."

For those who bought vinyl copies of *MMM*, there was the added bonus of a locked groove at the end of side 4, thereby assuring the (unsuspecting) listener of an endless journey into automated sound. While the double LP quickly went out of print, *MMM* found new life on compact disc. And like the 8-track format, the CD allowed one to hear Reed's sonic montage from beginning to end without making consecutive decisions to forge ahead with sides 2, 3, and 4 (lengths 15:40, 16:04, and 13:40, respectively).

When I began this investigation, I hit an unanticipated snag that brought my research to a standstill. That is, I kept listening to Lou Reed's *Metal Machine Music*. The more I heard it, the more I liked it, and this concerned me. My desire to hear conventional music diminished, and all my friends stopped visiting. I was discouraged about the whole thing until I bumped into musician/recording engineer Steve Albini at a Chicago nightclub called The Empty Bottle. After explaining my obsession with *MMM* to Mr. Albini, he kindly consented to discuss the record. He said:

> *When I lived in Montana in 1977 a friend of mine told me about this weird Lou Reed album that everybody hated but he thought was pretty cool. He played it for me and I thought it was just totally captivating, really amazing. The thing that we both appreciated about it was that within the noise there are these little fluttery beautiful tiny melodic bits, which are probably part of the generative systems that were put together to make all the sounds. Those sounds may not have been orchestrated or intentional in any way, but were there— and no less interesting. People refer to that record as though it were completely chaotic noise. I have a lot of records that are completely chaotic noise and that is a total misunderstanding of this record. Whatever Lou Reed's motive for making it, it's still a really*

outstanding nonharmonic piece of music. There were clearly choices made about how much density and which sounds in particular would get layered on top of each other. I don't hear Metal Machine Music *as a feedback and improv record; I hear it as a pure sound sculpture. I really enjoy listening to it. It's not that weird, it's only weird given that it came out in 1975 and was presented as a pop music record.*

Now that's exactly what I was looking for. Someone articulate and knowledgeable who thinks *MMM* was pretty cool *and* fun to listen to. Perhaps Lester Bangs did know what he was talking about when it came to *Metal Machine Music*. Even Lou Reed said, "In time it will prove itself." He also claimed to have laughed himself silly after presenting *MMM* as a serious piece of music to the honchos at RCA.

I really don't know what to believe, but I do know a good controversy when I hear one. Play it again, Sam.

—*M.M.(M.)*

More Musings and Meditations on Metal Machine Music

I ASKED SOME OTHER PEOPLE WHAT THEY
THOUGHT OF MMM; THIS IS WHAT THEY TOLD ME.

JIM O'ROURKE
(MUSICIAN, PRODUCER, SONIC YOUTH, SOLO ARTIST)

"I first bought it on 8-track at a Walgreens drugstore along with the Jethro Tull album *Songs from the Wood*. When I listened to it I thought for sure that the 8-track was playing backwards. It was definitely the

first noisy album I ever bought. Later on I checked a vinyl copy out of the library and read the liner notes with his reference to La Monte Young. I even recorded it onto tape and slowed it down to hear what he was doing with feedback. When I listen to it now I find it to be quite soothing."

JON LANGFORD
(MUSICIAN, MEKONS, WACO BROTHERS, SOLO ARTIST)
"I thought it was a great bash against the record company, the critics, and his fans as well as an exploration into that kind of music. It's Lou Reed's easy listening album and much less whiney than the rest of his work, probably my favorite."

BOB NEUWIRTH
(SONGWRITER, PAINTER, PERENNIAL INSIDER)
"The reason I respect Lou Reed is because he never writes about anything he doesn't have intimate knowledge of. So I'm sure *Metal Machine Music* was exactly what he was hearing in his head at the time or something very close to it or a 'Lou-ization' of what he was hearing, and that's what makes him authentic. I don't think artists make insincere efforts."

ROBERT QUINE
(FORMER LOU REED GUITARIST, DECEASED)
"My friend Lester Bangs was a major fan of it. As a gesture it's absolutely 100%. It's 150% it's 200%. It's great as a gesture, a fuck you, giving the middle finger to the record industry, his fans—just don't ask me to listen to it. If you want real intelligent improvisation go back and listen to "Sister Ray." I spent about a half an hour listening to it and

I think that's more time than he put into it. My humble opinion is that it's a total shuck, there's nothing happening there, it's a bunch of fucking noise. He did nothing; it's garbage. As a gesture, it's magnificent. It took a lot of courage to do it."

BILL BENTLEY
(INDUSTRY STALWART, MUSIC PUBLICIST)

"That's what it sounds like when you're trying to go to sleep and you can't. I was very close with a guy who was quite partial to Methedrine for a period there—that was his favorite record. I don't think [Lou] did it as a joke."

GLENN BRANCA
(SERIOUS COMPOSER)

"I think *Metal Machine Music* is one of the great classics of late-twentieth-century music. Certainly, if Lou Reed had decided to pursue a career as a serious composer he would probably be one of the best composers in the world today."

DAVID THOMAS
(SINGER, PERE UBU, SOLO ARTIST)

"I remember Peter Laughner liked this record a lot but I was never sure if it was for the noise or the attitude. I listened to one side and didn't see the point. It would be interesting to return to it years later, I suppose. My opinions should always be considered in light of my basic dogma: Music without vocals is utterly pointless."

STEVE WYNN
(MUSICIAN, DREAM SYNDICATE, SOLO ARTIST)

"I like side 3 the most."

SYLVIA REED
(LOU'S EX-WIFE)

"I first heard it at a party Lester Bangs gave where he drunkenly swore at everyone that it was the greatest album ever created. He drove everyone out of his apartment by putting it on right then and there. I had just met Lou and was head over heels in love with him and so I went and got my own copy. I intended to listen to it straight through. In spite of my affection, I could only make it through the first three sides before giving up. I still respect it as a great piece of concept art."

KRAMER
(MUSICIAN, PRODUCER, BONGWATER)

"In high school I worked in the record department of a large department store. I had the opportunity to steal anything I wanted. I took everything I possibly could out the back door. I liked just about everything with the exception of *Metal Machine Music* by Lou Reed. I thought it was shit stacked higher than the band he used to be in, the Velvet Underground. Cut to ten years later: I now understand those awful sounding records I used to hate, from the Velvets all the way to *MMM*. Pure white noise, pure cacophony, pure chaos. I understood, I had respect, but I didn't really like it. Cut to the present: I now own all Velvets' recordings on both LP and CD. I still have not found a way to start my day with *Metal Machine Music*. I still listen unconditionally. I do not think of how the recordings were made, or how they were released, or who signed them, I only wonder why."

PENN JILLETTE
(ILLUSIONIST, MEDIA PERSONALITY)

"Teller says '————.'"

PAUL WILLIAMS
(WRITER, EDITOR OF *CRAWDADDY!*)

"With *MMM*, Lou definitely made one of the most memorable and effective conceptual art statements in rock recording since the Beatles and before, um, Laurie Anderson. . . ."

LEE RANALDO
(GUITARIST, SONIC YOUTH)

"I love the thing and it is a crucial record, both conceptually and in the history of seventies rock (a major label put this out! Did Lou have that much clout??). We used a loop of it as the background bed of a song off *Bad Moon Rising* ('Society is a Hole'). I've always wondered exactly how the sounds were created (not that it matters). . . ."

PAUL SCHUTZE
(ESOTERIC BRITISH MUSICIAN)

"I bought *MMM* as a teenager the week it came out. At the time I was a devoted Krautrock and electric jazz fan and not remotely interested in American rock music. I had never heard a Velvet Underground album. The relentless single-mindedness and clarity of this most minimal piece excited me in the same way that *Outside the Dream Syndicate* by Tony Conrad and Faust had a few years before. Rock had become more and more about timbre and less about melody and rhythm. *MMM* is pure sound. Rock reduced to its essence."

ENDLESS BOOGIE

"Hey baby, you wanna boogie?" According to Richard A. Spears's *Forbidden American English*, "to boogie is to copulate or have sex." Spears goes on to say that there are "many other general slang senses, such as those having to do with dancing, partying, departing, etc." *The Rolling Stone Encyclopedia of Rock & Roll* maintains that "the term [boogie] derives from the jazz-based 'boogie-woogie,' which generally referred to a style of piano playing that featured a 'hot' rhythm based on eight-to-the-bar figures with the left hand."

Some historians say that boogie-woogie echoed the railroad rhythm of the steam locomotives that beckoned plantation workers in the Mississippi Delta, promising a life found better elsewhere. Along those (railroad) lines, "Pinetop's Boogie-Woogie" by Clarence "Pinetop" Smith was an influential piano boogie recorded in 1928.

Boogie-woogie really took hold in Kansas City during the 1930s with two-fisted piano players like Albert Ammons, Pete Johnson, and Meade "Lux" Lewis—who (occasionally) performed together as the Boogie Woogie Trio, and were (sometimes) accompanied by the famous blues shouter, Big Joe Turner.

Those same boogie rhythms were the building blocks of early rock

and roll. In *Hellfire*, Nick Tosches's fine biography of Jerry Lee Lewis, Tosches recounts a scene where young Jerry Lee is playing a Pentecostal hymn at a chapel service and, "the preacher shot him a glance of reproach, for he was playing it boogie-woogie style . . . and he beat the boogie so hard there was nothing left of the hymn, nothing but the sounds of the Holy Ghost that inspired it."

The phrase boogie-woogie possibly came from "booger-rooger," which meant a wild party or a musical good time—and was first coined by Blind Lemon Jefferson, a Texas bluesman who came to prominence in the 1920s. By the 1940s, "boogie" was used to describe a chugging guitar style, as illustrated by tunes like Albert Smith's "Guitar Boogie."

Of course, the most famous boogieman of all time is John Lee Hooker, whose primal "Boogie Chillun" was a hit for the Modern record label in 1948. In "Boogie Chillun" Hooker sang these now-immortal words,

> *One night I was layin' down,*
> *I heard mama 'n papa talkin'*
> *I heard papa tell mama, let that boy boogie-woogie,*
> *it's in him, and it got to come out*

John Lee's fanatical one-chord stomps are classics of the boogie genre and his haunting, stream-of-consciousness boogies inspired musicians like the Lovin' Spoonful, Van Morrison, and ZZ Top, to name a few.

The most notable boogie band of all is Canned Heat. Canned Heat was named after a brand of cooking fuel that came in small metal containers—from which desperate members of Skid Row would filter out the alcohol to drink.

Formed in 1966, Canned Heat featured heavyset singer Bob "The Bear" Hite and nearsighted Alan "Blind Owl" Wilson on guitar,

harmonica, and vocals. With songs like "Let's Work Together," "Goin' Up the Country," and "On the Road Again," the Heat were much loved and they boogied the world over, including an appearance at the original Woodstock festival, where they played (what else?) the "Woodstock Boogie."

Canned Heat even made a couple of albums with Sir John Lee Hooker, thereby confirming their claim to the estimable boogie throne. Sadly, "The Bear" and "Blind Owl" died before their time and it fell to the band's drummer, Adolfo "Fito" De La Parra, to keep the Heat boogieing on down the road.

Born of the blues and birthing rock and roll, boogie can be found in R&B, hard rock, country music, rockabilly, jazz, and Texas swing. The Delmore Brothers performed "Hillbilly Boogie," Ella Fitzgerald sang "Cow Cow Boogie," and everyone from Louis Jordan to Asleep at the Wheel recorded "Choo Choo Cha Boogie."

In the 1970s, concerts by southern rock ensembles like Black Oak Arkansas and English groups like Foghat expanded the boogie concept to new, sometimes ridiculous heights. As the years went on, catchphrases like "Born to Boogie" and "Boogie Till You Puke" were transformed into song. Obviously, pop tunes like "Boogie Bands and One-Night Stands" and "Boogie Nights" had little in common with the original boogie style.

And no requests for "The Boogie-Woogie Bugle Boy," please.

Revivalists like Alvin Lee, former guitarist and singer of Ten Years After—an archetypal British boogie band from the 1960s—have helped keep boogie alive. Just like Canned Heat, Ten Years After played at the original Woodstock festival, where Alvin boogied well beyond reason with his over-the-top performance of "I'm Going Home."

In the twenty-first century, Alvin made a CD called *Alvin Lee in Tennessee*, which featured the bedrock talents of Elvis Presley's old

Memphis sidemen, drummer DJ Fontana and guitarist Scotty Moore. For fans of those vintage railroad rhythms, Lee kicks things off with "Let's Boogie" and closes out with a jumping remake of "I'm Going Home."

In short, Alvin Lee—much like Jerry Lee Lewis, John Lee Hooker, and all the other great boogiemen—unlocks the not-so-secret history of American roots music.

That is, he boogies like it's going out of style—which it never has and, apparently, never will.

WHEN HARRY MET ALLEN

Were prophecies evoked in 1965 when the Fugs sang the words, "*Village Voice* nothing, *New Yorker* nothing, *Sing Out* and *Folkways* nothing, *Harry Smith* and *Allen Ginsberg*, nothing, nothing, nothing?"

The Fugs were a lot of things back then—they were literary, politically active, antiwar poets who embraced comedic folk-rock and bridged the generation gap between the beatniks and the hippies. Involved in music, literature, journalism, theater, and films, they reigned shrewdly, crudely, and lewdly over the East Side of Greenwich Village—especially when it came to the free love and the drugs.

The song "Nothing" was included on *The Fugs First Album*, which was produced by Harry Smith. That was nearly a decade before Harry Smith and Allen Ginsberg combined their own talents for an impromptu (or was it planned?) recording session at the Chelsea Hotel, which resulted in the Allen Ginsberg album *First Blues: Rags, Ballads & Harmonium Songs*.

So then, might *First Blues* be a representation of the existential nothing? Or is it really something?

Allen first met Harry in 1959 at the Five Spot in Manhattan, where pianist Thelonious Monk was enjoying one of his residencies.

Previously, Ginsberg had only heard about Smith, but recognized his presence immediately—Harry was sitting at a table transcribing Monk's angular melodies into impressionistic drawings. Allen described his first vision of Smith as "slightly hunchback, short, magical-looking, in a funny way gnomish or dwarfish, same time dignified."

A chance meeting? Not necessarily, considering the synchronistic Weltanschauung when it comes to all things Harry Smith. And just how much empyrean nonsense is it to contend that these two opposites did indeed attract?

Surely, the two men couldn't have come from more contrasting orientations. One, a hermetic, neocelibate white-bread record collector/visual artist from Oregon with roots in freemasonry and an attraction to occultisms. The other, a free-loving Buddhist Jew queer from New Jersey who became reigning ambassador of the beat generation and a poet of Whitmanesque proportions.

Ginsberg was an exhibitionistic showman who, to quote historian Harvey Kubernik, "was a tireless self-promoter that would show up for the opening of an envelope."

Smith, on the other hand, was a cultural obeah man who lived on Skid Row in small rooms stacked with books and kept dead animals stuck in the freezer.

Their talents differed, but Harry and Allen both had an impact on the expanding of consciousness in the twentieth century. Ginsberg's epic poems, "Howl" and "Kaddish," fueled the imaginations of many. Along with Messrs. Kerouac and Burroughs, he contributed to a generative unshackling of prose and poetry. His libertine lifestyle ran against the grain of the intellectual establishment and his countercultural stance encompassed drug and sexual experimentation, political dissidence, gay rights activism, and antiwar protests.

For his part, Harry Smith enriched the realms of film, visual art,

and cultural anthropology. Most notably, his annotated compendium of rural song traditions, *The Anthology of American Folk Music* (first released in 1952), has had a lasting influence on music appreciation in the (post) modern world.

The album these two men created together, *First Blues*, is a folk-form cryptogram of sorts, with connections, implications, and historical significance that defy simple assessment. *First Blues* was compiled by beat biographer Ann Charters and was released on Moe Asch's Folkways label. Compounding the mystique, confusion, and interconnectivity of these beat/archival coincidences is the fact that there are actually two *First Blues* albums credited to Allen Ginsberg. Both albums were recorded in the '70s, and both remained unreleased until the early '80s.

Columbia Records impresario John Hammond produced the other *First Blues*. But because Columbia considered Allen's works too brazen, Hammond was compelled to release the double album on his own (short-lived) JHR label.

Unlike the solo recording produced by Harry Smith at the Chelsea, Hammond's production features Allen singing with group accompaniment. Musicians like David Amram and Happy Traum performed on the Hammond sessions, as did Allen's lover Peter Orlovsky, and Allen's dear friend Bob Dylan.

Although some of the same songs appear on both *First Blues* albums, the two recording sessions were quite different—as different, we might say, as Harry Smith and John Hammond.

When I discussed the Smith-Ginsberg *First Blues* with Hal Wilner (who produced the Ginsberg CD anthology, *Holy Soul Jelly Roll: Poems and Songs, 1949–1993*), he wondered, "Was it a conscious decision to record in Harry's room at the Chelsea for environment as opposed to Allen's? [There is] kind of a tense atmosphere and Allen doesn't sound all that relaxed."

Wilner's observation seems accurate—singing his "blues" while playing a small harmonium from Benares, India, Allen Ginsberg struggled through those Chelsea performances, mostly bereft of conventional musicality.

But if Ginsberg was really the sole performer, the lonesome entertainer, the solo-ballad-blues disciple, why does Harry Smith loom so large in the proceedings?

Practically speaking, Smith's documentation of Ginsberg at the Chelsea is no different from any other anthropological fieldwork, just like Smith's 1965 recording of peyote rituals by the Kiowa Indians in rural Oklahoma (see Conrad Rooks's film *Chappaqua* for additional clues).

And what of the eternal Bob Dylan? Allen loved Bob and was eager to impress him. "I don't think I would have been singing if it wasn't for younger Dylan," Ginsberg told Harvey Kubernik. "He turned me on to actual singing. Dylan's words were so beautiful. The first time I heard them I wept."

Not only did Dylan inspire Ginsberg with his words, but Bob also showed Allen the three chords he needed to write a folk or blues tune— insisting that it was Allen's time to sing out rather than recite his prose. So, while Smith may have been Ginsberg's twin tower of aesthetic strength at the Chelsea, Dylan figured into their *First Blues* as a more subliminal conspirator.

While Dylan repaid artistic debts to Ginsberg (and Kerouac) by encouraging the poet to sing, there's a less obvious connection between Bob Dylan and Harry Smith. That is, Dylan's first album (produced by John Hammond) contains songs drawn from *The Anthology of American Folk Music*. And surely as Dylan gained insight into America's folk/blues evolution by listening to the *Anthology* in the early '60s, Bob made his circuitous back-payment to Mr. Smith via *First Blues*.

Dylan wasn't present during the Chelsea recording session, but he played on the "other" *First Blues*, thereby further illuminating the extended relatedness between himself and gurus Ginsberg, Smith, *and* Hammond.

What does all of this say about Harry recording Allen at the Chelsea? Merely that Ginsberg's eccentric performances would have been forgotten were it not for Smith's predilection for recording folk art and documenting everyday life.

"It was just another example of field anthropology in a postmodern mode," said Ed Sanders of the Fugs. "Allen always rose to the occasion of spontaneity, this was one short slice of twentieth-century existence. Two geniuses colliding at the Chelsea Hotel in 1973."

Fug Tuli Kupferberg maintained a more speculative assessment of the Smith-Ginsberg Chelsea encounter: "When two geniuses get together, you've got to expect something great! . . . Is there music on it?"

A fair question, it was only after this particularly raw phase of his singing career that Ginsberg began working in more sophisticated musical environs, ones that departed from his raggedy voice plus harmonium expositions at the Chelsea.

Guitarist Steven Taylor worked with the Fugs, and he was also Ginsberg's accompanist for years, even playing on Hammond's *First Blues* sessions. Taylor reflected on Ginsberg's "blue" period of the early '70s. "Blues is a particular genre within a larger history of African American folk music," said Taylor. "One of Allen's main inspirations was Leadbelly, who was on the radio when he was a kid. Leadbelly is generally considered to be a songster, not a bluesman. Blues could be part of his repertoire, but the songster is a larger tradition. Allen was more of a songster than a bluesman—a historian in song, a singer of ballad narratives, and a singer of topical material."

"Blues are a funny thing," said Fug Ed Sanders. "They are supposed

to make you sad but they make you triumph, too. Allen's diaries are strangely filled with the down mode. The poor guy was so publicly joyous and exalted, but in his private moments he was quite sad and dejected. He was drawn to the blues. He had been a fan of Ma Rainey and 'CC Rider' was the final music, the last tune he listened to before he died."

And what of the implicit connectivity that Harry Smith brought to the sessions at the Chelsea Hotel? Does it serve the same creative function that Smith unleashed when he first traced the paths of interrelated folk and blues idioms with the *Anthology of American Folk Music*?

John Feins studied under both Harry and Allen at the Naropa Institute in Boulder, Colorado. He thought that Smith's efforts to document life and sound were informed by a deep empathy for humankind. "What's great is that Harry wasn't an elitist, he recorded everybody," said Feins. "Harry felt that every occasion of sound was a recordable event and it had not just artistic merit and meaning, but anthropological meaning. If a human being opened his mouth up for song, Harry treasured and honored it as an archivist and a scholar and an anthropologist. He captured it when he could."

Just how does *First Blues* sound? Noted Ginsberg authority Bob Rosenthal is tough but fair. "I'll be frank with you. I couldn't listen to this record," he said. "I just wrote it off as caterwauling. I was so skeptical when I heard someone was going to reissue this. I'll confess I'm much more interested in it now than I was at the time when it came out. Allen saw the possibility of helping to change people's consciousness. And so did Harry, although they were total opposites in methodology."

Hal Wilner felt that *First Blues* was more than just an archival curiosity, and he included some of the Chelsea sessions on his Ginsberg anthology. "I'll admit when I first was slated to produce an album with

Allen I was holding my ears," said Wilner. "Yet, it's amazing how this stuff holds up and just gets better. I felt I needed it for the historical aspect—here's Harry Smith producing Allen Ginsberg. But when I went back to those tapes, I couldn't believe how strong it was."

Were Ginsberg and Smith blue when they made these recordings? Were they stoned? Whatever the mood, Harry allowed himself to be subsumed by Allen's *Rags, Ballads & Harmonium Songs*. As a witness to the (painful) birthing of Allen's career as a singer, Smith showed his colleague patience and understanding, supplying Ginsberg's ritualistic display at the Chelsea with the dignity it deserved.

"The role of the documentarian is often restrictive because of the attention to detail, the mechanics, or just removing your own ego," said historian Kubernik. "To help govern the person you are recording, you go into a secondary position. Harry was willing to do it. He put himself below the title to benefit the attraction."

According to Ginsberg, Harry Smith disagreed with some of the choices that Ann Charters made when compiling the album. Why Smith himself wasn't able to complete the task of editing the album is yet another cause for deliberation.

Harry's relationship with Folkways honcho Moe Asch was perpetually strained, but Asch respected Smith's archival efforts and used his understanding of art and ceremony to great effect. Like Smith, Ginsberg also had an appetite for collecting, and his own record collection reflected a deep love for music, especially the blues.

"When you collect, you put disparate things together in relation with other things and you get new results from that," said John Feins. "Harry loved to determine patterns in things. I think he derived meaning and insight from patterns that he saw in things that he collected or examined. Easter eggs, Indian rugs, paper airplanes, he would be interested in all the different forms and make great leaps of genius

thanks to the juxtaposition and understanding of patterns and syn-chronicity and the overlapping of things."

One thing is certain: We no longer ignore Smith's role as a cosmic documentarian. His preternatural musical tastes and hyper-informed critical judgments made him a cultural Nostradamus whose anticipatory discoveries and polymath predictions are unfolding still.

Harry's earnest contextual framework fueled Allen's gay vaude-villian prose attack, transforming poetic diatribes into semimelodic riddles, verbal instructions, joyous celebrations, and coherent protests, all captured in real time.

So, *First Blues* is the meeting of two friends, one poet reborn and one great rememberer, who both found the ways and the means of making the extramusical musical.

So much for nothing.

THE POWER OF TOWER

I was strolling through Tower Records at Fourth and Broadway in Manhattan one night when the strangest thing happened. It was closing time and I was in search of a gift for my parents. I was the only one browsing the classical section and I guess the Tower employees were in a big hurry because before I could get out, they locked up the store and accidentally left me inside.

Now, you'd imagine that being trapped overnight in such a store would be a dream come true for a music fanatic, but I was stuck in the classical section and couldn't get anywhere near the stuff that I really liked.

There I was, sitting on the floor, surrounded by thousands of CDs. But instead of digging around the vintage reggae or sampling the latest jazz, I was forced to amuse myself by examining the works of Bach and Chopin.

Just as I was getting depressed and a little uncomfortable, I looked up at a wall display and couldn't believe my eyes. There, in the classical section, was a Sonic Youth album that I had never seen before. The cover was psychedelic and the words *Goodbye 20th Century* peeked

through a spiraling purple vortex. Upon closer examination, I saw that this double disc was on the band's own SYR label.

So, I snuggled up to one of the listening stations and put on the headphones. Then I closed my eyes and leaned back against a shelf filled with Beethoven's Ninth. "Finally," I thought. "Some rocking entertainment to help me make it through the night."

Well, I couldn't have been more wrong. The music didn't rock; as a matter of fact, it didn't roll, either. It turned out that Sonic Youth were paying tribute to the conceptualist avant-garde, and most of the tunes were "composed" during the 1960s.

I say "composed" because there's a lot of noise involved, and if not for the electric guitars, you wouldn't even know it was a rock band playing. Still, the night was passing slowly and I couldn't sleep, so I listened to the (misguided) Youth perform compositions by eccentric artists like John Cage and Yoko Ono.

Now here's the thing. Sonic Youth display a succinct understanding of the abstract artistry that emerged during the latter half of the twentieth century, and while the music doesn't have a real backbeat, it does contain some interesting textures and effects.

Using sampling, discordant guitar riffs, tape loops, and other electronic noises, Sonic Youth embrace the groundbreaking reconsiderations of the '60s avant-garde by way of intangible atmospherics, repetition-of-sound-as-art, atonal colorings, and white-noise-as-entertainment.

So, by the time Tower Records opened the following morning, I was a changed man.

You can imagine the staff's surprise when their first customer of the day emerged from the classical section rather than the street. But there I was, standing at the checkout counter with a batch of CDs by

composers like Pauline Oliveros, Christian Wolff, Steve Reich, and James Tenney.

Now, don't tell anyone, but I kept a copy of *Goodbye 20th Century* in my pocket when I left the store. I mean, you've got to be a little bit of a rebel in this world, don't you?

WHO WILL SAVE THE WORLD?

It wasn't just another terrorist threat; this one had the country completely in its clutches. Aliens indistinguishable from humans were unleashing deadly clones into the population. The White House had reverted to a shadow government, sequestered in bunkers and communicating to the nation from undisclosed locations.

At first there was panic in the streets, but the president gave a speech insisting that people should go back to living their normal lives or else they'd be giving in to alien terrorism. The president reluctantly admitted that the nation's security forces were baffled as to how to identify the new enemy, but he vowed to find and destroy the alien terrorists by any means necessary.

The aliens' weakness might never have been discovered if not for a chance coincidence. The big break came at Forest View High School's reunion for the class of 1975 in Mount Prospect, a northwestern suburb of Chicago. A DJ was playing old vinyl albums at the reunion party.

Everyone was having a good time until the DJ put the needle down on "Paranoid" by Black Sabbath. Suddenly, class president Terry Diferio began shaking violently and changed form, revealing his identity as

a hideous alien before disintegrating into a bubbling mass of proto-plasmic goo.

Authorities were on the scene within minutes. The police were there as well as the NSA, the FBI, the CIA, and several other secret service agencies. Witnesses were interviewed and media coverage was intense. It wasn't until the same thing happened a month later at another class reunion in Spokane, Washington, that scientists determined it was the *analog* version of the song "Paranoid" that turned the aliens into mush.

Despite the government's efforts to control this information for the sake of their covert war on alien terrorism, news of the discovery leaked onto the Internet and was picked up by the mainstream press.

People tried downloading "Paranoid" onto MP3s and began burning copies of Black Sabbath's famous second album, only to find that digitized reproductions of the original vinyl record were useless against the aliens.

It was then confirmed that first-generation analog copies recorded on old-fashioned audiocassettes could also be used to kill the alien enemy. The fading market for turntables and blank audiotapes surged, and the sales of outmoded tape recorders skyrocketed overnight.

It still hadn't been determined why the vibrations of Ozzy Osbourne's keening voice combined with Tony Iommi's scorching guitar, Geezer Butler's booming bass, and Bill Ward's tribal drumming were so deadly to the creatures from outer space. The fact that it was just the one song, "Paranoid," and all the other Sabbath tunes were ineffective against the aliens provided some clues, but early tests on alien detainees proved to be tortuous and inconclusive.

The government began round-the-clock experiments, covert and otherwise. They commandeered hundreds of turntables and tape decks, and commissioned lucrative production contracts to favored stereo manufacturers.

Vigilantes began taking action. Some drove through city streets with their windows down, blasting "Paranoid" on tape decks at full volume in hopes of nailing a stray alien. Other concerned citizens fastened down turntables in rental trucks with speakers attached to the roofs, driving from town to town and playing the song nonstop. This "Paranoid" strategy actually worked in Cleveland when an off-duty cabdriver melted a couple of space geeks posing as street vendors.

By this time there was a mad rush for old copies of Black Sabbath vinyl. People were buying everything, not just the *Paranoid* album, but the entire Sabbath catalogue. Record collectors were forced to protect themselves from panicky neighbors who tried to steal their vintage Sabbath LPs. Domestic disputes erupted as family members turned on one another. In an ironic turn of events, teenagers begged parents to stop blasting loud music on their home stereos.

Industrious bootleggers began selling copies of the song on eBay at outrageous prices. The original album was soon worth $20,000 and first-generation audiocassettes went for as much as $1,000 apiece. DJs who owned the record were hired to spin it in public places to reassure patrons that various malls, restaurants, and sporting venues were alien-free zones. The *Paranoid* album was re-released on 180-gram virgin vinyl and went straight to the top of the charts.

Music once again became a high priority across the nation, and people began having anti-alien dance parties. Aging hipsters bonded at heavy metal raves and you couldn't go anywhere without hearing Black Sabbath. Mind-altering substances like marijuana, downers, and hallucinogens all became more fashionable than they'd been in decades.

Then, a grassroots movement began which accelerated the sense of urgency in America. It started when someone forwarded a joke e-mail saying that everyone in the country should play an analog version of

"Paranoid" at full volume on July 25, precisely at 12:00 midnight Eastern Time. In a matter of days, word had spread, and people began synchronizing their collective effort to destroy the alien terrorists.

The sonic countdown had begun.

Government officials initially discouraged the plan as dangerous and ill-conceived. But as public opinion polls displayed overwhelming support for the idea, as well as a mounting belief that the White House was soft on alien interests, politicians of all stripes came out in favor of the plan and rallied around the impending target date.

Radio and television pounced on the latest news craze; talk shows were filled with celebrities eager to prove that they were loyal humans. Leno and Letterman pandered to Middle America with humorous, anti-alien monologues. *Larry King Live* changed its opening theme to the Sabbath tune, and programs like the *O'Reilly Factor* explored conspiracy theories—blaming the alien problem on evildoers of earthly, liberal origins. Daytime television was just as bad, with Jerry Springer and his ilk preying on the fears of the simpleminded, pitting friends and loved ones against each other in every conceivable "Paranoid" combination.

VH1 quickly produced a *Behind the Music* episode of "The Making of 'Paranoid,'" which they ran eight times a day.

Pat Robertson, accompanied by other leaders of the religious Right, held a press conference condemning the use of "Paranoid." Robertson insisted that while Black Sabbath was known as a pop group, they were actually agents of the devil. He suggested that the public try alternative anthems by other color-coded heavy metal groups like Deep Purple or Blue Cheer. A protester unexpectedly disrupted the press conference with a portable cassette player blasting "Paranoid," and Robertson, along with three of his aides, were exposed as aliens, dissolving into protoplasmic goo in a most repulsive fashion.

Other public figures were exposed as clones. The aliens had re-
placed politicians, business executives, movie stars, and game show
hosts, but the tide was finally turning thanks to the "Paranoid" vigi-
lantes. Two prominent members of the Catholic Church melted down
after Sunday mass in Boston, finally distracting critics from the cler-
gy's sexual abuse scandals.

Rumors that Tom Cruise and Michael Jackson were aliens had to
be officially disproved after campaigns designed to discredit the pair
were printed in the tabloids. A list of sports figures, including Barry
Bonds and Tiger Woods, began circulating, challenging the athletes
to publicly endure the Sabbath tune and authenticate their earthly
status.

The nation had gone totally "Paranoid." There were Paranoid T-shirts
and Paranoid American flags. A lascivious beer commercial coined the
phrase, "Dude! You're so paranoid!" Three Sabbath tribute discs were
rush-released, as well as a collection of top electronic artists remixing
"Paranoid." Sabbath tribute bands were popping up everywhere and
teenagers started dressing like '70s-era Ozzy. One married couple in
Minneapolis even named their newborn baby "Geezer."

People were putting "Paranoid" on their answering machines and
businesses played Muzak versions for customers on hold. Only ada-
mant protests prevented "Paranoid" from supplanting the national
anthem before a Cubs game at Wrigley Field, and violence erupted at
a synagogue in Cincinnati when it was decided *not* to play the tune
through the intercom.

MTV brought back *The Osbournes* and the show's ratings were
fantastic. Interest in the lives of Ozzy, Sharon, and their kids was
unparalleled in the history of television. Black Sabbath and the Os-
bourne family were on thirty magazine covers in the same month as
they all braved their way through the media frenzy.

The first episode of the show's new season was a two-hour special. The program featured Sharon Osbourne brutally negotiating with a group of millionaire baby boomers who'd formed a corporation in hopes of persuading Ozzy to play a special concert with Black Sabbath.

The consortium wanted the original Black Sabbath to perform on the same night as the Paranoid countdown (P-Day, they called it). In a gesture of on-camera solidarity, Tony Iommi, Bill Ward, and Geezer Butler were flown in, and the three publicly committed to perform if Ozzy agreed to the gig.

Just a week before P-Day, the deal was confirmed. Per Sharon Osbourne, a special summer concert would occur at Shea Stadium under the auspices of Ozzfest for the amount of fifty million dollars. While Tony, Bill, and Geezer were only getting a million apiece, they were contracted to receive backend money for the movie rights, as well as soundtrack royalties. The concert would feature Sabbath performing at midnight, timing its live version of "Paranoid" to coincide with the original recording being played across the nation.

Old heavy metal groups volunteered to appear on the second stage or open directly for Sabbath. Scheduled bands included AC/DC, Uriah Heep, Deep Purple, the Scorpions, Cream, and Blue Oyster Cult. Jimmy Page and Robert Plant promised to reunite with bassist John Paul Jones and perform as Led Zeppelin. Even Spinal Tap was booked to appear.

An unprecedented number of news conferences followed, and everyone involved with the show was pushed to the limits of their endurance. When Sharon and the members of Black Sabbath took turns fielding questions with "Paranoid" blasting in the background, Ozzy was a trembling mess who could barely speak.

The show was just four days away.

As P-Day loomed closer, an uncertain panic set in across America.

Airport security began guiding travelers past an imposing sound system before they were allowed to board their flights. Although "Paranoid" continued to destroy aliens, people were now deemed suspicious just for not liking Black Sabbath.

An elderly man got sick to his stomach after being exposed to "Paranoid" at extremely high volume and was beaten up by a group of skinheads. Talk-show host Bill Maher was attacked near his home after he insisted that aliens had civil rights and they deserved to be tried in a court of law.

With two days left, anyone who spoke out against P-Day was branded an alien sympathizer. Still, some experts predicted that the forthcoming decibel levels would cause earthquakes in California, and pediatricians were warning parents to keep their younger children away from the sonic assault.

These concerns were discounted by the "Paranoid" masses. Police chiefs and high-ranking representatives of the armed forces strongly suggested that all citizens should attend the countdown in public. Anyone declining to commit to one of the many "Paranoid" rallies was reported to the authorities. Informants were everywhere.

On the afternoon of P-Day, three self-confessed aliens ran into the Chinese Embassy begging to be given soundproofed asylum before the supersonic moment occurred. Media coverage was relentless from coast to coast, but especially surrounding the Ozzfest in Queens. Traffic was jammed all across New York, and there was pandemonium in the five boroughs. The entire country watched nervously, anticipating the night's earsplitting finale.

Monstrous sound systems had been set up in rural and urban settings alike. Free earplugs were handed out at banks, supermarkets, and gas stations. Nightclubs, neighborhood bars, and outdoor music venues had events planned for the countdown, as did community centers,

health clubs, and retirement homes. Stereo stores engaged in last-minute promotions, eager for recognition after the fact.

With only a few hours to go, sound levels were rapidly rising. People were testing their audio equipment and in some cities the noise was already overpowering. People who didn't own an analog version of "Paranoid" went to neighboring house parties or headed off to publicly sponsored events. Others just stayed home and listened to radio stations promising giveaways to the hundredth "Paranoid" caller. The bedridden, stranded in nursing homes and hospitals, cranked up portable boom boxes provided by absent relatives.

In an unusual alliance, Greenpeace and the Teamsters sponsored a massive function in Tucson, Arizona, featuring Courtney Love singing with the Foo Fighters. The president went down to Austin, Texas, for a "Paranoid" fund-raiser with five thousand wealthy GOP loyalists. Michael Bloomberg and Rudy Giuliani traveled in a motorcade to Shea Stadium with Hillary and Bill Clinton, Spike Lee, Barbra Streisand, and John McCain.

It was the eleventh hour and unprotected eardrums were bursting across the nation. There were hundreds of premature births and countless miscarriages. Hospital emergency rooms filled beyond capacity, and even the deaf were feeling deleterious effects from the mammoth volume.

Power companies sent out repeated requests for citizens to shut off all unnecessary electricity. Windowpanes cracked and old buildings shifted on their foundations. Aliens hiding in insulated basements wondered if they would survive the aural onslaught.

Meanwhile at Ozzfest, the Who had just finished a thunderous set and Pete Townsend lost what was left of his hearing. Security was tight, but the "Paranoid" crowd was uncommonly aggressive, and fights were breaking out all over.

Backstage, Ozzy was having troubles of his own. "I can't do it," he cried. "It's too much. Won't this 'Paranoid' business ever stop?"

Ozzy's wife, Sharon, looked at him sadly. Then she screamed, "Fuck you! Get the fuck out there and sing the fucking song! It's five minutes to midnight for Christ's sake! Every fucking television station and newspaper in the world is waiting for your fucking entrance!"

Sure enough, the moment of truth was at hand. The rest of the band was already onstage, but Ozzy stood frozen in his dressing room, blubbering like a child.

So, Sharon reached into her handbag and pulled out a large vial and a small handgun. "Here," she shouted over the din. "Have some of this! It's all you've wanted to do for months anyhow. And if you dare come off the stage before you're finished, I'll fucking kill you!"

Ozzy Osbourne consumed the contents of the vial in an instant. Then, holding back the tears, he took a deep breath and marched toward his destiny.

You can imagine what happened next.

SOMETHING FREAKY
THIS WAY COMES

It was summer's end when the carnival finally came through La-Crosse, Wisconsin. Billy Potter and Alex Noble were horsing around and eating cotton candy when they passed an oily-looking fellow with a black mustache standing between two tents.

"Step right up, boys!" the carny barker shouted. "Come inside and see the freak show—just seventy-five cents for the experience of a life-time!" The two friends looked at each other and emptied their pockets for loose change.

"That's it, boys, come right this way," the barker cried as he led them into the larger of the two tents.

After their eyes adjusted to the darkness, Alex and Billy saw Thelma the Bearded Lady eating lunch (which was extremely unappetizing to say the least). Then there was Stretcho the Human Pretzel, Alfred the Hermaphrodite, a "geek" who bit the heads off of live chickens, a sickly pair of Siamese twins, and a surly-looking midget in his underwear, sucking on a cigar.

Billy kept staring at the barely clad hermaphrodite, while Alex became distracted by strange music coming from the other tent. He was about to peek inside when he felt the carny barker's clammy hand

grip his shoulder. "Sorry, kid," the barker said sternly. "No one under the age of eighteen admitted at any time. Absolutely no exceptions."

Alex pulled Billy away from staring at the hermaphrodite ("It winked at me!" Billy exclaimed), and the two boys soon devised a plan to sneak into the forbidden tent that evening. "We just got to see what's in there," Alex insisted.

Late that night, after sneaking out of their respective bedroom windows and meeting on the outskirts of town, the young boys hid quietly in some tall grass, waiting for the carny folk to fall asleep. There was much shouting and shrieks of drunken laughter, but the grounds eventually fell silent and the pair slipped through the roped-off entrance to the forbidden exhibition.

Once inside, Billy and Alex stood there in total darkness. All they could hear was the sound of their own breathing when suddenly the lights went on and the air was filled with a cacophony of peculiar sounds.

The carnival barker was standing right in front of them. "You just couldn't leave well enough alone, could you?" he shouted. "Well, feast your ears, it's too late for the two of you anyhow!" Staring in wide-eyed wonder, Alex and Billy witnessed the most bizarre conglomeration of musical freaks they had ever seen.

First, out of nowhere, emerged an out-of-tune Eliert Pilarm, the Swedish Elvis impersonator, who neither looked nor sounded like Elvis at all.

Artistic pariahs of every description, men and women whose outsider expressions set them apart from all others, surrounded the boys. There was a decrepit Tiny Tim singing "Tiptoe Through the Tulips." "I thought he was dead," Billy whispered.

Next to Tiny Tim, there was the three-hundred-pound schizoid poet-rocker Wesley Willis and the pudgy, bipolar rocker-cartoonist

Daniel Johnston. The two men seemed oblivious to each other, and they sang simultaneously in different keys and clashing tempos. An old bald man stood off to the side, watching a small black-and-white TV and holding a sign that read, "Syd Barrett."

Alex and Billy shook with uncertainty and fear as the Legendary Stardust Cowboy sang his notorious nonhit single "Paralyzed" while riding an old broomstick like a bucking bronco.

Then, in a hyperkinetic state of absolute panic, Alex wrenched himself free of the barker's oily grip. He ran hysterically from the tent, pushing past the bearded lady, kicking the hermaphrodite in the nuts and knocking over the cigar-smoking midget in the process.

When Alex (accompanied by his and Billy's parents and the La-Crosse authorities) returned early the next morning, the carnival had disappeared without a trace.

Meanwhile, somewhere down Interstate 294, a frightfully bandaged Billy Potter (now called "Danny the Dog-Faced Boy") was tearfully taking his first singing lesson from Wild Man Fisher and Shooby Taylor the Human Horn.

"Let's take it from the top," said Fisher. "And this time try it in the key of Z."

— For Irwin Chusid

THE MONK AND THE MESSENGER

Among the classic albums of the 1950s, *Art Blakey's Jazz Messengers with Thelonious Monk* is a distinctive collaboration between two giants. There are other recordings by both Monk and Blakey that have been more highly rated, but this particular union remains an essential document, frozen in time and place.

A little history lesson might be useful when approaching *Art Blakey's Jazz Messengers with Thelonious Monk*, for the lives of Blakey and Monk intertwined long before this collaboration and continued long afterward.

Art Blakey was born in Pittsburgh in 1919 and played piano before switching to drums. He married at the age of sixteen and worked in steel mills but soon became a full-time musician, joining Fletcher Henderson's band in 1939.

Art's early influences were two famous swing drummers: Big Sid Catlett and the diminutive Chick Webb. He was also impressed with able-bodied percussionists like Papa Jo Jones, Sonny Greer, and Kenny Clarke (the father of modern jazz drumming and original member of the Modern Jazz Quartet).

In 1944 Blakey became part of singer Billy Eckstine's group, where

he first played alongside young lions Dizzy Gillespie and Charlie Parker. Later, Art became absorbed with his African heritage, and after traveling to Africa and jamming with tribal drummers, he took up with Islam, adopting the Muslim name of Abdullah Ibn Buhaina.

Thelonious Sphere Monk was born in Rocky Mount, North Carolina, on October 10, 1917. He grew up in New York City's San Juan Hill neighborhood, close to where Lincoln Center is now located. Monk expressed interest in the piano at age six and was mostly self-taught. He played organ in church and toured briefly with a female evangelist who doubled as a miracle healer.

Returning to his family in New York in 1936, Monk continued working professionally, showing the influence of pianists Earl "Fatha" Hines and Art Tatum. Monk's ability and reputation grew, and he began playing gigs with Ellington trumpeter Cootie Williams.

In 1940, Thelonious found himself among a group of musicians congregating at Minton's Playhouse, a Harlem nightclub where manager Teddy Hill and drummer Kenny Clarke were organizing nightly jam sessions.

Jazz would never be the same.

Thriving at Minton's, Clarke and Monk played alongside a number of talented players. Exchanging new musical concepts were pianist-turned-drummer Denzil Best, trumpeters Dizzy Gillespie and Joe Guy, bassist Nick Fenton, and guitarist Charlie Christian. A little later, altoist Charlie "Yardbird" Parker came on board.

Together, they formed a brash inner circle of bebop revolutionaries. Jazz elders like Coleman Hawkins, Lester Young, and Roy Eldridge started dropping in at Minton's, as did eager players like saxophonist Don Byas, bassist Jimmy Blanton, Monk's protégé Bud Powell, and a forceful young drummer named Art Blakey.

Although Monk and Blakey shared a love for bebop, neither fit

precisely into the conventions of the new music that they helped to create. Monk contributed to the fashions of bop with his goatee, beret, and glasses (as well as his hipster vernacular), but his angular piano style was more restrained than the frenetic approach of his peers. As a result, Monk was rarely used at recording sessions, with the bop illuminati opting for the less idiosyncratic piano efforts of Bud Powell or Al Haig.

Although Art was clearly inspired by Kenny Clarke's modern drum innovations, he wasn't as experimental as the elder Clarke—or even as much as another young drummer named Max Roach.

There were also marked differences between the personalities of Monk and Blakey. Thelonious was emotionally erratic and needed a lot of support. Well insulated, Monk developed much of his musical approach within the confines of his mother's home. During his "house seminars," Monk discussed his abstruse theories with eager students like Sonny Rollins, Bud Powell, Miles Davis, and later, John Coltrane. But Monk was unreliable, arriving late to gigs, falling asleep at the piano, and sometimes not showing up at all.

Monk's recording career began with a 1944 session, called *Bean and the Boys*, accompanying tenor saxophone titan Coleman Hawkins. Thelonious was at his most boppish with Hawkins, playing fast and furious. As the years progressed, his deliberate style grew slower, jagged and sparse. He began implying more on the piano, wandering further behind the beat and using fewer notes.

Monk's music embraced irregular rhythms and had an internal harmony all its own. His compositions were as peculiar as his piano technique, and some of Monk's tunes were just too tricky for his fellow musicians to play. Due to an unfortunate and controversial drug bust in 1951, Thelonious lost his cabaret card, which severely restricted his opportunities to perform in Manhattan.

Art Blakey, on the other hand, was a hardworking drummer who

made his name as a bandleader and a worldwide ambassador of jazz. Not innovative like Monk, Dizzy, or Bird, Art's style was more direct, compensating with incredible strength, excellent listening skills, and a superb sense of dynamics. His group, the Jazz Messengers, became a virtual finishing school for many young musicians.

However different, Monk and Blakey had much in common. Both men recorded their bandleader debuts on Blue Note Records in 1947. The LP edition of Monk's *Genius of Modern Music* (Volume I) collected his 78 rpm singles and introduced epic compositions like " 'Round Midnight" and "Ruby, My Dear."

Monk's debut also featured Art Blakey, as Art was the pianist's most favored drummer. Thelonious took Art under his wing soon after the drummer moved to New York. And just as Monk had done with Bud Powell, Thelonious made sure that Art was welcome to play at various jam sessions in the city.

Art Blakey appeared on more Monk recordings than any other drummer until the end of the 1950s—including Monk's groundbreaking work on the Prestige and Riverside labels. Their relationship would come full circle in 1971, when Blakey played on Monk's final recordings, *The London Collection* (Volumes 1, 2, and 3).

Art's debut as a bandleader on the *New Sounds* LP was less auspicious than Monk's 1947 record. His group, "Art Blakey's Messengers," had been scaled down from a big band ("The 17 Messengers") to an octet. The "Messengers" name endured—signifying the group's preponderance of Islamic believers as well as their swinging musical message.

Art soon became busy as house drummer for Blue Note Records, and the Messengers remained dormant until Blakey joined forces with pianist Horace Silver in 1954. Their group, the Jazz Messengers, signaled the advent of what came to be described as hard bop. The original band included tenor saxophonist Hank Mobley, trumpeter

Kenny Dorham, and bassist Doug Watkins, and they remained a co-operative unit until Silver's departure in 1956.

From then on, the Jazz Messengers were fully under Art's command.

The Jazz Messengers showcased Blakey's roaring percussion style. Playing hard and loud but never out of control, he'd establish several rhythms simultaneously, keeping time on the ride cymbal and accenting offbeats with the hi-hat. Inevitably, Art would unleash a thunderous press roll on the snare—and dropping these percussive punctuations became his most explosive trademark.

Featuring a traditional bebop lineup—piano, bass, and drums with saxophone and trumpet—the Messengers dutifully followed the formula made popular by Bird and Dizzy. The sax and trumpet would present an introductory theme, harmonizing in unison with just the slightest dissonance. A string of individual solos would follow. After an instrumental round-robin, the front line would restate the opening theme, signaling the tune's conclusion.

There were other groups who played "soulful" jazz around this time, like Cannonball Adderley and the combo he led with his brother Nat. Still, the evolution from bebop to "hard bop" can be traced directly to Blakey's invigorating work with Horace Silver.

On their 1954 recording, *Horace Silver and the Jazz Messengers*, the band presents an upbeat yet simplified manifestation of bebop using Silver's bluesy, gospel-tinged compositions, like "Doodlin' " and "The Preacher."

The funkier aspects of hard bop emphasized the beat, making it less cerebral and more physically expressive than the earliest bop experiments. This swinging, soulful style was well established on the first Jazz Messengers record, and subsequent editions of Blakey's band simply refined their waggish, hard-bop strut.

Besides the first Silver-led session, the original Jazz Messengers recorded a pair of live albums in 1955 called *At the Café Bohemia*. Then the band went through a striking series of personnel changes, making several albums for a variety of record labels in the space of two years. This *almost* brings us to the musicians who took part in the making of *Art Blakey's Jazz Messengers with Thelonious Monk*.

But first: Ace trumpeter Kenny Dorham abandoned the group and was replaced by Donald Byrd, who in turn was replaced by Bill Hardman. Tenor saxophonist Hank Mobley also left the fold, but rejoined temporarily (and not for the last time), with altoist Jackie McLean replacing him on both occasions. Before McLean departed, tenor man Johnny Griffin was enlisted to succeed him, and for a brief time the two saxophonists shared the bandstand. Jimmy "Spanky" De Brest supplanted bassist Doug Watkins, who was later killed in a car crash (1962).

When pianist Horace Silver split in 1956, his substitute was Junior Mance, who was followed by Sam Dockery. Although Monk sat in for Dockery on this one recording session, Sam continued playing with the Messengers, only to be replaced by the returning Junior Mance and also by Walter Bishop Jr. Later, in the summer of 1958, Bobby Timmons would take a more lasting residence at the keys.

So, Art Blakey took an archetypal bop aggregate of saxophone, trumpet, piano, bass, and drums into the recording studio on May 14 and 15, 1957.

Trumpeter Bill Hardman came to Blakey after a stint with Charles Mingus's Jazz Workshop, but he didn't have the talent of Kenny Dorham or Donald Byrd. Still, the Cleveland-bred Hardman was a solid craftsman with a tempestuous sound. Ironically, his tenure with the Messengers was further overshadowed by his successors, Lee Morgan

and Freddie Hubbard. Hardman did, however, rejoin Blakey, and he recorded with the Messengers again in the 1970s.

Chicagoan Johnny Griffin was a sizzling tenor saxophonist, and his urgent playing suited both Art Blakey and Thelonious Monk. Indeed, Griffin joined Monk's own quartet after leaving the Messengers. Griffin's furious tenor wail provided Thelonious with a transitional link between John Coltrane and his later, most dependable saxophone foil, tenor man Charlie Rouse.

Spanky De Brest was the weakest link, and the bassist from Philadelphia sank into obscurity after leaving Blakey.

Monk was going through his own changes when this record was made. Most importantly, he had finally regained his cabaret card, thanks to manager Harry Colomby and devoted jazz patron Baroness Nica de Koenigswarter. Monk's residence at the Five Spot with Coltrane brought him a great deal of attention, and in the year before the Messengers album, he released *Brilliant Corners*, recorded the solo album *Thelonious Himself*, and appeared as a sideman on *Sonny Rollins Volume 2*.

This session highlights the kinetic interplay between Monk and Blakey. Their rapport was more than a decade in the making, and Monk's uncommon sense of time is juxtaposed against Art's forceful yet restrained punctuations. Mostly unhurried by Blakey's vigorous timekeeping, Monk's whimsical dissonance and illustrative solos were tempered by the Messengers' visceral bop methodology.

The Messengers were actually less boisterous than usual—but they still bopped hard enough to keep Monk from drifting too far into his own fractured eccentricities.

Fortunately, Monk's offbeat nature didn't prevent him from responding in kind. Minding his role as guest pianist, he followed the

group's structure—comping shrewdly when the spirit moved him, and embellishing the melodies with strange, dramatic flair. Blakey returned the favor by selecting some of Monk's most memorable compositions, as all the album's tunes (save one) were taken from his celebrated songbook.

A near-perfect example of what must be considered a manifesto in modern jazz, *Art Blakey's Jazz Messengers with Thelonious Monk* is an exercise in swinging eclecticism. The performances unveil sharp solo improvisations fixed within timeless small-group arrangements.

Blakey sounds exuberant from the opening strains of "Evidence" right up to the closing moments of Johnny Griffin's composition, "Purple Shades." Contrapuntal conversations between Monk and Blakey abound as Hardman and Griffin breathe fire into Monk's überlogical sound sketches. They flesh out Monk's dangling chord structures and oblique harmonies, while the wide open spaces and contemplative silences of his piano work remain intact.

The rendition of "Rhythm-A-Ning" is particularly unrestrained, and it allows Griffin and Blakey to showcase their fleet inventiveness. Tunes like "I Mean You" and "In Walked Bud" were already more than a decade old, but the band celebrates Monk's timeless melodies with sparkling energy.

A grooving synthesis of bluesy blowing and stylish structure, the album finds Blakey and Monk communing blissfully, and the end result is far greater than its composite parts.

What would this group have sounded like if they'd played together for more than those two days in May? All we can say is that Blakey's drum solos were richly indulgent pleasures, and invigorated by Art's faith and leadership, Monk was at the top of his game.

Not exactly hard-bop or bebop, neither stereotypically cool nor hot, *Art Blakey's Jazz Messengers with Thelonious Monk* stands as a testament to creative individualism, friendship, and the collaborative spirit of jazz.

Need more "Evidence?" Just listen.

CAPTAIN'S ORDERS

The rock critic sat in the dining room of his apartment, surrounded by stacks of press releases, DVDs, CDs, and other artifacts of popular music culture. While there were unopened packages strewn all over the place, the critic's attention was focused on just a few parcels.

It had taken some real effort to obtain the obscure Captain Beefheart material. After pleading with his editor for an actual assignment, he had to locate and then contact several small record companies before acquiring the many different Beefheart collections. Now he had them all.

Of course, the critic had been listening to Captain Beefheart for years, but he was still thrilled to have gotten so much fresh product. He had just settled down with the first disc of the five-CD retrospective, *Grow Fins*, when his lovely wife returned home after a long hard day at the office.

"Hi, honey!" he yelled while Captain Beefheart, aka Don Van Vliet, wailed through the speakers. The critic's wife walked straight into the dining room and glared at him. "What's wrong?" he asked. "Your boss giving you a hard time again?"

"You know damn well what's wrong," she answered sharply. "We've

talked about this a million times. You know I support what you do for a living. You know that I understand how music is your life and your record collection is a vital resource that helps you with your job no matter how cluttered it makes the apartment. I even learned to appreciate jazz when you were doing that big essay on John Coltrane, but this is too much. I can't stand Captain Beefheart and will not be forced to listen to him in my own home."

"But honey!" the rock critic pleaded.

"Don't 'But honey!' me, you bastard!" the critic's wife screamed. "I've heard your whole spiel about how Beefheart is one of the true original musicians to emerge in the post-Elvis age. I know that you passionately believe the man was a psychedelic rock bard whose unique grasp of blues, boogie, Dadaist poetry, avant-garde jazz, and arcane field hollers informed an incredibly distinctive sonic identity both onstage and in the studio. I've heard all about the harmonica hoedowns, the distended guitar soli, and Beefheart's relationship with Frank Zappa, as well as his obtuse blues mutterings and the Magic Band's polyrhythmic group encounters. I know that you think the Beefheart universe is a consistently strange and beautiful place that captures the spirit and alchemy of an essential American artist. I don't care anymore and I won't have it! It's Beefheart or me! Now make your decision once and for all!"

The critic stared at his wife for a very long time.

Finally, he whispered, "Can we at least wait until this song is over? It's one of my favorites."

IT'S HOW YOU PLAY THE GAME

The year was 1998. Stephen D'Angelo and Mark Spinetti were in Mark's basement apartment sitting on the couch, drinking beer and watching the Yankees on TV. It was another hot afternoon in Queens, New York, on the seventh of August, and the two had nothing better to do but get drunk and reminisce about the good old days when punks were punks.

"Hey," said Stephen. "Remember when Johnny Thunders went out with your sister and you wanted to kick his ass?"

Mark stared blankly at the ball game—the Yanks were already clobbering the Royals and it was only the second inning. "Yeah, I remember," he said finally. "And when I caught up with the little scumbag he promised to get us into one of those New York Dolls gigs at the Mercer Arts Center. Good show, too. That was when Billy Murcia was still alive and playing the drums for them."

"Uh-huh," Stephen agreed. "I really thought those guys were going to hit it big for a while there. After Jerry Nolan replaced Billy they sounded even better, but dope broke up that band pretty quick."

Mark walked to the fridge and fished out two more beers. He could hear a soap opera blaring from his parents' home upstairs.

"That's for sure," he sighed. "How about the time we saw Thunders at that used record store in the East Village? He was selling off a whole stack of Dolls LPs for a dollar apiece. Nowadays those things go for big bucks!"

Stephen took a beer from his friend and held the icy can against his forehead. He glanced at the tube and noticed that Darryl Strawberry had just hit his twenty-first home run of the season.

"Johnny had formed the Heartbreakers by then, hadn't he?" Stephen asked rhetorically. "It was Thunders, Nolan, and Richard Hell from Television when they started out. Man, what a bunch of fucking prima donnas. Hell didn't last too long before leaving to form the Voidoids. Hell was cool, but he couldn't put up with those other guys. Besides, the coolest thing they ever did together was to steal the song 'Chinese Rocks' from Dee Dee Ramone."

Mark laughed loudly, "That's true. Then Johnny got Billy Rath on bass and Walter Lure on guitar. The Heartbreakers even did that Anarchy Tour in Europe with the Sex Pistols, the Clash, and the Damned. Kicked punk ass on those little limeys, too, from what I'm told. Thunders and Nolan were just way more experienced than those British kids at that point."

Mark's mother hollered downstairs that it was time for her son to pick up the dry cleaning from the Laundromat. "Later, Ma!" Mark yelled back. "It's a doubleheader and we're killing them—I'll go between games!"

Somewhat embarrassed, Mark resumed his nostalgic rumpus with Stephen. "The Heartbreakers were great. But it was just like they sang it, 'Too Much Junkie Business,' know what I'm saying? They couldn't keep it together for five minutes—like when Thunders rumbled onstage with that punk John Spacely and clubbed him with his guitar. Anyway, after Jerry quit to form the Idols, the band just fell apart."

Stephen shook his head in solemn agreement. The first game was over and the Yanks had put Kansas City away 8–2. "Yeah," he said. "Except for those farewell gigs they did later at Max's Kansas City. Those shows might have been the best of them all."

Mark smiled at the mention of Max's and said, "Man, I loved that place in the '70s; even *I* was getting laid back then. You would always see Lou Reed or someone from Warhol's crowd or maybe Patti Smith. But you're right—those gigs at Max's in '79 were great. It almost didn't matter that Jerry was gone because Ty Styx never missed a beat. Everything was so offhand that you forgot how hard they were rocking. Perfect rock 'n' roll like that is deceptively simple. I guess the shows were special because there was no pressure by that time, other than Thunders having to show up and not fall down."

Mark grinned as he added, "Johnny and Walter sure had that whole wiseass junkie Bowery Boys shtick down pat, didn't they?" Then Mark became lost in a yearning reverie as he drained his seventh beer.

The Yankees began their pummeling of the Royals once again as Stephen picked up where Mark had trailed off. "They sure did. And for all of the foulmouthed, aggressive music making going on, Thunders made it sound so easy. That's why seeing live music was exciting— you never knew what was going to happen. I mean it wasn't like there were huge crowds lined up to see those guys. They just ripped through their set in such a savage way that you have to thank God someone actually recorded the show."

Mark's eyes snapped back to reality. He turned up the sound on his TV in a vain attempt to drown out his mother's nagging voice from upstairs. He ignored the old lady's repeated requests and shouted above the sports announcer's fervid play-by-play. "I really loved Johnny's buzz-saw guitar, but why was he so into '60s girl groups like the Shangri-Las? It was such a weird mix of musical influences, but it worked so well."

Stephen D'Angelo struggled to his feet and made his way to the door. The Yankees were well on their way toward another rout of the hapless Royals. It was almost too easy. Mark was still arguing with his mother about the stupid dry cleaning and she was telling him to get a job for Chrissakes as Stephen bid his friend good-bye.

Mark stopped his quarreling, turned toward Stephen, and said, "Shit. Billy's dead, Johnny's dead, Jerry's dead—what a sad bunch. There's no more heroes in this world, that's for sure."

The Yankees went on to win the second game 14–2. The rest is history.

— *With apologies to Legs McNeil and George Steinbrenner*

BACK TO THE FILLMORE

The year is 2069 and Adam Coil V is celebrating his eighteenth birthday alone in his room with his computers. Adam's mother had just put one hundred and fifty bancredits into a digital dollarfund and given him his very own access code to the account.

Within fifteen minutes, Adam had transferred the entire sum over to Grateful Dead Enterprises (a wholly owned subsidiary of the one and only Record Company). He then opened his personalized Dead file and examined his new purchases, which were the three latest Grateful Dead live collections, (*Dick's Picks*) Volumes 1498, 1499, and 1500.

Adam browsed through the still images, video clips, and historical text that accompanied the postdigital sound files. Then he downloaded the information into his custom database that cross-referenced each Dead recording by date, personnel, song selection, venue, set list, and many other categories. While Adam was thrilled to bring his archive up-to-date and hear the latest *Dick's Picks*, he was already thinking about the next five hundred Dead recordings scheduled for release.

At the same time, he was restless and bored. Despite all of the data that streamed into his computer, the days held little mystery for Adam.

He rarely went outdoors since the earth's atmosphere made it impossible to breathe easily. Besides the terrible environment that kept him inside, his legs were weak from lack of exercise, and the recreational drugs provided by the WG (World Government) made him sleepy. Lately, he'd been more lethargic than usual, and he couldn't shake the sense of dull apprehension.

The Grateful Dead were Adam's main escape from a dreary reality. He came from a long line of Deadheads, and while his father's own interest in the family's Dead collection had waned when Adam was just a child, Adam Coil IV still made sure to pass down the library of hard-to-find Dead relics to his only son.

The inherited memorabilia from the twentieth century included live Dead recordings preserved on Maxell XLIIS hi-bias cassette tapes, vinyl LPs, vintage compact discs, ticket stubs, backstage laminates, and original poster art from the Fillmore West. Of course, these items were merely the foundation for Adam's current collection. He'd been immersing himself in Dead culture since he was eight and devoted every bancredit that came his way toward his passion.

His interest in the Dead began during a childhood trip with his anthropologist grandfather, Adam Coil III, to the Terrapin Museum and Grateful Dead Memorial Library. Since then Adam had taken to collecting books made of actual paper, old-time videos, and every Dead-related recording he could find. He'd amassed thousands of essays written about the band, including rare interviews and forgotten concert reviews. Adam took after his grandfather and considered himself an authority on all things Dead.

Adam's parents were gone for the season, so he had invited some friends over to watch holographic concert films of the Dead on his quantum-entertainment console. He rarely saw his peers in person; it was easier to see them on the home videophone or enjoy qua-encounters

on the computer. He was actually startled when the doorbell rang that afternoon. It was still too early for visitors.

It was a delivery service, and when the autobot informed him of a priority letter for Mr. Adam Coil V, he enthusiastically accepted the package. He became even more excited when he saw that the parcel was from his grandfather.

He tore open the envelope and found a handwritten letter attached to a large folder of official-looking documents. "Dear Adam," the note read. "Here is your birthday present. Use it wisely and be sure to tell your old granddad all about your trip upon your return."

"Trip?" Adam thought. "What kind of trip? Gramps knows that I hardly ever leave the house." It was true; Adam had no desire to travel and like most kids his age, he did his globetrotting through the Virtual Reality Voyage Vender. It was quicker, safer, and much less strenuous.

Adam examined the contents of the folder. There he read the words: "This voucher entitles Adam Coil V (only) to one round-trip ticket anywhere in the past two hundred years. Some restrictions may apply. See pages 2 through 12 for details and international guidelines. Please bring three separate items of identification and a signed copy of the consent contract (page 13) to your local time-travel representative after reading the regulations and choosing your exact destination and itinerary."

A journey through the past! Adam wasn't sure how his grandfather had managed to pull the strings for such a high-level excursion, but when he checked with the Bureau of Time and Space Travel, they confirmed his eligibility.

"Just make sure to read the entire contract before you plan your trip," the department chief told him. "It's not complicated, but there are some very important rules when it comes to time travel. Basically, you can't tell anyone you meet anything about the future, you can't have sex

with anyone from the past, you can't do any drugs, and you absolutely must return to the present exactly twelve hours after your departure from our time zone. You know, the standard time-travel restrictions."

It hadn't been difficult for Adam to choose a destination for his fantastic voyage. When he first saw the travel voucher, the thought came to him that he could go see the Grateful Dead perform at the Fillmore West on February 28, 1969. That was supposed to be a magical gig. Even the classic twentieth-century album *Live/Dead* contained performances from that psychedelic evening.

Adam couldn't say what drew him to that particular Friday, but there was something about the date that called out to him. He knew that the Fillmore West (formerly the Carousel Ballroom) began its operations under Bill Graham in the summer of 1968, and that the original Fillmore had closed in the aftermath of Martin Luther King's assassination. Adam barely recalled who Martin Luther King was, but he knew a lot about the Fillmore.

The prospect of catching the Dead on the second of four nights at the Fillmore was just too good to pass up. He would be seeing Jerry Garcia at his early peak and keyboardist Ron "Pigpen" McKernan in his boozy prime. According to Adam's archives, Mickey Hart's role as the band's second drummer was already established, and on February 28 the Dead had jammed their way through a cosmic second set including immortal renditions of "Dark Star," "Saint Stephen," *and* "The Eleven."

There was no doubt about it; Adam was going to see the Dead in San Francisco!

It took him a week to finalize his travel plans. Of course, his parents were upset about Adam going back in time all by himself. They resisted the idea until he wore them down with a combination of pleading, golden promises, and black oaths.

"Fine, go ahead and time travel if that's what you really want to do," his father said wearily on the videophone. "But I'm going to speak to your grandfather about this. Next time he'd better clear things with us before putting crazy ideas into your head. You never know what kind of people you're going to meet back there in the past. I only hope that you'll be extra careful and not talk to any strangers. It was an uncertain world back then."

When Adam arrived at the Time Travel Agency, he was ushered into a white room with two men sitting at a long table. He was intimidated by the formality of the screening process and wondered if the men were dressed in identical suits because they were required to or because it was the current style.

"Do you understand the international rules and regulations of time travel as they have been presented to you?" one man asked. "Yes sir," Adam answered. "Do you agree to comply with the aforementioned rules?" asked the other man. "Yes sir," Adam replied again. "Good," said the first man. "Now remember that you'll have to stand in the exact same spot where you materialized when it's time for your return." "I will, sir," answered Adam.

Then the second man leaned forward and said sternly, "You can't be at all late when the time comes to return home. Otherwise, you'll be stuck in the past and we would have a hard time ever finding you again. The consequences of reckless time travel are quite serious, young man. Your grandfather is highly respected here at the Bureau, and he personally vouched for your qualifications. If it weren't for him, you'd be on an eternal waiting list, like everyone else from the consumer sector."

After several more reminders, they asked Adam if he was ready for his maiden voyage. "I guess so," he said nervously. Adam had dressed for the occasion in a leather jacket with fringe hanging from the

shoulders and a skull and roses embroidered on the back. He'd taken it from a box in his father's closet. "I was going to auction it off and put the bancredits toward your educational dollarfund," his father told him, "but we can always sell the jacket when you get back."

Adam's father seemed sad when they exchanged good-byes on the videophone. "Don't worry, Dad," Adam had said reassuringly. "The whole trip will only take an hour or two on this end. You won't even have time to miss me. I'll call as soon as I get home, I promise." Still, Adam felt anxious as he walked toward the room with a floating sign that read, "Time Travel Division: Departure Department."

Before a team of technicians began their final countdown for Adam's timelaunch, one of the men made him empty his pockets and took away his electronic wallet with all of his identification. Then he handed Adam an envelope and said, "Your grandfather asked us to give this to you. It's the only thing you're allowed to take with you that you don't have to bring back."

Opening the envelope Adam found a twenty-dollar bill from 1964 and a note that read, "Don't spend it all in one place! Have fun, Granddad."

The time technicians explained that they'd be transporting Adam directly inside the Fillmore, so he wouldn't have to worry about buying a ticket to the concert. "You'll be arriving at the venue a few hours early, so just try to blend in until the show starts. And please, remember the exact spot where you arrive because you have to be in that same location when it's time to come home."

Finally, the head technician clamped a titanium timepiece on Adam's right wrist and said, "You have exactly twelve hours. Enjoy your trip."

The time transport itself was not unpleasant, but the brief period of disembodiment left him senseless when he arrived in 1969. At first,

Adam stumbled around and couldn't see or hear a thing. Gradually, he began to acclimate to his surroundings and sensed a bright light above him. He concluded that he wasn't in the Fillmore, but outdoors. He also sensed that someone else was standing quite nearby.

As his eyes and ears slowly adjusted, Adam realized that someone was yelling at him. It was an intense, dark-haired man and he was screaming in Adam's face. "What in the hell is wrong with you, kid? Are you too stoned to understand English? I told you that you couldn't stand here; now get in line like everybody else!"

Looking around bewilderedly, Adam saw that he was just outside of the Fillmore and a number of young people were standing in a line alongside the building. Several bystanders laughed as he tried to take a step and fell right into the arms of the screaming man.

"Jesus Christ!" the man screamed. "What is your problem?" Adam tried to speak but his mouth refused to form any words. Then, the smells from Earth's rich atmosphere and the dog crap under his feet made Adam sick to his stomach. He puked violently and the screaming man got more irate.

Adam was starting to fear for his safety when a tough-looking guy dressed in motorcycle garb stalked up to his raging antagonist. "Hey, Graham," the biker shouted. "Why don't you pick on somebody else? Don't you have anything better to do than harass your own clientele?"

The screaming man whirled around and said, "What the hell do you want, Barger—are you turning into some kind of humanitarian? Why don't you just go ride your damn Harley, man, and let me run my own business?"

Meanwhile, Adam had pulled himself together and was trying to figure out what was happening. Then it hit him: The two men arguing were none other than Fillmore impresario Bill Graham and the

infamous leader of the Hell's Angels, Sonny Barger. "Wow," thought Adam. "I made it. I'm actually here!"

Sonny Barger and Bill Graham were nose to nose. Both men were swearing and arguing until Graham finally said, "Okay, Sonny, you win. Just get this kid the hell away from me before I bury my foot up his ass. I've got a million hassles to deal with tonight and you aren't one of them."

"Screw you, Bill," Barger shot back. Then Sonny grabbed Adam by the scruff of his neck and dragged him away from the Fillmore. Down the street, several men were waiting on their motorcycles.

Adam tried to squirm out of Barger's iron grip. "Hey," he pleaded. "Let me go. I've come a real long way to see the Dead and I've got to hang around for tonight's show."

Sonny threw Adam against a car and held him down by his throat. "Listen, punk," he growled. "I saw you appear out of nowhere. One minute the sidewalk was empty and then you just materialized out of thin air. I don't know where you came from or how in the hell you got here, but I'm not letting you out of my goddamn sight until you tell me what's going on. Understand?"

Adam was frightened and puked again, barely avoiding Barger's boots. He tried telling Sonny that he was just another kid who'd come to San Francisco to be with the hippies. The Hell's Angels surrounded Adam as Sonny shook his head, "No, you're coming with us. I've got some important meetings tonight and we've got to get going right now."

"But I've got to see the Grateful Dead," Adam wailed. Sonny slapped Adam on the back of the head and said, "Quit crying or I'll give you something to cry about. Besides, the Dead won't be on for hours. Just tell me how you got here and I'll bring you back to the Fillmore. I know Garcia and I know Rock Scully. Hell, I've done business with

both of them. And, motherfucker, you *will* tell me what I want to know, one way or another."

The Angels laughed and gunned their engines as Sonny threw Adam on the back of his motorcycle. "You better hang on, kid," Barger said. Howling maniacally, Sonny and the Hell's Angels roared off in the direction of the Bay Bridge.

Their first stop was a seedy bar in Oakland and the place was loaded with intoxicated bikers. Adam was dizzy from the first motorcycle ride of his life—as well as the residual effects of his journey through the space-time continuum. He'd kept leaning the wrong way during the motorcycle ride, and Barger had threatened to push Adam off his Harley. He was both frightened and exhilarated by the experience.

Terry the Tramp, one of the Angels who'd been with Barger near the Fillmore, said to Adam, "Hey, kid, you got any cash? We need some beer."

"All I have is this paper money my grandfather gave me," Adam replied. "I'm not supposed to spend it all in one place."

"Well, this is an emergency," said the Tramp as he grabbed the twenty and strode toward the bar. Adam was now broke, kidnapped, and far from the Fillmore. He looked at the front door of the bar, but before he could take a step he felt a heavy hand on his shoulder.

"Don't even think about it," a deep voice said. Adam turned around and stared up at the biggest man he'd ever seen.

Hell's Angel Armand Bletcher was six foot eight inches and weighed around three hundred fifty pounds. He was wearing a sleeveless jean jacket, sunglasses, and a scowl. His massive arms were tattooed and he smelled as strong as he looked.

Armand drained a glass of beer and said, "Sonny says for you to stay right here while he does his business." Adam looked around and

saw two dozen Hell's Angels, some members of the Nomads, and a smattering of rough-looking women. They were all drinking, yelling, and laughing like crazy.

Suddenly, a fight broke out. Mouldy Marvin must have said something offensive to Doug the Thug because they'd knocked over a table and were rolling around on the floor. They were punching the living hell out of each other, much to the enjoyment of their fellow Angels. The fight spilled out onto the street but five minutes later the two men were back in the bar smiling, bleeding, and drinking together in the corner of the room.

"These people are insane," Adam thought. "What was I thinking, coming to such a backward and dangerous time period?" The odors of the bar, combined with the exhaust fumes he'd inhaled on the motorcycle ride, made Adam's stomach churn.

With Armand Bletcher watching him, Adam sat near the window and tried to calm his stomach. A moment later, Terry the Tramp was next to him with a drink in his hand. "Here, kid," he said with a leer. "You gotta be thirsty. Have a beer on me."

Adam sat frozen as Terry extended a bottle in his direction. The biker asked, "Are you refusing to drink with me?" Adam shook his head fearfully. "Good," the Tramp laughed. "Then drink up." Meekly, Adam took a sip.

"I said drink it, not play with it," the Tramp insisted. So, Adam guzzled the beer with the Angel nodding approvingly. "That's it, kid. You'll be fine in no time."

Terry the Tramp strolled back to the bar. Adam was certain that Terry was talking about him and when the Tramp caught his eye, the biker raised his glass high into the air. There was more laughing and Adam wondered what was so damn funny.

Still nauseated, Adam peered out the window. He saw Sonny Barger and three other Angels step out of a car parked across the street. Some kind of deal must have just gone bad because the driver jumped out of the car and ran after Barger, yelling about money. Within seconds, the Angels began kicking the man to the ground. This wasn't a good-natured bar fight like the one between Doug the Thug and Mouldy Marvin. This was a vicious beating pure and simple.

Adam was horrified. The Angels walked back into the bar, leaving the man stretched out near his car. Once inside, Barger made his way across the room and walked up to Terry the Tramp. They seemed to be looking in Adam's direction.

Sure enough, the Angels approached him. "So, kid, how you feeling?" Sonny asked. "Not too good," Adam answered. Sonny winked at Terry the Tramp and said, "Listen, we're done here. Are you ready to go to a party? There will be loads of hippie chicks, you might even get lucky."

"But what about the Grateful Dead?" Adam asked.

Barger put his arm around Adam and pulled him close. Adam felt Sonny's sour breath on his face as the biker whispered hoarsely, "There's still plenty of time to go back to the Fillmore; let's head to this party first and talk about it there."

Before he knew what was happening Adam was back on Sonny's Harley, hanging on for dear life. Terry the Tramp and Mouldy Marvin were on opposite sides of Barger, trailing slightly behind as they all sped off into the night. Adam heard Sonny say that they were going to Marin County.

As they rode in the moonlight, Adam stared up at the sky in wild wonder. His queasiness had passed and he'd never seen a sky as breathtaking as this one. Each star twinkled and gleamed, and the

constellations seemed to dance before his eyes. The fringe from his leather jacket was flapping in the wind and the sounds of the motorcycles roared in his ears.

Unaware that Terry the Tramp had dosed his beer with a large amount of LSD, Adam began to let go of his fears and frustrations. He loosened his grip around Barger's waist and started leaning into the turns as Sonny instructed. He inhaled deeply through his nose and finally understood what fresh air was supposed to smell like.

Sonny was humming "Good Morning Little Schoolgirl" and Adam found himself singing along. He felt an abrupt sense of discovery and had a series of revelations regarding nature's delicate balance and the spectacular beauty of life itself. Adam could hardly believe that he was really on a motorcycle in northern California in the year of 1969. He threw back his head and laughed. By the time the bikers rolled into Marin, Adam was howling at the moon.

The party was in full swing when they arrived. Music blared as the Angels cut their engines. There were people sitting in the moonlight, while others wandered in and out of the sprawling ranch house. Almost immediately, a skinny long-haired guy accompanied by three young girls greeted the bikers. "Sonny, man, glad you finally made it. I've been waiting all night. Is everything cool?"

Kissing one of the girls, Sonny nodded and said, "Sure, Roger, everything's cool. Let's go work out your thing right now." The skinny hippie looked pleased as he and the girl followed Barger into the house.

"What are all these people doing out here?" Adam wondered. He was confused, and turned to see Terry the Tramp stripped down to his underwear and dancing with the other two girls. The night air was cool and Adam shivered while Terry and his nubile partners boogied in the moonlight.

Adam looked over at Mouldy Marvin and Mouldy Marvin looked back at Adam. "We better get some beer," Marvin said. As they walked inside, Terry and the girls ran laughing into the woods behind the house.

By this time Adam was hallucinating in Technicolor and eventually concluded that he was tripping on some old-fashioned bathtub acid. "This sure isn't anything like the hallucinogens that the government provides back home," he thought.

Music was reverberating throughout the house and there were hippies everywhere. Rooms were filled with chattering longhairs, and thick clouds of pot smoke rolled in the air. Adam gawked shamelessly and was thrilled when people smiled and said hello. He followed Marvin into the kitchen and stood there high as a loon while the biker drank three beers in rapid succession.

A couple of teenaged girls came into the kitchen and one of them started talking to Mouldy Marvin about his motorcycle. Marvin and the girl began kissing. Embarrassed, Adam looked away and saw that the other girl was smiling at him. Shyly, she asked, "Are you with the Hell's Angels?"

"I guess I'm with the Angels tonight," he replied. The girl had long dark hair and big brown eyes. She was barefoot and wore a long peasant dress. Adam was feeling self-conscious and his mind was reeling, but the girl had such a gentle manner that he found himself feeling happy and relaxed.

"I thought you were with the Angels because of your leather jacket," she said. "Do you really know Sonny Barger?" Adam was lost in the girl's big brown eyes. "Yes," he said. "I rode up here on the back of his motorcycle."

"You can call me Cinnamon Girl," she said. "My name is Cindy

but everyone calls me Cinnamon Girl." Adam was so entranced that he almost didn't notice Mouldy Marvin and his new girlfriend had slipped off into another room.

But Adam saw the opportunity for escape. "I wonder where Sonny is now," he said casually. "Oh, he's in the back "with Roger Dodger," answered Cinnamon Girl. "I don't think he'll be coming out for a while though. My friend Donna is with him and she and Sonny will be making it groovy tonight."

Even in his acid-drenched condition, Adam knew that this was his chance to make it back to the Fillmore. So he said, "Hey, I've really got to go, but it was nice meeting you."

Adam was caught off guard when Cinnamon Girl leaned over and kissed him. He held her tightly and the warmth of her body radiated through him. Then Cinnamon Girl exhaled into his ear and Adam forgot all about the time-travel contract that he'd signed in the future.

With music and smoke swirling around him and fireworks going off in his head, Adam followed Cinnamon Girl into an empty bedroom. She switched on a black light and pulled off her dress. Adam was technically still a virgin in 2069, but he knew what he wanted to do with his Cinnamon Girl. The sex that they had was exquisite. He'd only known Cindy for half an hour, but Adam was falling in love.

Afterward, they lay in each other's arms until Cinnamon Girl sat up and said, "Hey, what's your name anyway?" "Adam," he answered. "Well, Adam, my friends and I are heading over to see the Dead. Are you going to the Fillmore tonight?" Adam couldn't believe his ears. He was about to ask her for a ride to the concert when he looked up and saw Sonny Barger standing silently in the doorway.

Adam turned back to Cinnamon Girl and said, "Yeah, I'll be there. Shall we meet up later?"

"That would be cool," she answered. "Is it okay if I wear your leather jacket to the show? I promise I'll give it back."

"Sure," he said. "Take the jacket. I'll find you at the Fillmore." Cinnamon Girl put her dress back on and leaned down to kiss Adam. Then she grabbed his jacket and ran off to join her friends.

Adam sat unmoving until Sonny said, "Well, get dressed, motherfucker. And hurry up! You've got some explaining to do or else you're not going to make it in time for your date."

Adam knew that he had a decision to make. He also knew that by going to bed with Cinnamon Girl and tripping on acid, he'd broken two major time-travel rules. There was going to be hell to pay back home.

He was in double jeopardy and counting. "What will happen if I tell Sonny what he wants to know?" Adam wondered. "The entire universe could be affected and it would be my fault. And what if Sonny doesn't take me back to the Fillmore after I tell him? What if this whole thing with Cinnamon Girl is some kind of setup?"

Adam recalled the vicious beating the Angels had administered outside of the bar in Oakland. He began to hyperventilate as he imagined being murdered right there in Marin County. Shaking, he walked into the kitchen where Sonny Barger, Mouldy Marvin, and Terry the Tramp were waiting.

"Okay, Sonny," he said. "You win. I'll tell you what you want to know." And with the dose of acid still saturating his brain, Adam told Sonny all about the future. He explained his obsession with the Grateful Dead, Grandpa Coil's spectacular birthday gift, and the approaching deadline for his return to the year 2069.

His confession initially amazed the bikers, but Marvin and Terry became bored with Adam's tale. He kept going on about the terrible state of the future and how technology and pollution were killing

man's spirit and how they all had to get back to nature to avoid the trappings of corporate greed. Adam was reliving the events of his own future in an inverted, psychedelicized state. You could even say that rather than an acid flashback, he was having a flash-forward.

Marvin and Terry soon had their fill of Adam's blather and they departed on their motorcycles, promising to meet up with Sonny at the Dead show should he make it back to the Fillmore.

The entire time Adam spoke, Sonny Barger sat and listened. He would ask a question now and then, but for the most part he let Adam ramble on. At one point Sonny handed Adam a beer, which he drank greedily.

After what seemed like an eternity (it was about twenty-five minutes), Adam looked straight at the leader of the Hell's Angels and said, "Well, that's the story. I really don't care whether you believe me or not but I would really appreciate it if you'd take me to the Fillmore before it's too late. I've just got to get back home."

"Well," mused Sonny. "I guess I could take you back. Maybe you can tell me a few more things about the future on the way." "Anything!" Adam promised. "Just please take me back to the Fillmore. Maybe I'll get to say good-bye to Cinnamon Girl." "Hell," Sonny said. "You keep telling me details and I'll get you back in time for the second set."

On the ride to San Francisco, Sonny quizzed Adam about the future. Sonny told Adam that he didn't care about the deaths of Jimi Hendrix, Jim Morrison, and Janis Joplin; the Kent State incident; Woodstock; the future of the Grateful Dead; or the tragedy at Altamont. He was more interested in the Vietnam War, big business, drug laws, the CIA, Bob Dylan, national politics, and the Watergate scandal.

Sonny also inquired about the stock market, but by that time the second dose of acid he'd slipped into Adam's beer started to kick in.

They were crossing the Golden Gate Bridge when Adam became extremely disoriented. After that, he couldn't remember any U.S. history except for the Microsoft years and when Bill Gates ran for president. Still, Sonny seemed satisfied and brought Adam back to the Fillmore.

After parking his Harley, Sonny walked to the Fillmore entrance with Adam following behind. Then Adam got sidetracked. He began gazing at a bright red-orange concert poster announcing the Dead's current four-night stint and was transfixed by the mesmerizing combination of photography and psychedelic art. "There they are," Adam murmured. "The greatest-performing rock band of all time. But who are Pentangle and the Sir Douglas Quintet? There's so much that I still don't know."

Sonny poked Adam in the ribs, "Kid, the party is *inside* the Fillmore, not out here. Do you want to see the show or not?" Adam nodded, and then he started gagging and shaking uncontrollably. "Oh Jesus," Sonny muttered. He grabbed Adam by the arm and dragged him back toward the entrance.

When they got to the front door, the guy collecting tickets stopped them. "Don't you know who I am?" Sonny asked. The guy looked blankly at Sonny and said, "No, who are you?"

At that point Sonny snapped. "Motherfucker! I'm Sonny fucking Barger and you'd better let me in before I burn this place to the ground! Why the hell don't you just get Scully or Bill Graham or Garcia? You think I'm one of these hippie wannabes who just hitchhiked here from Idaho to walk around barefoot on the Haight? I should kick your ass!"

Right then, an older black man came out from behind the soda counter and said, "It's okay, you can let them in." Sonny brushed past the ticket guy and shook the black man's hand. "Thanks, John, I was

going to take that guy out. Listen, my friend here came a long, long way to see the Dead, but he's a little out of it right now. Can you keep an eye on him?"

The man smiled and said, "Sure, I'll try, Sonny, but I'm a little busy tonight. I just hope your friend isn't too far gone." "He'll be okay," Barger promised. Then Sonny turned to Adam and said. "Kid, this is John Walker. He'll show you around."

With that, Sonny Barger walked off, leaving Adam dazed and confused, and in the care of kind John Walker.

John Walker had worked at the Fillmore for quite some time, and he had seen a lot of kids in Adam's condition. He gently led Adam over to a wooden barrel filled with apples and said, "Son, you look like you could use something in your stomach. Try one of these and tell me how that makes you feel."

As soon as Adam bit into the apple, he felt the world open up like a flower blooming in the sun. He looked around and saw hundreds of exotic people dressed in colorful clothes, all moving and grooving in complete communion with a colossal good vibe.

A moment later, Adam heard Bill Graham's voice come over the PA system, "And now the last of the gay desperadoes, the Grateful Dead!" Music seemed to come at Adam from every direction as the band began playing "Cryptical Envelopment." The resounding psychedelia surged and intensified around him, and the striking sense of unity that Adam perceived grew even more exaggerated.

"You okay, son?" John Walker's voice interrupted Adam's cosmic reverie.

"Yes," said Adam. "I'm perfect. Would you mind it if I called you Uncle John?"

"No," John Walker replied. "I guess that would be all right. Are you feeling okay? I should be getting back behind that counter soon."

"I'm fine, Uncle John," Adam laughed. "I've come to hear the band."

As Adam bid goodnight to John Walker, he had the distinct sense that time was being stretched and slowed and somehow bent to his will. He heard the Grateful Dead segueing from "The Other One" back into "Cryptical," and he hurried out onto the main floor of the Fillmore.

The band launched into "Dark Star," which psycho-activated Adam's barely suppressed memories of his unique, nonlinear reality. It was like a déjà vu with the poignancy of a perfect stolen moment that never was. He stared wide-eyed at the band as they launched into a spirited version of "Saint Stephen." Then, he decided to look for Cinnamon Girl.

Adam wandered around, and eventually glanced at the titanium timepiece fastened to his wrist. His heart sank. According to the timepiece, he had just fifteen minutes to get outside in order to make his trip back home. He was just getting into the groove and the concert wasn't going to end for another hour and a half.

Adam thought about the rest of the second set, which he had memorized. The Dead were due to play "Death Don't Have No Mercy" and then jam on "Alligator," which went in and out of "Drums" and into "Caution (Do Not Stop on Tracks)" before closing with "We Bid You Goodnight." Adam didn't know what to do.

By this time the Dead were well into a cooking version of "The Eleven" and Adam heard these words reverberating in the air. ". . . *now is the time of returning . . . with our thought jewels polished and gleaming. . . . Now is the time past believing . . . the child has relinquished the rein . . . now is the test of the boomerang . . . tossed in the night of redeeming. . . .*"

"Wow," thought Adam.

He wondered about the trouble that he was going to be in when he

got back to 2069. "What's going to happen now that I had sex with Cinnamon Girl and did acid and told Sonny Barger all about the future?" Adam remembered the liability clause of the contract that he had signed and the massive bancredit debt his family would incur.

And what would Grandpa Coil say?

Besides all of that, Adam really just wanted to stay out past his stupid time-traveling curfew. He hadn't even found Cinnamon Girl yet—would it really matter if he let her keep his jacket? It was a dilemma that Adam was in no condition to contemplate. "Man, the future is uncertain," he thought.

Adam became distracted by the psychedelic light show going on behind the Grateful Dead. He gazed at the splashing hot colors and the lights that throbbed in sync with the music. When Adam shifted his gaze from the undulating backdrop, he saw Sonny Barger, Bill Graham, and John Walker standing together on the right side of the stage. Adam was also pretty sure that he'd glimpsed Terry the Tramp stripped down to his underwear again.

At the last minute, he spotted Cinnamon Girl and her friends spinning around near the front of the stage. The room was shimmering in a great golden light, and it occurred to Adam that everyone he knew at the Fillmore was smiling. Cinnamon Girl was smiling. Terry the Tramp and Mouldy Marvin were smiling. John Walker was grinning from ear to ear, and even Bill Graham and Sonny Barger looked happy.

But there was no time to say good-bye. Adam had to leave immediately if he was ever going to get back to his life in 2069.

As Adam sadly turned away from the dancing throng, he realized that he himself had never danced, ever. Adam had not danced one time in his entire life and now he was heading back to a world that didn't dance, either.

Impulsively, Adam ran back through the crowd toward Cinnamon

Girl and began moving in a wild, spastic manner. He twisted and twirled and jumped up and down as the music of the Grateful Dead echoed around him.

At that precise moment, Adam decided that being stuck in the past wasn't such a terrible thing after all.

His long strange trip had truly begun,

— *Deadicated to J. R. Young, wherever you are*

THE STEEL-STRING TRILOGY

A Man Out of Time

John Fahey's life on Earth ended in 2001, but the iconic guitarist was always a man out of time. Fahey, the man, was perennially self-destructive, squandered money, and spent his final years occupying Oregon flophouses or living out of his car.

Fahey, the musician, was an obstinate blues scholar who advanced a decidedly nonfolkie version of instrumental Americana and formed his own record company at the age of twenty. Along the way, he revived the art of steel-string solo guitar.

John despised the decade in which he came into prominence and reserved a particular antipathy for the grandiose self-indulgence of hippies. In 1964, while most people his age were digging the Beatles, John soldiered down to a hospital in Tunica, Mississippi, and unearthed lost bluesman Skip James. He took James to the Newport Folk Festival where the elder was treated like an anthropological discovery. The appearance revived James's long-dormant career, though after the fact, Fahey determined that Skip was a recalcitrant SOB and regretted wasting his own time and effort.

In 1970, despite differences with the director and disdain for the

other performers, John appeared on the soundtrack of Michelangelo Antonioni's *Zabriskie Point*. "I hate all those phony fake suburban folk singers," he later insisted. "When Jerry Garcia died, several people phoned me up and said, 'Have you heard the good news?'"

So he was a cultural misanthrope, but big deal—Fahey's fingerpicking utilized open tunings, Charlie Patton's unorthodox delta blues, classical structures, and syncopated ragtime rhythms. A steady-rolling nonjazz improviser, he energized his music with avant-garde abstractions and an aggressive punk attitude. Perpetually dissatisfied with his own work, Fahey denounced his performances and re-recorded entire albums. He always had a soft spot for baroque and medieval carols, and Fahey's best-selling works are still his Christmas LPs.

In 1959, John formed the proto-indie label, Takoma Records, and put out his first album, *Blind Joe Death*. Blind Joe Death served as Fahey's recurring melancholic blues alter ego, and established his resolute artistic vision. It was his dream to generate an "American Primitive" school of solo steel-string guitarists and raise the experimental folk form to the level of classical music. His pursuit inspired many disciples, some of whose records Fahey released on Takoma, most notably Leo Kottke and his 1969 opus, *6- and 12-String Guitar*.

Decades later, using an inheritance as seed money, Fahey funded the start of yet another indie imprint, Revenant Records. His final CD, + (its title literally a red cross), was completed before his death, but it took another year before Revenant cofounder Dean Blackwood could face the emotional task of preparing the disc for release.

On +, Fahey abandoned the sound collages and technology that typified his later recordings and finally made peace with his acoustic past. His picking had become slower, starker, and more focused than it once was. Time itself had made Fahey technically less proficient, but

the mythic heart of his playing—that of a strangely detached romantic—remained timeless.

John dedicated the album's dissonant title track, "Red Cross, Disciple of Christ Today" to Guitar Roberts, better known as Manhattan-based experimentalist Loren Mazzacane-Conners. The droning composition "Ananaias" extended Fahey's meta-guitar vocabulary, while his eerie interpretation of the Gershwin Brothers' "Summertime" swings pensively, resonating with cold (but not indifferent) precision.

But it was Fahey's handling of "Motherless Child" that emerged as the album's emotional centerpiece. Wielding his piercing tone like a buck knife, the guitarist carved concentric circles around the traditional melody. Repeating and reframing the eternal lament as a cosmic blues of epic proportions, John Fahey put the song, and his own myth, to rest.

— *The Strength of Strings* —

Leo Kottke's debut album, *6- and 12-String Guitar*, first came to light in 1969. His music was a straightforward antidote to the fervor of the '60s hard-rock scene, and Kottke was lauded as a welcome alternative to the era's heavier, more publicized artists.

Kottke's technical virtuosity emerged fully formed on the LP, but it was more than his quick-fingered precision that filled the grooves with excitement. Leo had captured something both astonishing and ephemeral—acoustic guitar lightning in a jar—and he opened the lid for all to hear.

The story of this record isn't just Kottke's. It's the tale of two guitarists, Leo Kottke and John Fahey. The two were worlds apart when Leo recorded his landmark debut; Kottke was working the coffee-house scene in Minneapolis while the enigmatic Fahey was running Takoma Records in California. Leo had innocently sent a demo tape

to Takoma that impressed John, and after months of benign neglect, the elder guitarist finally contacted Leo and commissioned the recording that would become 6- *and 12-String Guitar*.

John had been making his own solo steel-string guitar albums on his insurgent record label since 1959 and his influence on Leo was profound. "I have a real fondness for [6- *and 12-String Guitar*] because of John Fahey," Leo told me. "John was the only guy interested in recording me at that time and if it hadn't been for him, none of these things would have happened. My whole life was at a critical point and it pivoted because of John. I wasn't planning to do anything as far as making a living as a guitar player. I just wanted to meet John."

Although commissioned by Fahey, Leo was still on his own when arranging his first real recording session. The process was simple, but some '60s synchronicity graced the circumstance as well. "It was recorded at Empire Photo Sound, a little idea of a studio working out of a warehouse," Leo recalled. "I set it up myself, just looked them up in the phone book. They were looking for work doing sound for films. The only other thing they had done at the time were the first promos for the 747 airplane—they weren't set up for me at all."

Though the makeshift elements of that Minneapolis recording studio were crude, the bright clear sound attained on 6- *and 12-String Guitar* was nearly perfect. "The engineer was Scott Rivard who's now working for *Prairie Home Companion*," said Kottke. "They hung sheets in the warehouse and it was as if I was in this little square white room. They used an old technique for the microphone placements called near/far. The 87 microphone was near the guitar and the 451 microphone was further away.

"The 451 microphone was placed above—at about head level. This had advantages and disadvantages, but it was the first time I'd recorded anything that threatened to be a real record. Now Scott says that he

would switch the two microphones but then, it worked. He recorded the tape at 15 inches per second with no noise reduction and I don't believe there is any reverb either—I doubt they could have afforded it."

Leo had his performance repertoire down cold, but the young guitarist still felt the anxiety of his maiden voyage. "I remember being scared to death," said Kottke. "I was just petrified, so concerned to get it right and I didn't know what right was. My foot made a lot of noise so I took my shoes off." Despite his nervousness, Leo completed the entire recording session in a little over three hours.

Besides being well rehearsed, Kottke credited his trusty guitar for the easy time he had in the studio. "The thing about [the record] is the 12-string. It was unusual, a Gibson B-45. I had stripped the finish off it. The first B-45 by Gibson was the good one, Gibson gradually revised it but the first few years it was fabulous. I had heard that raw linseed oil was a good way to finish a guitar and it sounded fantastic. I also painted that guitar brown. It had a magical quality—it was the only guitar that recorded itself—it loved tape. I've always thought that a big part of the record's staying power is the sound of the guitar."

Kottke's enchanted B-45 served him well, but the album's distinctively low guitar tunings were mostly guesswork. "Originally 12-string guitars were supposed to be tuned down to accommodate the tension, but most weren't strung that way," Kottke said. "This one was strung with silken steel strings and I tuned it way down. I had no idea of actual pitch and it was in between everything. I've always been a tone player but that guitar and the linseed oil—linseed oil had actually been used to finish violins—for the first six months it would be great and then the violins would die, the linseed oil would never make it through the wood."

Ultimately, the B-45's luminous sound and Scott Rivard's judicious microphone placement combined for a dynamic recording that captured the immediacy of Leo's style.

Leo's symbiotic relationship with his dependable 12-string led to some difficult moments later on. "I went out to meet John [in Portland] and right after the first job we did together my guitar was stolen. It sent me into a tailspin and I had to relearn everything. The guitar meant so much to me and when I used other guitars it sounded like crap and drove me crazy for years. The 6-strings were never a problem. It was the first 12-string that sounded like that and it was one of a kind. I [have] found a bunch of B-45's and they just don't sound the same."

Leo recovered from the loss of his favorite guitar, and his admiration for Fahey remained undiminished. "With John, you have to figure he stole the guitar," Kottke said only half-jokingly. "I was so happy to meet him. The whole trip out West—it was just to meet John Fahey. My friend had John's *Blind Joe Death* album and it was clear there was this whole musical world that had been around but John was the only one who knew it. 'Sligo River Blues,' I learned it off of *Blind Joe Death*. That record was the one for me and to meet the guy who had done that stuff was really a big deal. He could have my guitar."

For the album's release, John Fahey made some prudent editorial decisions. "None of us knew anything about sequencing," Kottke recalled. "We sent it to John just as we did it. It was the actual sequence but John just took off three tracks and released it as a record. It was the simplest record I ever made. I have another soft spot for it because it was the only recording I made where it was all the material I knew. It would never be the same after that."

Subsequent reissues of the album have always contained the same fourteen songs, without variations or additions. And for those wondering what became of those three tracks John had deleted, you can find them on Takoma's classic guitar compilation, *John Fahey/Peter Lang/Leo Kottke*.

Looking back, Leo has come to terms with Fahey's role as an impos-
ing career mentor. "At John's funeral I realized it was always obvious
that I wouldn't be working if it weren't for John," said Kottke. "I'd be
playing, but not working as a musician. It struck me that John gave me
my whole life. He was one of those dangerous teachers where your entire
life is in jeopardy and it's all in that record. John was the real thing."

Along with the music, Leo's album was noticed for its cover art, a
black-and-white drawing of an armadillo. Sometimes referred to as
"The Armadillo Album," the record captured the hearts and minds of
guitar lovers across the country. In the early '70s, it was nearly impos-
sible to enter the home of a fledgling acoustic guitarist and not find
the armadillo staring out from the record collection.

But where did the armadillo come from in the first place? "I was
performing at a coffeehouse called The Scholar," said Kottke. "A
woman who worked there made the menus and drew the armadillo.
One night I was having trouble with my 12-string and said, 'There's
an armadillo in my guitar.' She put it on the menu and I loved it and
asked her to do the album cover."

"I was always really happy about the armadillo," Kottke contin-
ued. "John Fahey added the scrolls on the cover but I could have left
them off. Then I got booked at the Armadillo World Headquarters in
Austin, Texas, and before I played there they took me to somebody's
house and interrogated me. They wanted to know all about my rela-
tionship with the armadillo. We became a real pair—the Armadillo
World HQ and me—I really wanted to be a performer and the HQ
showed me what a real performance could be."

The Armadillo album sold more than a half million copies, but
it took nearly forty years to get there. The record's gradual impact
helped elevate the concept of solo steel-string guitar music into the
acknowledged art form that Fahey envisioned.

The recording first gained national attention in 1970 thanks to a glowing review in *Rolling Stone*. And while Kottke's back-porch fingerpicking may have been out of step with the amplified sounds of the times, he struck a universal chord that has never ceased to resonate.

More than anyone, Leo was shocked by the response to his first album. "I was flabbergasted at the reception of that record and I didn't realize until years later how much impact it had," he admitted. "The *Rolling Stone* article was important. And there were also two guys in Chicago, Randy Morrison on WLS and John Schaffer at WXRT; they were both playing it. Radio still existed then and DJs could pick up a record with no label behind it—it was a different world—and the record just took off."

Nineteen sixty-nine was an exotic time for music and pop culture, and in retrospect Leo's dazzling display doesn't seem so out of place. Tapping into the era's collective consciousness, Kottke and Fahey somehow found each other and created a unique musical document that has withstood the test of time.

"When someone is really, really enjoying themselves, it can happen," Leo Kottke concluded. "I think that's another reason why people like that record and began playing guitar that way. It's a great privilege of the job to be part of that. I was recording it for this oddball character and it made me feel like I had found home. John liked it for the same reason I liked it—for what it was."

~ *Bundy K. Blue's Dance with Death* ~

Bundy K. Blue was bored. With hopes of breaking the monotony and getting his artistic juices flowing, he invited some friends to his loft in Chicago to play some acoustic music. Within a few days, his buddy Curt flew in from New York and good old Chris arrived from Boston.

Bundy's pal Doug was also in town and he promised to bring over a few bottles of wine.

While everybody was eager to jam, things started slowly. Each player had been working on new compositions, but their group sound had yet to meld. After hours of aimless jamming, the foursome decided to go out for Mexican food. It was a warm Chicago night and there was plenty of activity on Damen Avenue as they walked down the block.

It was then that the strangest thing happened. They had just stepped off the curb to cross the street when a flash of light exploded before them and blinded the group for a good twenty seconds.

As their vision returned, they noticed that Damen Avenue was practically deserted. The street also seemed different in some way. "What the hell happened?" exclaimed Bundy. The men huddled and tried to cope with their uncertainty.

A few moments had passed when Chris noticed a newspaper on the sidewalk and shouted, "Hey! Look at the date on this paper. It says today is July 25, 1973!" Doug snorted and said, "Yeah, right, and we're the freaking Hardy Boys. Let's ask somebody what on earth is going on here."

As luck would have it, a tall bearded hippie was walking past the bewildered foursome.

Without hesitation, Curt said, "Excuse me, sir, but do you know what year it is?" The hippie stopped and stared at them. "What year? C'mon, I know it's harvest season but the grass going around isn't THAT good. It's 1973, of course."

Bundy and his friends became hysterical and started arguing among themselves. The hippie (whose name was Fred) watched them squabble for several minutes before interrupting their heated debate: "Hey, I don't know what's wrong, but if you guys need to crash at my pad and sort things out, you're more than welcome."

"Gee, thanks," said Bundy. "Maybe we can figure this out if we get off the street for a while."

When they entered Fred's apartment, the dazed time travelers let out a collective gasp. For there, strewn all about the room, were a dozen vintage guitars. A beautiful Guild 12-string guitar was sitting by the couch and a Martin was propped up against the wall. There was a dobro, a mandolin, and even a stand-up bass. "Yeaaah," Fred drawled. "These are my babies. Any of you guys play?" The four laughed nervously and settled down in the cluttered living room.

Almost immediately, Chris spied something familiar on the floor near Fred's stereo. "Hey, check it out, a brand-new copy of Leo Kottke's Takoma album, 6- *and 12-String Guitar.* I'd recognize that armadillo anywhere."

Before they knew it, Bundy, Chris, Doug, and Curt were lost in discussion with Fred. They spoke for hours about the history of steel-string guitar music. Fred really knew his stuff and was a pretty tasty player, too. He was a walking encyclopedia when it came to John Fahey's Takoma label and he had all of the albums by Fahey and Kottke (up to 1973). He also knew about other, more obscure acoustic guitarists, like the mysterious Robbie Basho.

"Yeaaah," said Fred. "Kottke is an incredible technician while Fahey is the ultimate stylist/composer. I've got a permanent cramp in my left hand from trying to play 'Vaseline Machine Gun' like Leo." The five men drank coffee and continued discussing requiems, Fahey's classic, *Blind Joe Death*, and other solo guitar innovations.

They talked deep into the night about the American folk form phenomena: big wooden guitars, all loosely strung with open, dropped tunings and fingerpicking styles from the 1930s played by southern blacks and poor white folks.

"Yeaaah, it was an American interpretation of Renaissance music

with some Delta blues thrown in for good measure," Fred chuckled. "Now let me show you my version of Kottke's 'Cripple Creek.'"

It was two in the morning when Curt, Doug, and Chris began to get hungry. "We gotta go out for something to eat, Bundy," said Doug. "You want to come?"

Bundy looked up from the guitar in his hands and said, "Nah, Fred and I want to try the Allman Brothers' tune 'Little Martha.' I'll catch up with you later."

As the trio left Fred's apartment and walked out onto Damen Avenue, another blinding flash of light appeared before them. When their eyes finally readjusted, they realized something had changed once again.

"Oh no," Curt moaned. "We're back in the present, but Bundy is still stuck in 1973 playing guitars with that guy Fred. What are we going to do now?"

"Let's head back to the loft," Chris said. "There has to be some resolution to all this."

As they approached the door of Bundy's loft, the three heard a ringing acoustic guitar inside. They knocked, and a spry old man answered the door.

"Bundy?" they screamed.

"Yeaaah, it's me," answered Bundy. "What took you guys so long? Come on in and close the door. I think I've finally got this solo steel-string guitar stuff down pat—I've been doing a whole lot of practicing."

ROUNDABOUT

Adam Coil strolled down the hall toward his dorm room. As he reached the door, he heard some peculiar sounds coming from the other side. The burbling noise was not like anything he had ever heard before—then it stopped.

Adam entered to see his roommate Bill stripped to his underwear, bong in hand, clumsily pressing the play button on Adam's $4,000 stereo. The same strange sounds began once again.

"What the hell is this?" Adam demanded.

"Hey, dude, sit down and check this out," Bill replied. "It's these Germans who claim to be radical poststructuralists. They digitally process environmental recordings and electroacoustic sound files. Listen! It messes around with an auditory aspect of the spatial scope. Heavy dimensionality and no beats!"

Adam eyed his roommate carefully. He knew Bill was having trouble in several of his classes and had been down in the dumps. Now the kid was sitting around nearly naked, listening to this arrhythmic, electronic mishmash.

A few moments passed and just as he was about to speak—Adam got it. The liquid noise *did* seem to move around the room. Without an

actual meter, the software-based innovations somehow suspended human time, and deepened his personal reaction to the ambient milieu. Lost in the sound, he didn't even hear his roommate dress and leave the room.

Suddenly there was a knock on the door. It was Tim, the R.A. from down the hall.

Adam put down the bong, clumsily pressed play on his $4,000 stereo, and said, "Hey, dude, sit down and check this out . . ."

WAR ALL THE TIME

According to common legend, rock criticism first raised its pointed little head somewhere around 1966. As if on cue, young volunteers sprang up across the country to join the original rockcrit army. Among the idealistic soldiers to hit the front line was one Richard Meltzer. Perhaps Meltzer didn't know that his writing was going to turn into journalistic warfare, but he fought long and hard and took no prisoners.

Of course, the music industry's scorched-earth policy eventually caught up with Richard as he wrote, drank, screwed, and battled his way through the fire. Long a self-described geezer, this militant soul ultimately survived to see his explosive musings compiled in the greatest hits collection *A Whore Just Like the Rest: The Music Writings of Richard Meltzer.*

It's all there in Richard's battered journal, including fond remembrances of colorful comrades in arms and requiems for sad casualties like the late Lester Bangs. Meltzer also goes out of his way to identify some traitors from the battlefield as well as unloading both barrels on old adversaries like *Village Voice* mainstay Robert Christgau and rock-academic Greil Marcus.

Not surprisingly, Meltzer has taken his share of abuse over the decades, and some say he's still asking for more. A bitter anti-journalist who literally wrote himself in and out of several jobs, he offended record company honchos and humble music fans alike with his irreverent diatribes on rock culture. Eventually banished to the outskirts of the rockwrite community, Richard was denied the soft comforts of corporate journalism (you know, free stuff) and by the mid-'70s he was on the outside looking in.

The funny thing is, nobody told Richard that the war was over and he kept dropping bombs and naming names with a vengeance. But let's go back to the beginning and access the bloodshed, the victories, and the personal price of Richard Meltzer's literary combat.

"R." Meltzer first hit the scene with a blazing labyrinth of a term paper he'd written while attending the State University of New York at Stony Brook. Excerpted in 1967 by a young editor named Paul Williams, Meltzer's rousing article (originally called "A Sequel: Tomorrow's Not Today") was featured in the eighth issue of Williams's now-fabled fanzine, *Crawdaddy!*, under the auspicious title, "The Aesthetics of Rock."

Around the same time, Richard was drummed out of the graduate program in philosophy at Yale University. His academic offense? Writing essays about rock 'n' roll for class courses, like Laws of Nature, and Being and Becoming in Greek Philosophy.

Meltzer's unwieldy assertions on music were unlike anything his generation had ever seen in print. Spewing a booze-and-dope-fueled rant wedding traditional dialectics of art criticism and philosophy with the context and content of '60s pop counterculture, "The Aesthetics of Rock" provided abstract (and concrete) connections in wholesale and hallucinatory fashion.

Free-associating in tangential hyperdrive, Richard examined the

influences and sonic antecedents of the Doors, the Beatles, Moby Grape, Jefferson Airplane, and countless others. His comical treatise gained theatrical momentum by weaving the Sisyphus myth into rock culture and using the concepts of worldly philosophers like Nietzsche, Plato, and Immanuel Kant.

Obtuse, passionate, sublime, ridiculous, and all but unreadable, the excerpted essay (and the 1970 book version) of "The Aesthetics of Rock" garnered both high praise and damning criticism. In any case, Meltzer wrote the damned thing.

This all happened a few months before Jann Wenner began publishing the world's most famous music magazine, *Rolling Stone*. Besides Meltzer and Paul Williams, other writers who began making rock 'n' roll a priority included East Coast upstarts like Meltzer's former schoolmate and future Blue Oyster Cult producer Sandy Pearlman, Richard Goldstein, and Patti Smith's soon-to-be-perennial guitarist, Lenny Kaye.

And the beat went on; LA writer Greg Shaw had a fanzine called *Mojo Navigator* while Robert Christgau wrote for *Esquire* and the short-lived *Cheetah*. Lured by the ambitious Jann Wenner, future Springsteen manager Jon Landau contributed to *Rolling Stone*'s very first issue and Bay Area writer/editor Greil Marcus soon followed.

Despite his enthusiasm and originality as a young rock scribe, Meltzer's professional sojourn was not an easy one. While he was observant enough to become the first American writer to profile Jimi Hendrix, his mocking diatribes and combative persona challenged readers and editors alike.

Crawdaddy!'s Paul Williams remembered Meltzer's provocative impact on the then-innocent rock world, "When Richard handed me his manuscript I loved it and excerpted it as 'The Aesthetics of Rock.' We had some personality conflicts but I kept publishing him and I'm

certainly very proud of it. Of course, some of the magazine's readers totally freaked out and hated Meltzer. For example, with his piece, 'What a Goddam Great Second Cream Album,' Richard was already (implicitly and explicitly) criticizing the fan attitude and taking it right to the readers. Naturally, a lot of them hated it. At the same time, Richard would have demands that I couldn't meet. I just thought he was brilliant and he thought I didn't appreciate him."

Predictably, Meltzer and Williams parted ways, and the '70s found Richard hustling his singular brand of review-speak to a slew of new rock magazines. A primary influence on the bleeding-heart-gonzo-rock-journo-savant Lester Bangs, Meltzer found shelt(z)er for his stream of consciousness/deconstructionist rock ravings in periodicals like *Fusion*, *Rolling Stone*, *Zoo World*, and Detroit's very own music magazine, *Creem*.

Bolstered by the drunken camaraderie of equally brazen writers like Nick Tosches and rising star Bangs, Meltzer entered into a prolific period of extemporaneous rock writing. Ironically, while he was improving as a writer through the rigors of nonstop work, Richard was losing his enthusiasm for the music itself. More precisely, he became disillusioned with the commerce-driven marketplace called rock 'n' roll.

Speaking to me from his home in Portland, Oregon, Meltzer recalled the long and winding road involved in his being and becoming a writer, "I don't think I've ever made a middle-class income per se, but I have survived by writing," he said. "I feel in some ways it was good that I had these options early on to write for crummy mags that paid ten dollars a review. When I wrote for enough of them I was able to get by—it forced me to be prolific and get my chops. I also got on all these mailing lists and suddenly I was being force-fed the whole gamut of [rock] releases."

Receiving and immediately selling off his promotional albums, Meltzer survived the early '70s by eating and drinking (gratis) at the countless press functions held in Manhattan. Constantly drunk and a relentless lecher, he devolved into a rogue critic who would engage in food fights, piss anywhere anytime, and even feel up somebody's mother. Basically, Richard seemed eager to go that extra mile in order to embarrass and/or outrage everybody.

Above and beyond the stresses of maintaining his bad-boy persona, Meltzer became dependent on the music industry for his daily fix of promotional records. He also developed serious artistic conflicts when it came to writing about music.

"[Getting free albums] is a worse addiction than crack," Richard admitted. "Those people who I have known that have had that habit—some of them are lifers. You have to ask yourself, 'Will my enthusiasm be enough if I'm not getting these perks?' I don't think anybody that I've known has been capable of doing that and maintaining enthusiasm. It's very difficult to be objective and you turn into a shill. I was kicked off every mailing list and I'm glad. I just don't know how glad I was at the time."

Nonetheless, Meltzer had his fun while living and working in New York. He was the life of the party in the early '70s, at least in his own mind. Strutting a punk philosopher guise in *Creem* and scribing under pseudonyms like Borneo Jimmy and (Not the) Audie Murphy, Meltzer's street life became fodder for his art. Besides writing song lyrics for Blue Oyster Cult, he was bosom buddies with Patti Smith and schmoozed with an outrageous cast of characters.

Marty Balin, a former lead singer of Jefferson Airplane, recounted his association with Meltzer, "Richard wrote about me in some book in which he had me hanging around New York with Joe Namath, smoking cigars and picking up women. I never ever met

Joe Namath. That never happened. Richard's stuff was a little radical, even more out there than most guys because he would go to the farthest limits about stuff. I guess he made up a lot of his own stories. He had a sense of humor about all of it—it made you laugh anyway. I haven't seen him since 1967."

Sadly, many of the relationships Meltzer prized during the '70s have soured. He no longer speaks to Sandy Pearlman, citing a cruel withholding of songwriting royalties from Blue Oyster Cult as the final straw. Resentment also runs deep toward failed friends like Patti Smith. "There was a moment where the public Patti was it, and the private Patti didn't need friends," Meltzer said wearily. "She was the most non-ironic, shoot-from-the-hip anti-Semite I'd ever met. Patti wanted to be all things to all people. Little by little it seemed so absolutely phony."

In addition to personal quarrels, Richard's enmity toward professional rock journalism manifested itself in feuds that have endured for decades. Booted from the record review section at *Rolling Stone* in 1971 for penning a Commander Cody review credited to Nick Tosches (and coconspirator Nick returning the favor by writing Richard's review of the same album for *Fusion*), Meltzer was locked in a dance with his most despised foes: editors.

Clearly, the journalistic demands of magazine editors went against the grain of Meltzer's artistic sensibilities. "Journalists are chumps," Meltzer exclaimed. "I mean, to do any form of coverage of things in the real world for papers and mags is a real chore. I feel like it has to come close to tearing your heart out."

Richard's controversial response to his dilemma was to review certain albums without actually listening to them. To his credit, history has borne out his decision to actively ignore industry-hyped (and now-forgotten) artists of the time like Ned, Barbara Mauritz, and Black Grass.

Alienated, intimidated, and generally objecting to established music editors like Robert Christgau, who presided over Richard at the *Village Voice*, Meltzer left New York in the mid-'70s and moved to Los Angeles. Sick of rock writing and listening almost exclusively to jazz, Meltzer applied his dense, self-referential joke-prose toward essential topics like boxing, wrestling, and a guidebook to L.A.'s ugliest buildings. He found an authentic voice writing visceral poetry and applied the tough-vision/nocturnal emissions of his true-to-his-life fiction in a dark comic novel, *The Night (Alone)*. He even sang his outrageous prose as the front man for a punk group called Vom.

While living and (dying) writing in Los Angeles, Meltzer's muse was revitalized by the city's fledgling punk scene. In the early '80s he wrote vividly about groups like the Germs, X, The Blasters, and the Minutemen. Meltzer considered the musicians he wrote about to be his friends, and some of them are still devout fans.

Bassist Mike Watt voiced his resounding support for Meltzer's outsider perspective, "Me and D. Boon [late guitarist/singer of the Minutemen] used to learn all of the lyrics for the Blue Oyster Cult, which was our primo band thirty years ago. Then we got to actually meet Richard Meltzer. He told you a lot with his work. It was different than reading the *LA Times*; it was another way of writing. He wrote like somebody who you'd really want to know. These other cats, they seemed like the lamest teachers you had at school. I guess in the grand scheme of things those other guys won. But I don't know if the world was really richer for it."

Roots-rock musician Dave Alvin (once of the Blasters) echoed Watt's devotion to Meltzer's work, "Richard writes in a way that's very musical; there's a rhythm to it that's like listening to Jerry Lee Lewis at the Star Club. There's real intensity to his writing, a sort of fuck-the-consequences edge that's in all the best rock 'n' roll records. It's also

challenging to read Richard, and most music writing isn't challenging. He makes you think, and uncomfortably so sometimes. Back in the '80s we did several poetry readings together. Richard used to write a column for the *LA Reader* and he pissed off so many people that there would be bomb threats phoned into the readings. It's amazing to think, 'What you're doing is nothing, man, Meltzer's getting bomb threats.' Of course there were times when I was reading his book and I thought, 'Why didn't you just play the game, just a little bit?' But then Richard wouldn't be who he is, so what are you going to do?"

What Meltzer did was to grow into a masterful writer who demanded to be dealt with on his own terms. His best works come fully loaded with powerful insights, and are fueled by a cold, brilliant solipsism. In the essay "As I Lay Dead," he wrote his own postmortem testimonial, "I was generous then (i.e. now *my* now) always gave the whole wad away, squandered my fluids on writerly whims with but the most esoteric payoffs, spent 5-6-7 years on books that didn't get me laid, didn't earn me a can of clams, and the bounty of that generosity lingers on."

Maintaining his un/usual verbal dexterity, and drawing provocative recollections from his personal-cum-professional lifetime, Meltzer found playful ways to entertain. He wrote red-herring travelogues like "Of Peep Shows and Piano Bars" and the brutally observant in-search-of-Lawrence-Welk saga, "All the Tired Geezers in the Sun."

After two decades of not-all-that-much-fun-in-the-sun, Richard abandoned Los Angeles in favor of the beatnik-friendly Northwest. He moved to Portland in 1995 and soon began struggling with some very human concerns. Those concerns would include mortality, his ever-increasing geezerhood, and the practical limits of a vaguely foreseeable future.

"Basically, I have to start thinking about the number of things that I'll have time to do," said Meltzer. "That number is very finite now. I have time for three or four more books and I have time for [so many] magazine pieces in the course of the year. It takes me longer to write now and I really have to figure out what to do next."

An eternal fringe player in the rockcrit game, Meltzer's sense of humor is self-deprecating, but it can also be quite deadly when he turns his aim toward others. His powerful 1998 essay, "Vinyl Reckoning," serves as a handy-dandy sequel/bookend/antithesis to "The Aesthetics of Rock."

"Vinyl Reckoning" is a carefully crafted memoir-via-artifact that has geezer Meltzer reminiscing through his record collection and airing dirty laundry from past decades. While a sense of closure is attained in this piece (it's FINAL, okay?), Richard is not going gently into that dark night, nor does he intend to go there alone.

So, Meltzer spills the beans. There, strewn among his dog-eared albums are the emotional remnants of a record-beaten life; memories of his girlfriend's abortion, an unmistakable diatribe against Sandy Pearlman, the man's whole rock-qua-rock verbosity shtick, Sisyphus again, and of course, his never-ending venom for rock establishment types Robert Christgau and Greil Marcus.

Meltzer's autobiographical ramblings unfold mightily in the course of "Vinyl Reckoning," especially his resentment and single-minded contempt for the editors he believes, or at least maintains, kept him away from some big-time recognition and a few decent paychecks. Savaging Christgau and Marcus for slights real and imagined that date back to the '60s, Meltzer accused his contemporaries of the worst crime imaginable, being uptight.

"Robert Christgau and Greil Marcus were squares, outsiders to the

[rock] experience," Meltzer said emphatically. "They're just stuffed shirts who find themselves talking about colorful characters and high times who are apart from those things and those people."

That these men are still writing about music and have attained a certain professional status seems to irk Meltzer, as if the two have somehow stolen his original rockwrite thunder. Still, Meltzer can't help but wonder what his old foes might say about him. "I have no idea whether Christgau or Greil have read any of this stuff and whether they ever will," he said. "I would like to get some feedback from them, just to get a sense of the ongoingness of the damn thing."

Oh, there's ongoingness all right. Speaking from his home in New York, Robert "The Dean" Christgau was well able to discuss Meltzer's *A Whore Just Like the Rest* shortly after composing his review/rebuttal for the *Village Voice*.

"I had plenty of negative things to say about [Richard] but the book impressed me," Christgau said. "I didn't expect to be impressed but I couldn't ignore what he'd accomplished. He's an excellent writer about music in his own way. Not the way that I would recommend but rules are made to be broken and he breaks them and does it often, brilliantly. He regards himself as some kind of avant-garde writer and at some level he doesn't understand why he's not as famous as William S. Burroughs. There are a lot of bohemians who believe that they ought to be famous who haven't accomplished anywhere near as much as Meltzer has. All I can say is that nothing he said about me seems to me to be grounded in fact. Nothing. He got everything wrong."

Author Greil Marcus was less willing to discuss Meltzer's notorious taunts in "Vinyl Reckoning." "I can't speculate on anybody's motives and I'm just not going to get into any of that," said Marcus.

When it came to the premise of having one's identity forever tied to being a music writer, however, Greil was somewhat more reflective.

"It's a title that is very difficult to escape," Marcus explained. "It's an easy way to dismiss somebody, call him or her a rock writer or a rock critic. To a lot of people it seems like a ridiculous thing to be spending your time on. Richard did unique work writing about music but if you read what he wrote as he wrote it, he's playing with words. I don't mean that in a frivolous sense, he's trying to find out what words can do, which is what writers do."

It's interesting to note that both Christgau and Marcus were willing to say that Meltzer is a talented writer, which is the one thing that Richard rarely admits about them.

To be sure, Meltzer still matters. With a (baker's) dozen books to his credit, his writing has grown stronger over the years and he continues to get under the skin of rivals who would have been more than happy to forget all about him. Of course, there's nothing like a little provocation to bring out the best and/or worst in people. Meltzer's supercilious attacks on Bob Christgau in *A Whore Just Like the Rest* didn't go to waste, as Christgau's retaliation in the *Village Voice* was the critic's best-written review in ages.

Obviously, the shoot-yourself-in-the-foot path Meltzer has taken is not lost on his peers. Dave Marsh, who edited Richard during their early days at *Creem* and declined to commission him while editing at *Rolling Stone*, had no problem taking Meltzer to task.

"I listed *The Aesthetics of Rock* as one of the worst rock books," Marsh said. "Part of Richard's strategy has always been to get people to react. From very early on it became clear that [his position] was coming out of contempt for rock music. What you see is somebody who's very good and who has something to say, paint himself into a corner. What's the paintbrush? The paintbrush is self-loathing. I think he was funny about things when people needed to be reminded that funny was part of it. People think that being a rock critic is easy, well,

maybe for two years. After that, you're on your mettle. Richard, not for lack of talent, decided he didn't want to do it."

The late David Walley, author of *Teenage Nervous Breakdown: Music and Politics in the Post-Elvis Age*, remembered these veteran music critics from his own ambitious youth, seeing them at other people's parties and working with a few. Walley dropped out of the East Coast rockwriting game about the time Meltzer abandoned Manhattan for L.A. Equally disgusted by the rock/commerce equation, he respected Meltzer's principles but not his methods.

"I like Richard but we never got along," Walley said. "He's the Charles Bukowski of rock 'n' roll. [The people he attacks] sold out years ago. In fact, there was never a question that they would sell out, they were sell-outs when they started. It's impossible for pop music to be revolutionary in a market society. Rock 'n' roll today is very capitalist whereas rock 'n' roll of our day was very anti-capitalist. That's a very severe difference."

Richard's old pal Nick Tosches, now enjoying great success as a hard-boiled novelist and well-paid biographer, declined to be interviewed for this story. He did, by way of Meltzer, provide one quote (and let's just hope Richard didn't write it himself).

Nick wrote, "The fact that Richard, after all these years, is still not full of shit—a *very* normal outcome for writers, frycooks, and thieves—is staggering evidence of not merely the truth but the *stamina* of his vision."

'Nuff said.

ERECTOR SET

Little Jonny Jewel was in a great big hurry. He'd waited for his mother to leave the house for work that morning, but the old lady had taken more time than usual. Now Jon was pedaling his bicycle like mad to make up for lost time, and his backpack bounced off his shoulders every time he hit a bump on the sidewalk.

"Darn," the boy thought. Here it was his first time being invited to one of the secret meetings at Brad's house and he was going to be late.

The twelve-year-old checked his Mickey Mouse watch as he threw his bike down in front of the Conner residence. "Not too bad," thought Jon. "Its only five minutes past noon."

Clutching his backpack, Jon rang the doorbell and held his breath. Brad Conner opened the door slightly, looked around for a moment, and let Jon into the house. "Hey, glad you could make it," Brad said. "Some of the guys thought you couldn't come." Jon looked into the living room and saw a group of young boys laughing and watching TV.

Brad gripped Jon by the shoulder and leered devilishly. "Well, did you bring your contribution to this afternoon's proceedings?" Jon smiled weakly at the older boy and his voice cracked as he replied,

"I did. I got what you wanted." Brad clapped his hands together and shouted, "Great! Let's get started then, shall we?"

Brad led Jon into the living room and addressed the youthful gathering. "See, I told you he'd make it. Show the guys what you've brought us, Jonboy!" Jon blushed as he revealed three issues of *Penthouse* that he had taken from underneath his older brother's mattress. The kids cheered as Jon threw the magazines on the floor in the center of the room. *Deep Throat* starring Linda Lovelace was on the TV with the sound down, and sex-related materials were scattered all over the room. One nine-year-old boy was enthusiastically showing the others his deck of pornographic playing cards.

It was then that Jon heard the music coming from the speakers suspended from the ceiling in the living room. A chorus of voices emerged over an insistent, bouncing, rock-reggae vamp. "What the heck is this?" he wondered out loud.

"It's the Mekons, Jon," Brad answered. "I found the CD buried in my dad's bottom drawer. He's been collecting the stuff for years and must have over twenty different Mekons collections. I thought it would be just perfect for our little circle jerk."

"I guess so," Jon responded.

Brad laughed gleefully as he used a remote control to turn up the volume and turn down the lights. "My dad says they're from England and used to inhabit a sociopolitical/musical realm somewhere between the Clash and the Pogues."

Jon scanned the room and made sure that no one else had started jacking off yet. He didn't want to be left behind and was totally confused as to whether you won or lost by being the first to finish or the last.

"I always thought the Mekons were a punk group from Leeds that

came up the same time as the Gang of Four and had Celtic and country music influences," Jon said.

Brad began passing around small tubes of flavored lubricants as he hummed along with the music. "Yes, that's them; they've even used electronics and computers in their music, but it's still rock 'n' roll—VERY ADULT rock 'n' roll. I think that they're one of the most interesting groups in music. I mean, how many bands have had a curse put on them anyway?"

Talking in the room subsided, and most of the boys' attention shifted toward Linda Lovelace's award-winning performance on the video.

Suddenly, the lights flashed on and Mrs. Conner was screaming at Brad. "What in the hell is going on here?!?" Everyone immediately scrambled to their feet except Bill Bessfield who was listening to Metallica on his iPod with his eyes tightly shut.

Jon almost tripped over his pants, which were down around his ankles, but he managed to right himself and grab his backpack before flying through the kitchen and out the back door.

Jon was a good half-mile away from the house before he stopped running. As he searched through his backpack, Jon realized that he had left the dirty magazines behind, not to mention his bicycle. His brother was sure to kick his butt when he got home. It was right then that he found the stained booklet from the Mekons CD that he had heard at Brad's place.

"Excellent," Jon thought. "Now Brad will have to invite me back the next time he has everyone over to the house."

CLASSICS VS. ANTHEMS

Let's play a game. It'll help if you have some working knowledge of pop music from days gone by, but anyone who's listened to the radio in the last forty years will do just fine. It's simple really; all you have to do is pick out which song is a classic and which one is an anthem.

For the record, *The Concise Oxford Dictionary* (9th edition) defines the word *classic* as (a) "acknowledged excellence" and (b) "outstandingly important." An *anthem,* on the other hand, is understood as (a) "a solemn hymn of praise" or (b) "a popular song that is defined with a person, group, etc."

Now that we've got our basic terms straight, let's get started and learn more as we go along. First question: the Rolling Stones—"Satisfaction" versus "Jumping Jack Flash." Which is which? The answer: "Jumping Jack Flash" is the classic and "Satisfaction" is the anthem. You may not agree with this judgment, but it's my game, so behave or you'll have to sit quietly while the rest of us have fun without you.

You see, not every classic is necessarily an anthem and not every anthem is a classic. Since neither category consistently subsumes the other, you're really going to have to consider the logic behind your answers. Here's one. Bob Dylan—"Like a Rolling Stone" versus "Blowin' in

the Wind." Answer? "Blowin' in the Wind" is just a classic, and "Rolling Stone" is the actual anthem.

I should say that it's possible for a song to be both an anthem and a classic, but anthems can also be quite horrible and some will never attain classic status. Is "We Are the World" an anthem? Yes, but it sure isn't a classic. The same goes for Twisted Sister's "We're Not Gonna Take It" and countless other Top 40 hits that I decline to mention. Just because a song has been played on the radio incessantly doesn't mean it has to be a classic or an anthem, let alone both.

Also, there's the notorious "Springsteen Principle" to consider. That is, some artists (like Dylan, Neil Young, and Prince) are predisposed to write in an anthemic voice and, as a result, many of their songs are anthems or pseudo-anthems. Think about it. "Born to Run," "Born in the USA," "Hungry Heart"—for a while Bruce couldn't clear his throat without the end result becoming an anthem.

Of course, the same goes for stadium rockers like Tom Petty and John Mellencamp; they just seemed compelled to write anthems. So did the Who's Pete Townsend, for that matter. From songs like "My Generation" to "Won't Get Fooled Again," old Pete wrote more anthems than that great American composer Stephen Collins Foster.

One good way to test out the classic versus anthem theory is to play the song in question at a sporting event. If the tune doesn't make it at a basketball game, odds are that it isn't an anthem. In this case, the late Freddie Mercury and his group Queen are at the top of the heap with anthems like "We Are the Champions" and "We Will Rock You."

But not all anthems are melodramatic, sloganeering pieces of rock propaganda; some aren't about anything in particular. Even a tune with no discernible words, like Gary Glitter's "Rock and Roll Pt. 2," rates as a huge anthem in the world of sports.

As a result, you'll never hear John Lennon's "Imagine" at halftime—but for some reason, cheerleaders are still shaking their butts to Paul McCartney's "Live and Let Die." Obviously, anthems like "Cocaine" don't make it into sports venues, but I do recall hearing "I Want a New Drug" at a basketball game a few years ago.

Also, I feel it's my civic duty to inform you that Curtis Mayfield's "Superfly" is an urban classic while Isaac Hayes's "Shaft" is the ultra-funky anthem. I don't remember exactly why, but that's the deal.

Here's one. Led Zeppelin's "Stairway to Heaven" versus "Whole Lotta Love." Answer: Both are classics, but neither are anthems. This goes back to the little-known proposition that Zeppelin damn near invented "Classic Rock" and thereby avoids the lowest common denominators frequently found in anthem rock (the same goes for Jimi Hendrix and Eric Clapton, by the way).

This brings us to my final point. You're probably not hearing as much "Classic Rock" as you think you are. In most cases, those radio stations clubbing you over the head are actually playing "Anthem Rock" and don't even know it.

As a result, I'm looking for a few serious investors for a new kind of radio station. Naturally, it's going to be anthem rock radio and our motto will be "All Anthems—All the Time." There will be no meager power ballads, no contrived golden oldies, and no sentimental dustys—just certifiable rock anthems guaranteed to pump you up.

We'll also be looking for a few good DJs who are willing to play "Freebird" during the A.M. drive time, but that shouldn't be a problem. Anthems are for the people, right? Just think of the advertising dollars we're going to haul in. It's enough to make a man stand up and salute.

Which reminds me, Bachman Turner Overdrive's "Takin' Care of Business" versus Pink Floyd's "Money." Any takers?

OH HAPPY DAY

Winter holidays are the time of year when writers are encouraged to bring out seasonal messages. I've always had a difficult time finding a good topic, but recently, I had a revelation and I'd like to reflect on "Oh Happy Day" by the Edwin Hawkins Singers—an unlikely hit single from the year 1969.

If the piano intro to this song sounds familiar, perhaps it's because George Harrison borrowed it for his own song of praise, "My Sweet Lord." "Oh Happy Day" was actually cut in 1967 when Edwin Hawkins, his brother Walter, and a woman named Betty Watson organized the Northern California State Youth Choir and privately recorded a devotional album entitled *Let Us Go into the House of the Lord.*

Watson and the Hawkins brothers sold just a few hundred copies of their album at the group's concerts. Then, a San Francisco music promoter discovered the recording and passed it onto Abe "Voco" Kesh, a disc jockey at radio station KSAN. The jock began playing "Oh Happy Day" as a novelty, but his listeners responded with a surprising degree of enthusiasm.

Word of mouth spread and the tune quickly became an underground favorite. Buddah Records then purchased the recording and

released the song as a single. If you look at the label of the original Buddah 45, you can see how they squeezed in a lengthy credit line going to "The Edwin Hawkins Singers featuring Dorothy Combs Morrison (Formerly the Northern California State Youth Choir)."

The Buddah single sold millions and earned the group a GRAMMY award for the best soul-gospel performance of 1969. And so, "Oh Happy Day," this rearrangement of an old Baptist hymn, became the rarest breed of commercial success, a crossover gospel hit that reached number four on the national pop charts—which to my knowledge had never before happened with a gospel recording and has not happened since.

Regardless of the song's status in the history of pop trivia, Dorothy Combs Morrison's ecstatic performance is wholly inspirational. Her voice is strong and clear and filled with love for her lord and savior. And when the elated chorus sweeps upward with "He taught me how . . ." the choir blows the roof off with righteous enthusiasm.

A simple, direct, and beautiful performance, Ms. Morrison's expressive vocal and the emphatically devout choir combine for a celestial call and response. While the song has been performed countless times since the making of this recording, no subsequent interpretation of "Oh Happy Day" holds the power and the glory of the original version.

Now, I don't consider myself a religious person but I do have my own sense of spirituality. And although my relationship with the figure that the Edwin Hawkins Singers sing praise to is quite limited, I can't help but feel inspired by the performance and want to send out an uplifting thought.

So, "Oh Happy Day" to all you people of Christian faith. "Oh Happy Day" to my brother, his wife, and his kids in Israel and Jews all over the world. "Oh Happy Day" to Muslims and Buddhists and followers of

every other religious persuasion, large and small. "Oh Happy Day" to the agnostics and the atheists, too.

"Oh Happy Day" to all of the different races and extraordinary cultures that inhabit this earth and "Oh Happy Day" to my family and all of my friends. "Oh Happy Day" to politicians and world leaders across the globe. And before I forget, "Oh Happy Day" to Mr. Edwin Hawkins, Dorothy Combs Morrison, and gospel singers everywhere.

Finally, "Oh Happy Day" to you—with so much tension, trouble, and controversy in this world, I know that we all can use some sweet inspiration.

So please, take a moment and consider this simple message of hope, spirit, and goodwill to mankind.

Peace on earth and have a nice day.

A LONE STAR STATE OF MIND

In the old days, unless your name was Bush, Texas kids (even the white ones) would rarely dream of growing up to be president of the United States. Of course, Texas has always had its share of idyllic wealth and golden opportunities, but the Lone Star State was one tough place to live in the early 1950s.

And for an all-American boy to imagine escaping the pervasive barrenness, narrow-minded intolerance, and soul-killing humdrum of everyday Texas life, dreams just needed to be a little bit more down-to-earth.

A San Antonio kid might fantasize about being a country-music legend like Hank Williams. A few years later, that kid might grease back his hair and emulate Elvis Presley or a local hero like Lubbock's Buddy Holly. Or maybe he'd learn to play the devil out of the guitar and dress to the nines like Aaron Thibeaux "T-Bone" Walker, a pimped-out blues pioneer from Linden, Texas, whose cutting flamboyance was the stuff of legend.

Later still, that very same kid could fantasize about being in a group like the Rolling Stones or singing like Bob Dylan, or maybe jamming with the Grateful Dead.

Doug Sahm dared to dream all those different dreams, and he grew up to be all those different people. He traversed the realms of country, jump blues, honky-tonk, primal rock 'n' roll, Cajun, San Francisco psychedelia, all sorts of roots music (including Tex-Mex, conjunto, and two-step polkas), as well as embracing jazz, soul, R&B, and Bob Dylan. Sahm met many of the famous artists he respected, shared in the joys of their music, and delved into their unique lives. But he always moved on.

Doug played American music. He mastered the steel guitar by the age of five and soon played fiddle, electric guitar, bass, and mandolin. He could also sing his ever-loving ass off. Looking back, Sahm epitomized the complex traditions of Texas music in a way that Willie Nelson never could. Of course, Willie was smart—smart enough to emulate Doug's redneck-hippie persona and doubly smart to hook up with Waylon Jennings, yet another Texas rebel.

Still, when it came to Texas, Doug Sahm was the man. The currency of Texas music enriched his life, and he made damn sure to tell the world all about it at every turn. Sahm was emotionally and professionally manic and at least half-crazy all of the time. His runaway lifestyle swept up everyone and everything around him. Is it any wonder that he came to be known as the Texas Tornado?

Doug was the hometown boy made good. He earned his own living on his own terms, was fanatical about baseball and wrestling, brought his reefer with him everywhere he went, and loved Texas as much as he loved music. A fast-talking cosmic cowboy, Sahm performed and recorded prolifically for more than fifty years, until his death on November 18, 1999.

"The more you find out about Doug Sahm, the more impressive he is," said subversive guitar strangler/country-music aficionado Eugene Chadbourne. "Doug's an example of why music is interesting, and it's

not about accumulating large amounts of money. The guy was into so many styles of music—it's too much for most people. Going from psychedelic rock to country and then a heavy blues thing, he kept jumping around the whole time."

Sahm fan and Bottle Rockets front man Brian Henneman agreed. "The first time I heard Doug Sahm, our friend put on (1969's) *Mendocino*," Henneman said. "From note one, the sound of that record was cooler than anything that I'd been listening to. I wasn't even wise enough to formulate the reasons why I loved it. I didn't realize that it was country and blues and Mexican music and psychedelic rock. I didn't separate it like that yet. I was still digging Aerosmith."

Born November 6, 1941, Douglas Wayne Sahm began making Texas music at a very early age. With his parents' encouragement, he was touted as a child prodigy, playing a triple-neck Fender steel guitar. An instrumental wunderkind, he appeared on radio and television and went by the stage name of "Little Doug."

Something of a novelty, Little Doug appeared on the *Louisiana Hayride* radio show, played with local western swing bands, and opened for big-time country acts like Webb Pierce and Hank Thompson. In 1953, Little Doug appeared onstage with Hank Williams in Austin, just two weeks before the ill-fated singer's untimely demise.

By the time Doug was a teenager he was already a seasoned entertainer. His taste in music had evolved, revealing a brash eclecticism that would carry him for the rest of his life. A smattering of black blues bars on the East Side of San Antonio had a huge impact on Doug. Sneaking into the Eastwood Country Club near his home, the underage Sahm would watch and listen to mature R&B performers like T-Bone Walker, Bobby "Blue" Bland, Hank Ballard, and Clarence "Gatemouth" Brown.

Drummer Ernie Durawa met Doug in 1957 and gigged with him

sporadically over the next four decades. "We bounced around all of the clubs on the East Side," said Durawa. "That was our education, learning to play blues shuffles. We had a gig playing in a black band led by a tenor player named Spot Barnett at a club called the Ebony."

Attending high school by day and performing at night, Sahm navigated San Antonio's multilayered racial structure. At a downtown nightspot called the Tiffany Lounge, Doug received a quick introduction to the sporting life, as well as greater exposure to the city's musical melting pot.

Add to this the sonic power of the Chicano-dominated West Side, where shootings were common and a breed of rough-and-tumble musicians were getting their start. The brusque mixture of white, black, and Hispanic culture was a natural part of life in downtown San Antonio and it became the central component of Doug Sahm's sound.

Doug made his recording debut in 1955 but it took a few years for his local appeal to take hold. Now leaning toward San Antonio's Hispanic "West Side Sound" replete with a bruising horn section, Doug enjoyed regional success on the Harlem record label with the Little Richard–inspired screamer "Crazy Daisy."

The nascent rock 'n' roll that Sahm played was a wild hybrid of youth, Texas bravado, and American roots music. And by the time Doug Sahm & The Mar-Kays (featuring tenor saxophonist Rocky Morales) hit it big in 1960 with "Why, Why, Why," his celebrity within San Antonio's Chicano population was well established.

As a hip-shaking-gone-cat-rock-'n'-roller, Doug provided South Texas with a local alternative to the growing number of entertainers inspired by Elvis Presley. During this time, he became aware of a Tex-Mex recording artist called El Be-Bop Kid. The Kid was born Baldemar Huerta but became forever known as Freddy Fender. Like so many musicians he met during those San Antonio days—Barnett, Morales, and Durawa

among them—Doug would pull Fender into his whirlwind for decades to come.

Sahm also befriended a young San Antonio drummer named Johnny Perez, who would become an original member of the Sir Douglas Quintet. "When I met Doug, he was playing with Rocky Morales at the Tiffany Lounge," said Perez. "Doug was playing rock 'n' roll, James Brown, blues and Top-40 stuff—a real mixture, especially for his age level. Doug was brilliant. He had a vision and he was destined to succeed because he had been putting records out from the time he was fourteen. He stayed at it until he finally bloomed."

The Sir Douglas Quintet was born of the British Invasion—and just as the Beatles and Stones captured the imagination of teenagers on both coasts, they inspired the racially mixed R&B groups in San Antonio, Texas.

Jack Barber was a friend of Sahm's since the 1950s and played bass for the Sir Douglas Quintet. He remembered things this way: "The type of music we played in San Antonio was rhythm and blues like Bobby Bland, with horns and a lot of chord changes. They had these 'battle of the bands' and everybody had to kick butt or you weren't in the clique. The Quintet came in 1964; Doug was ready to do something besides playing the local areas. He came up with the idea after the Beatles came out. He knew Huey could help us."

Enter Huey P. Meaux, aka "The Crazy Cajun." A self-styled hustler of dramatic proportions who owned a barbershop in Houston, Meaux had his fingers in countless pies and made business contacts in the course of his work behind the barber's chair. Just why Sahm was eager to make records with the Crazy Cajun is something to consider, but their alliance proved to be successful beyond all expectations.

The key to their success lay in the hands of yet another San Antonio musician, a childhood friend of Doug's by the name of Augie

Meyers. Augie owned a Vox Continental organ (the only one in Texas at the time), and it became the absolute jewel in Sahm's ornate musical crown.

"Doug and me grew up together since we were ten years old and met at my momma's grocery store when he was looking through all the baseball cards," recalled Meyers. "I had my band and he had his band until we were in our twenties, then we got together for the Quintet. I opened a show for the Dave Clark Five and Doug's band came on afterward. Huey Meaux was there, trying to see what all the commotion was about with those English bands. Huey said, 'Augie, you got long hair and Doug, you got long hair—you all got to put a band together. Let's get an English name and go with it.' So that's what we did, but it was really hard to pull off because we had three Mexican guys in the band."

Masquerading as an English group with Prince Valiant haircuts and a quasi-British moniker, the Sir Douglas Quintet's first single, "Sugar Bee," did not receive a royal reception. It was their second 1964 effort, "She's About a Mover," that broke things wide open. Powered by Sahm's bluesy voice and Meyers's monomaniacal Vox pulse, "Mover" borrowed from the Ray Charles song "What I Say" but added the demented context of infectious greaser garage rock.

"We were doing things different way back when," said Meyers. " 'She's About a Mover," was a polka with a rock 'n' roll beat and a Vox organ. I played what a bajo sexto [a 12-string bass guitar] player in a conjunto band would do."

Although their British facsimile eventually faded, Sahm, Meyers, Barber, Perez, and saxophonist Frank Marin were soon touring America, opening for the Rolling Stones, James Brown, Otis Redding, and the Beach Boys, as well as appearing on television programs like *Hullabaloo* and *Shindig*.

It was around this time that Sahm met Bob Dylan. Bob insisted that he wasn't fooled by Doug's English facade on *Shindig*, and the two men developed a strong affinity thanks to their mutual appreciation for roadhouse blues, country music, and vintage R&B. Like so many others, Dylan would encounter Doug repeatedly over the years.

Meanwhile, the SDQ released more singles, and eventually scored again with a song written by Freddy Fender called "The Rains Came." Unfortunately, the group's momentum came to a halt after the band was arrested in Corpus Christi for possession of marijuana. Pot laws in Texas were unusually harsh during this time, and the bust did not bode well for the SDQ.

Not to be deterred, Meaux released the band's first full-length LP, *The Best of the Sir Douglas Quintet*, in 1965. The "Best of" title was a confusing claim for an album debut, but Meaux was unsure of the Quintet's future after the pot bust. So unsure, in fact, that he designed a cover shot featuring the band in silhouette in an attempt to extend their *faux*-British mythos. Unfortunately, the anonymous group photo also allowed Meaux to package phony versions of the Quintet for concert appearances while Sahm and the boys were indisposed.

Musician Steve Earle grew up in Texas and he remembered the impact of the real SDQ. "I first became aware of Doug as soon as I started paying attention to music because I'm from San Antonio, and the Quintet were *the* local heroes," said Earle. " 'She's About a Mover' happened while I was in grade school and I was pretty plugged in to it. In those days, there were local teen shows and the SDQ did all that stuff. Then they moved to California."

According to Doug, there were only two Texas bands with really long hair in the mid-'60s: Roky Erickson's 13th Floor Elevators and the Sir Douglas Quintet. More or less set up for the bust in Corpus Christi and harassed for his rebel-hippie stance, Doug decided to escape the

repressiveness of San Antonio and moved his family to the more toler-
ant environs of northern California. Living in Salinas and spending
much of his time in San Francisco during the '60s heyday, Sahm im-
mersed himself in the liberated lifestyle of the Haight-Ashbury elite.

"When I met Doug, his little son Shawn walked in while we were
talking and Doug handed him a joint," said Denny Bruce, a producer
and manager who went on to run the Takoma record label. "It was the
first time I had seen an adult give pot to a kid, and Shawn took a toke and
his eyes started spinning. Doug was a real free spirit and probably took
advantage of the hippie thing. He liked the notoriety and the acclaim."

Reforming the Quintet without Meyers (who stayed in Texas), Doug
began his most adventurous musical period. Performing at the Fillmore
Auditorium and the Avalon Ballroom with the likes of Big Brother &
the Holding Company, Quicksilver Messenger Service, and the Grate-
ful Dead, Sahm became close with Jerry Garcia and partied heartily
with fellow Texpatriots like Chet Helms and Janis Joplin. To some,
Doug's enthusiasm, versatility, and revolutionary ways were more syn-
onymous with San Francisco than many of the rock groups that actu-
ally hailed from the Bay Area.

Doug flourished in San Francisco, and he was featured on the cover
of *Rolling Stone* in 1968 and again in 1971. George Rains was a drum-
mer who had moved from Fort Worth and played with the SDQ during
this time. "Doug was such a promoter of San Francisco," said Rains.
"He considered himself a hippie, the whole thing of getting loaded and
free love. He felt it was just heaven, and for a musician, it was. That's all
he talked about, 'Man, you gotta go up to San Francisco.'" This type of
endorsement would become a familiar refrain for Sahm. As the years
rolled on, he'd bless one new "scene" after another, discovering groovy
situations in Austin, Amsterdam, and Vancouver (to name a few).

The first California album, 1968's *Honkey Blues*, was credited to

the Sir Douglas Quintet+2. The record showcased a little big band with horns, playing jazzy, experimental, and strangely psychedelic rhythm and blues. The music was undeniably brilliant, but it confused both his record company and his fans.

Eager for another hit to fuel his career, Doug reunited with Augie and his Vox organ. The SDQ's next album was *Mendocino*, and the title track fused Sahm's affection for California with the infectious groove of his reconstituted Quintet. *Mendocino* was an instant classic and it signaled a new era for the band.

Like others who have found true inspiration in the Sir Douglas Quintet, singer/guitarist Jay Farrar recalled the mercurial sound of *Mendocino*. "There is an elusive quality to it that drew me in and never let go," Farrar explained. "The ease at which Doug moved around and blended styles from Tex-Mex to Texas R&B to psychedelia and country are what kept me a devotee."

Subsequent albums by the California edition of the SDQ (*Together After Five* and *1+1+1=4*, both from 1970) were masterful, but Doug was homesick and ready to move back to Texas. The cover of his 1971 album, *The Return of Doug Saldana*, said it all.

"He's sitting on my front porch (in Bulverde, Texas) leaning back in a chair holding a bottle of Big Red," said Augie Meyers. "He owes me enchiladas for that."

For the uninitiated, Big Red is an all-the-sugar-and-twice-the-caffeine soda pop that's found in Texas and usually consumed by kids too young to know any better. Sahm enjoyed the stuff—in the old bottles—and the elixir probably took the edge off the copious amounts of weed he was smoking.

Hyperactive with or without Big Red, Sahm came home to San Antonio only to leave again. This time he moved to Austin, where he helped blaze the trail of so-called redneck rock.

Newly divorced and living down the road from the Soap Creek Saloon, Sahm grooved into another essential phase of his career. Between Soap Creek and the Armadillo World Headquarters, there was a wide assortment of cosmic cowboys hanging around. That posse included Jerry Jeff Walker and the newly arrived Willie Nelson, who was eager to reinvent himself after a decade of songwriting in straight-laced Nashville.

Texas troubadours like Michael Murphy dominated the Armadillo, but Doug established a weekly gig at Soap Creek and set about gathering his troops. Bassist Jack Barber moved up from San Antonio and George Rains followed Sahm from San Francisco. Old friends like Rocky Morales and trumpeter Charlie McBirney gave Doug the toughest horn section in Austin, reviving the West Side Sound.

In 1972, Doug was the irrepressible ringleader of a free Thanksgiving concert at the Armadillo, jamming all night with the Grateful Dead and Leon Russell. "The Dead had a show the night before at a big auditorium and they just opened up the Armadillo for Thanksgiving," recalled Doug's friend, Bill Bentley. "All those guys played. It was a typical Doug Sahm ball and he led the whole thing. People coalesced around Doug—musicians loved to be around him because he was so talented. That's what they got off on."

The Austin scene allowed Doug to be supportive of other musicians. By recording Freddy Fender's classic tune "Wasted Days and Wasted Nights," Sahm showed great empathy for a forgotten compadre who had been imprisoned for a microscopic amount of marijuana and withdrawn from the music business. Doug coaxed the singer out of retirement and secured Freddy a reassuring comeback gig at the Soap Creek Saloon.

Doug produced the single "Red Temple Prayer (Two-Headed-Dog)"/"Starry Eyes" for Roky Erickson. The troubled star of the 13th

Floor Elevators had fallen on hard times due to a combination of drug abuse and mental illness, and Roky needed Sahm's emotional and aesthetic support just to record those two songs.

In 1973, Atlantic Records honcho Jerry Wexler produced *Doug Sahm and Band* in New York City. Sahm's star-studded *Band* featured Augie Meyers, Dr. John, David "Fathead" Newman, an obscure accordion player named Flaco Jimenez, and the very famous Bob Dylan, who sang and played some guitar.

"I pulled it together," recalled Jerry Wexler. "I invited various musicians to the session but Dylan turned up on his own. Doug's presence in Austin was one of the factors that made it such an important center of music. There was the Armadillo, there was Willie Nelson's presence, but Doug was like the king in Austin."

Wexler had signed both Doug and Willie to recording contracts, but neither artist fared well on Atlantic. Of course, Nelson went on to great fame after leaving the label. Speedy Sparks, a roadie and sometime bassist with the SDQ, recalled Doug's influence on Willie. "Willie Nelson wanted that rock 'n' roll crowd, and Doug had them," Sparks said. "Willie would come out and watch Doug and figure out what Doug was doing. Willie got the hip rednecks, and then he won everybody else over. At first, Doug was the king, not Willie or Jerry Jeff or Waylon. It was Doug, mainly because he had that album with Bob Dylan."

Using leftover tracks from Wexler's sessions and some San Francisco recordings, Doug pieced together the 1973 album *Texas Tornado*. The bold impact of Doug's uninhibited Texas vision made a lasting impression on a number of musicians.

"*Texas Tornado* is one of the records that made it hip to play country music in Texas," said Steve Earle. "There used to be a dividing line between musicians that played pop music and the musicians that

played country. It was a social line, too. That whole Armadillo World HQ, Soap Creek Saloon thing in Austin, it changed Texas, at least for a while."

Doug's next record, *Groover's Paradise*, was an obvious homage to Austin, and his band included Doug Clifford and Stu Cook, the former rhythm section of John Fogerty's Creedence Clearwater Revival. Again, Sahm was making rousing, creative roots music, but his commercial success was dwindling.

The "New Wave" craze of the late '70s revitalized some interest in the SDQ. Elvis Costello and the Attractions keyboardist Steve Nieve used an insistent, roller-rink organ sound that traced directly back to Augie Meyers and his Vox. On the 1981 album *Border Wave*, Doug gave a playful nod to his pseudo-British roots, and included a cover version of the Kinks tune, "Who'll Be the Next in Line."

Between solo efforts and periodic Quintet reunions, Doug always seemed be able to pull together one more recording session and a tour to go with it. Living the life of a journeyman—like the country, jazz, and blues veterans he emulated as a youth—Sahm pushed on.

He was a perennial showbiz sparkplug and a gifted organizer, but Doug wasn't the best businessman. Denny Bruce managed Doug's career for a while and released three of his records on the Takoma label. Recalling Sahm's erratic nature, Denny said, "Doug pulled a lot of stunts in his life, financially. I'm not saying Doug screwed Augie, but there were so many times that he would take advantage of him. But just when you would count Doug out, he would come up and it would be like, 'Let's go! Get on the bus, Augie!'"

Part of Sahm's survival was linked to his enduring popularity overseas. After signing with a Swedish record label, Sahm went platinum with the crowd-pleasing tune, "Meet Me in Stockholm." Besides touring

Europe, Doug personally moved up to Canada, and then back down to Texas again—peppering his travels with a requisite number of baseball games, hard living, and eclectic musical encounters.

Doug remained a sports fanatic throughout his life. There were times when he would refuse to come out of his hotel room—even to rehearse for an important gig—when watching baseball on television. Doug declined to tour one fall season, just so he could stay home and watch the World Series.

"He liked so many different teams," said Doug's son Shawn Sahm. "To be a baseball scout would have been his dream. He had a Joe Di-Maggio baseball and an autographed menu from DiMaggio's restaurant. He would call me from all these training camps, 'Yeah Shawn, I'm hanging out with the Cubs!' He was very into baseball and to a lesser extent he was very into wrestling."

Denny Bruce made a trip to Yankee Stadium with Doug and guitarist Alvin Crow. "Bobby Murcer was on the Yankees, and he was from the same little town in Oklahoma as Alvin Crow," recalled Bruce. "Doug worked his way down to the bullpen and was leaning over and talking to [relief pitcher] Goose Gossage. He came back and said, 'Man, I knew that Goose got high!' They were talking about pot."

Whether gigging with the West Side Horns or the Texas Mavericks, Doug was never far from his San Antonio roots. But it wasn't until 1989 that his love affair with Tex-Mex and conjunto music came to full flower. Along with Augie Meyers, Doug reunited with Freddy Fender and Flaco Jimenez to form the Texas Tornados.

Several Texas Tornados albums and tours were to follow, highlighted by a GRAMMY award in 1991. "Doug was a real versatile guy and soulful, of course," said Flaco Jimenez. "He was a groover— a super groover—and he played a pretty good bajo sexto, too. There aren't too many Anglos doing that."

Besides marketing the Tornados to America's Hispanic population, Doug stayed busy recording down-home blues and jazzy R&B. Forever returning to those intricate blues shuffles and triplets he practiced as a youth in San Antonio, he continued to work with old friends like Jack Barber, George Rains, and Rocky Morales.

Doug's rapport with his sons Shandon and Shawn was musical as well. In 1990, Doug Sahm & Sons appeared on *Where the Pyramid Meets the Eye* (a tribute to Roky Erickson), and in 1994 the boys played on the SDQ disc *Day Dreaming at Midnight*.

Doug later recorded *S.D.Q. '98*, which included collaborations with the Austin rockers the Gourds. Amid the typical manic Sahm discourse, Gourds member Kevin Russell noticed a hint of melancholy. "He had a taste of fame back in the day, and I think he was always trying to recapture that," said Russell. "There was always a little bit of sadness about his best days being behind him. He wouldn't say that, but I got the feeling that was how he felt."

Journalist and friend Chet Flippo reflected on those past glory days, and Doug's crucial bond with Bob Dylan, "In many ways, Doug and Bob were flip sides of each other's personalities, which is why they were so musically compatible. Each perhaps secretly envied the other a little bit and hoped that some of that particular magic would rub off."

Doug's impact on Dylan is tangible; Sahm's counterpart, Augie Meyers, was the only musician to play with Dylan on both *Time Out of Mind* and *Love and Theft*, and Dylan's former guitarist Larry Campbell was a member of the SDQ during the '80s. Charlie Sexton also played guitar in Dylan's group, and Charlie grew up in Austin under the care of Speedy Sparks—where he'd often sit (on the bar) and watch Doug's band rehearse.

Doug died alone in a hotel room in Taos, New Mexico, where he'd

gone in hopes of regaining his health. He was complaining about pains in his fingers, arm, and chest. Although he contemplated visiting a doctor the night he died of a heart attack, Sahm chose to tough things out on his own. His final recording was a beautiful country album called *The Return of Wayne Douglas*, released posthumously thanks to Bill Bentley.

Joe "King" Carrasco is a Texas musician who emulated Doug and enjoyed some success during the "New Wave" years. Joe is absolutely clear on Sahm's vital contribution to Texas music. "Nobody that had ever come from Texas covered the whole cross section of what Texas was about except Doug," said Carrasco. "The biggest funeral they ever had in San Antonio was Doug's and the next one will be when Augie goes. That's a whole chapter of what's the best of Texas. Once these guys are gone, that's it."

Doug's lyrics have been quoted often over the years, but none as much as the refrain from his song, "At the Crossroads." I didn't think that I'd have to include these words when writing this story, but I changed my mind.

Doug Sahm sang . . .

You can teach me lots of lessons.
You can bring me lots of gold.
But you just can't live in Texas if you don't have a lot of soul.

That's it.

TAKING TIGER MOUNTAIN

Dark clouds loomed ominously over the renovated Frankenstein chateau high on top of Tiger Mountain. A crowd had gathered in front of the gate at the castle's entrance. It was an unruly mob. Some carried hand-painted signs, which they shook angrily. Others shouted foul epithets at the lone figure staring down at them from across the moat.

Baron Von Frankenstein sighed deeply and turned his back to the window. "Bastards," he muttered. "What's wrong, Master?" his faithful assistant asked. "Why do the townspeople come and torture us so? We have done them no wrong."

The baron sighed again and answered in a weary voice, "It's all about the *Music for Airports* project, Igor. These boorish villagers seem to think that Eno's original creation is not something to be meddled with. Purists take issue with our rejuvenation of an entity that has remained frozen for so long. They say it is a crime against nature or some such nonsense."

Igor gaped quizzically at his patron, "You mean to say that they seriously object to a humanized interpretation of this complex sound sculpture? But, Master, it's a meta-classic! Eno created the piece decades ago

and it was even installed at the Marine Terminal of New York's La-Guardia Airport in 1980!"

"All true," the Baron answered. "But that was only until the airport employees complained the ambient-minimalist soundscape was driving them crazy and demanded that it be stopped. There still appears to be confusion about whether *Music for Airports* is background Muzak, a profoundly artificial musical milieu, or something even more vital. Remember, Eno didn't even compose the original score as much as he designed it from a few simple notes and the serial organization of variable tape loops that didn't quite match up. It was a groundbreaking elaboration on the spatial dimension, one that utilized silence, piano, synthesizer, a female voice, and most importantly, the technology of the studio."

Outside, the crowd had doubled in size and was struggling to break through the front gate. A number of townsfolk had lit huge torches that they held high above their heads as they flailed at the entranceway. Far above the growing din, Baron Frankenstein and Igor faced each other, alone in the castle's main tower.

The baron showed Igor an index of metals and some arcane, computer-generated diagrams on the back of an old, battered album jacket. "Years ago, the Manhattan group Bang on a Can transcribed Eno's ambient epic and developed a score to be played on conventional instruments," the baron intoned. "Instead of Eno's original treatment of an electroacoustic atmosphere using nondevelopmental forms that manifest themselves mathematically in low-frequency drones and a vibrant set of upper harmonics, we can now hear a contemporary chamber ensemble playing these long, calming notes like everyday music."

The baron continued his lecture to his faithful assistant, "What those common fools outside don't understand is that *it is* music, heav-

enly music. Eno was barely acknowledged as one of the more influential musical thinkers of his time, but in the 1970s he used the concepts of Satie, Cage, and Stockhausen, and made them accessible to a rock audience. Eno's shift of emphasis helped to pioneer the whole ambient strategy as we understand it today!"

Down below, the horde of outraged villagers had broken through the front gate and swarmed inside the castle. Fire was spreading throughout the lower quarters of the massive structure, devouring everything in sight. Chaos and destruction reigned as huge flames shot up the staircase and surrounded the penthouse laboratory.

Inside, Igor shifted uneasily as shouts of anger echoed through the fortress. "Yes, Master," he said nervously. "As long as our rendition is faithful to Eno's original masterpiece, it's an honorable effort, even if Eno didn't create ambient music with real instruments in mind—it deserves to have life and be performed like any other composition."

The laboratory door burst open and raging townspeople flooded into the room. Someone produced a rope with a noose tied at one end. Baron Von Frankenstein shouted to Igor as the maddened crowd carried them off, "Someday they will see that we were ahead of our time! Can't these people just accept a meditative piece of music divided into four discrete movements? Is nothing sacred before and after science?"

A week later there was still faint black smoke rising from the rubble that had once been Castle Frankenstein. The noonday sun was shining as two young boys approached the ruins and began picking through the debris.

"Man, that baron guy sure did go out kicking and screaming, didn't he?" said one. "That's how lynchings are, dude," said the other. "Hey, look—I think I found something!"

Together, the lads examined a charred document dated 1921—signed by a man named Varèse. One phrase remained legible.

It read:

The present-day composer refuses to die!

THE SWELTERING GUY

Adam Coil was feeling panicky. It seemed like he'd been walking for an eternity and the scorching sun still loomed high above him. Coil had smoked the last of his kif to dampen the pain in his legs and now he was parched like the desert that lay before him. Choking back his anxiety, he lurched forward desperately until a sudden sandstorm mercilessly beat him to his knees and then . . . only blackness.

When Adam awoke, he found himself in an earthly paradise. The smell of incense wafted thick in the air and fresh fruit sat alongside a tall pitcher of cool water. His filthy clothes were gone and his body had been washed, oiled, and scented. Wrapped in warm linen and supine beside a lotus garden, even his feet smelled of flowers.

But it was the haunting music that captured Coil's attention—he'd never heard the likes of it. His head swelled with droning reverberations once chronicled by our distant forebears from the East. Centuries melted away in a few lush seconds as wordless chants, tablas, tamboura, Tibetan singing bowl, oud, and hammered dulcimers all coalesced into an intoxicating drift of tantric exultation. Immersed in a swirling delirium, Coil was traveling the medium of sound itself when he suddenly heard the laughter of several young women.

"It looks like you're really into the music," said a petite beauty with dark, fluttering eyelashes. "It's these earthen soundscapes that use ancient drums and exotic stringed instruments—I play the CD when I teach my yoga class. Hey, you really did spend too much time in that tanning booth, didn't you? Drink some more of that Evian and I'll tell your trainer that you're back among the living."

"Damn," thought Adam. "If I don't get out of this health club by six o'clock I'm going to miss *Seinfeld*."

THE BALLAD OF JOHN HENRY
AND THE WHEELS OF STEEL

The John Henry Trio played every weekend at the Spotlight Lounge in Portland, Oregon. Not many folks remembered John Henry, but he'd worked with some jazz stars in the late '50s and early '60s. Back then he was a wunderkind, a teenaged rhythm whiz from Philadelphia who unleashed the history of the drums every time he picked up the sticks.

But drugs took John Henry away from the music business. A couple of busts in Southern California had led to prison time, which kept him out of circulation for nearly ten years. When John began his comeback, many bandleaders wouldn't hire him because of his troubled reputation.

John never blamed anyone for his difficulties, except himself. He took the long hard road toward recovery and remained humble—hanging out in jazz clubs and playing whenever he could.

John concentrated on regaining his chops, which had eroded during his time in the slammer. Unlike some other jazz cats, John didn't play music while in jail. Instead, he had devoted himself to his recovery and helped other addicts in their efforts to remain sober.

He arrived in the Pacific Northwest without any contacts, but he

met keyboard player Luke Smith, who led a grooving organ trio. Luke hired John and they enjoyed a long association, playing together for fifteen years. Then, Luke retired. But John kept the trio going—thanks to the band's weekend gig at the Spotlight Lounge.

It wasn't much of a gig at the Spotlight, but John did just what Luke had done before him; that is, hire musicians who would play for very little cash. John was just able to make ends meet with his earnings and avoided getting a day job.

For the last couple of years, John had been playing with young twin brothers, Matt and Tom Atkins. Matt had his own B-3 organ and Tom was a sharp guitarist straight out of the Wes Montgomery mold. The twins were barely twenty but they admired John's talent and adored his history. Matt and Tom worked cheap, and the boys were constantly bugging John for stories about the old Fifty-second Street, when jazz giants walked the earth.

Things were going well for John. Most importantly, his music was starting to cook like it did in the '60s. The money from the Spotlight wasn't great but it came in regular—cash every Sunday from club owner Mickey Sherman. Mickey and John had known each other since the drummer first moved to Portland. John didn't always like Mickey's high-pressure style, but they had a straightforward business relationship.

John was also in great physical shape. He'd gotten into exercise and diet while in prison, and after decades of sobriety, John understood that physical fitness helped his art more than drugs ever could. He was happy just playing live music and passing on his knowledge to younger artists who valued classic jazz traditions.

Then, out of the blue, Mickey Sherman gave John his walking papers. Mickey explained that it was nothing personal, but simple economics—he'd been letting this DJ work for free, and "tha Kid" was

drawing more people to the club every Wednesday than John brought in on the weekends. Mickey said he had to change with the times. John's crowd of middle-aged divorcées and boozy out-of-towners just wasn't happening. With "tha Kid" and his turntables Mickey could cut costs, make more money at the bar, and even charge admission at the door.

So, Mickey gave John one month's notice, after which the Spotlight would feature DJs on the weekends. When he got the bad news, John's first impulse was to get high. Thirty years sober and he still craved the drugs that he had once used to escape his problems. He was sixty-three and someone one-third his age was taking his job. The thought of being replaced by a kid and his turntables didn't seem fair.

Then, John had an idea and he made a proposition to Mickey, "Before it's all over, how about a face-off?" It was a challenge—John against the DJ—one-on-one at the club and may the best man win. Mickey could pick the judges or have the audience decide. But, if John could beat "tha Kid" in a cutting contest, would Mickey let him keep his weekend gig? Mickey loved the publicity angle for the club. "You may just have something there," he told John.

And so it came to pass that there would be a battle for the weekend engagement at the Spotlight Lounge. Mickey brokered an agreement between John Henry and "tha Kid" and went to work billing the contest as "man versus machine." Even though they'd been working at the same club for over a year, the rivals had never come face-to-face and were completely unfamiliar with each other's music.

The rules of the contest were simple: John and "tha Kid" would each get four minutes to perform in alternating turns. Continuity from one segment to the next was essential and each player would have to pick up the rhythm from where the other left off. It would go

back and forth like that until somebody quit or was obviously defeated.

Two men enter—one man leaves.

Word of the cutting contest spread among local musicians and club kids as well as the few older patrons who still frequented the Spotlight. One of the local newspapers ran a story on the upcoming battle, picking up on Mickey's "man versus machine" theme. The piece described how a "modern-day John Henry was going to compete against a DJ and his wheels of steel."

Soon, people were debating the contest on the Internet. Some folks began betting on the outcome and others just headed to Portland in support of their favored contestant. Hip-hop cliques from New York made plans to meet their West Coast counterparts at the Spotlight.

Turntablists from Seattle and Vancouver also made plans to attend, as did some military drum corps and second-line rhythm masters transplanted from old New Orleans. In solidarity, unemployed jazzbos from Los Angeles arrived to protest another one of their own being phased out of a job.

By this time Mickey Sherman had a lot more going on than just the contest between John Henry and "tha Kid." The club was booked solid for the two weeks leading up to the face-off. Several attractions were scheduled for each night, including guest DJs, jazz bands, and after-hours jam sessions. Mickey even allowed some drum circle kids to camp out in the Spotlight's parking lot.

Meanwhile, John was preparing for the upcoming battle with a new health regimen. He was jogging eight miles a day and drinking massive amounts of carrot juice. Finally, he eliminated all remaining junk food from his diet.

And for the first time since he was sentenced to prison, John's telephone was ringing. A couple of old pals from California called to say

they were coming to Portland for the "main event." John heard from other people whom he hadn't spoken with in twenty years. "I thought you were dead," said one. "Not yet," he laughed. John even did a phone interview with a writer from a national jazz magazine.

John went to hear "tha Kid" spin records that Wednesday and felt sure that he could hold his own against the DJ. Still, he had a newfound respect for the art of the turntable. He saw that the youngster was really talented, not just some punk playing records with a dance beat.

John saw a lot of himself in the young man, not all of it good. The DJ was at the center of a party scene and was clearly using drugs. John wanted to take "tha Kid" aside and warn him, but decided that it wasn't the proper time for an intervention.

He left the club that night with a sense of foreboding—something didn't feel right. But the week of the showdown had arrived and the wheels (of steel) were in motion. People were arriving from out of town and the club was buzzing with activity day and night.

Then John had lunch with a bassist from L.A. and was surprised when a former drug buddy showed up as well. It took John less than a minute to discern that old Ike was still using. Ike had brought his saxophone and said that he was looking forward to watching John cut "tha Kid" down to size. Memories of the old days filled his head and he fought off the urge to get high. John finished his lunch quickly and went straight home.

He had remained incognito the previous week, but when John returned to the Spotlight the next Wednesday, a young drummer recognized him. Soon he was surrounded by three generations of musicians and people were buying him drinks. John stuck to his nonalcoholic beverage, but felt himself slipping back into a mind-set he'd abandoned years before. Old Ike appeared at his side and asked if John wanted to "take a break." It took all of his willpower to refuse.

Meanwhile, action on the bandstand was heating up fast. DJs were cutting and scratching "rare groove" recordings, and the dance floor was mobbed. People were laughing and drinking, and there was a line just to get into the club. After the last DJ stepped down, a hot little jazz quartet took over. Ike and another saxophonist joined the band onstage for a lengthy version of Eddie Harris's "Freedom Jazz Dance." The crowd cheered as the musicians traded riff after riff.

Then one of the DJs jumped back up behind the turntable and started playing beats along with the jazzmen. The acid-jazz-funk-jam party was still going strong when John finally left the club at three in the morning. Somebody had called the fire marshal, but Mickey must have paid off the right people because the club stayed open well past dawn.

So it went on each night, with dancing and jamming and the breaking of old boundaries between jazz and DJ culture.

John Henry felt seduced by the scene at the Spotlight. All week long he nursed his carrot juice, spoke to new admirers, and met with old friends. John flirted with the young girls and watched quietly as "tha Kid" got totally wasted, partying with a different crowd every night.

Was John Henry worried about "tha Kid" or merely jealous? It was hard to say. John certainly envied his youth. It was tough feeling old while watching his immature rival glide recklessly through the club. And as John's frustration mounted, his old temptations were also growing stronger.

The night of the contest finally arrived. Of course, the Spotlight was packed, but the audience was different than it had been during the week. There was a new seriousness in the room and the spectators seemed tense. Besides media representatives and curiosity seekers, the club was filled with musicians, DJs, and hard-core rhythm fanatics.

Every table had been reserved in advance, and there was some heavy betting action near the back of the bar. Mickey Sherman himself was working the door.

It was almost ten o'clock and the face-off was about to start. Someone had been playing a mix-tape, and the room was rocking with sounds of "The Chase," a famous tenor battle from 1947 featuring Dexter Gordon and Wardell Gray.

The music faded as John Henry and "tha Kid' took their places. John made some last minute adjustments to his drum kit while the DJ tested the sound on his headphones and primed his turntables. Then Mickey Sherman walked up, grabbed the microphone, and addressed the crowd:

Ladies and gentlemen, you all know why we're here. This is a matter of honor that could only be settled on the bandstand. You're about to witness a groundbreaking competition between two highly talented individuals and the winner will have the privilege of providing weekend entertainment at this fine establishment. It may take all night so let's not waste any more time. In this corner, behind the drums, wearing a dark blue suit is Mr. John Henry. And in this corner, with not one but two turntables and wearing a white bandana is "tha Kid." They're both Spotlight favorites so let's give them a real big hand and settle in for an evening to remember—the battle of the big beat—man versus machine—the lowdown showdown of the twenty-first century. Ladies and gentlemen—John Henry versus "tha Kid"!

With that, Mickey Sherman took a large coin out of his pocket, looked over at John Henry, nodded, and flipped the coin high in the air. "Heads," John said. "Heads it is," cried Mickey. John looked over at

"tha Kid" and gestured for him to go first but the young DJ declined. "Age before beauty," he said. "Go ahead, old man."

John forced a smile and looked around the room. Then he pulled out a set of knitting needles and began tapping his ride cymbal in a slow, deliberate motion. The audience was hushed and people were leaning forward, eager to hear John's opening communiqué.

John's intricate cymbal work grew into an insistent pulse and at the end of four minutes "tha Kid" took over. He threaded a slippery electronic rhythm in sync with the meter that John had established and deftly transformed it into a railroad beat.

He then dropped in a vocal track from a vintage folk recording. An ancient disembodied voice sang out:

> *John Henry said to his captain:*
> *You are nothing but a common man,*
> *Before that steam drill shall beat me down,*
> *I'll die with my hammer in my hand.*

Finally, "tha Kid" scratched the ghostly vocal track up and down, repeating the line with John Henry's name over and over and cutting back and forth to the part about him dying with a hammer in his hand.

John Henry took back the railroad rhythm and toyed with it. He rolled away on his snare drum, accenting the momentum with his cowbell, and pushing the locomotion until the DJ came right back at him using Elvis Presley's "Mystery Train" fused with a disco undercurrent.

The DJ morphed the railroad pulse into Leadbelly's "Rock Island Line" and added Duke Ellington's "Take the 'A' Train," all without missing a beat. John Henry grabbed the opportunity to take things

back to a jazzier terrain and referenced Ellington drummer Sonny Greer's performance on "Jumpin' Punkins" and segued into another Ellington showcase, "Perdido."

The sonic combat went far into the night, with John and "tha Kid" trading riffs, creating new licks, and generating quotes from the annals of rhythm and music. John Henry cited old jazz drummers like Warren "Baby" Dodds, Chick Webb, and Big Sid Catlett while "tha Kid" answered with Africa Bambaataa's "Planet Rock," adding the funky double-drumming of James Brown's Jabo Starks and Clyde Stubblefield, and an accelerated drum solo from "In-A-Gadda-Da-Vida."

With barely enough time to take a drink or go to the bathroom, the two battled intently, listening hard and maintaining the unbroken flow of their percussion discussion.

It was four A.M. when fatigue set in for both John Henry and "tha Kid." The Spotlight was still filled to capacity, but the strain was starting to show all around. "Play 'Misty' for me," one wise guy shouted. Another voice came from the back of the bar, "They shoot horses, don't they?"

Meanwhile, John's back was aching and "tha Kid" was having trouble with his eyes.

Then John noticed "tha Kid" snorting something during one of his breaks. John became angry, wondering how long he himself would be able to last without a little something extra. But the battle wore on. John Henry mixing triple-paradiddles and military marches and "tha Kid" cross-fading Sugarhill 12-inches with the original soundtrack to *Planet of the Apes*.

Neither John nor "tha Kid" had ever played so long without a substantial break, and the mood on the bandstand was getting mighty grim.

By six in the morning, most of the crowd was gone and John's back

felt like it was on fire. He was sweating profusely and his head was pounding. Whenever John stopped playing, his back would spasm and he became afraid that he might pass out. It wasn't the performing that was bothering John but the torturous downtime that he couldn't endure.

John Henry's pain was now beyond measure. He'd just completed a segment echoing the immortal press rolls of Art Blakey and couldn't bear the thought of stopping again. John remembered how Blakey could barely lift his arms near the end of his life—until he sat down to play the drums. Somehow, Art would always find the strength to play with brilliant energy and contagious enthusiasm.

John saw that his young opponent was still having troubles of his own: Besides the vision problem, "tha Kid" was running low on records and short on ideas.

So, when the DJ began his next portion of the face-off, John Henry didn't stop playing. Instead, he accompanied "tha Kid," who was scratching out an inverted rhythm over a dub version of Cher's "Believe."

At first "tha Kid" was concentrating so hard that he didn't even notice that John was playing along with him. When the DJ finally realized that John was drumming during his turn, he assumed that the old guy was trying to throw him off. He wondered if this should disqualify the jazzman.

But as tired and miserable as "tha Kid" was, he didn't want to win on a technicality. Even though he'd felt the elder's eyes judging him harshly for the past week, the young man had come to respect the old drummer. The DJ listened to John's counterpoint and jammed along with the beat he was laying down.

The four-minute rule was thrown out the window, and the two

men performed as if they were of one mind. Their newfound interplay reenergized the competition, and the rhythms ebbed and flowed. They traded cadences back and forth, playing faster and faster until the beats were virtually indistinguishable from one another. In near-telepathic communion, they emulated "The Drum Battle," a classic percussion performance by Gene Krupa and Buddy Rich.

Together, the pair made sounds that exceeded what either man could have done alone. The few spectators left in the audience were amazed, and one man held up a cellular phone so that his friends on the East Coast could hear the fascinating rhythms. The two players accelerated their tempo to an incredible rate, and then stopped cold at the exact same moment.

The contest was over, the outcome a draw.

As the last few onlookers staggered outside and squinted into the sunlight, John Henry, "tha Kid," and Mickey Sherman made their way to a breakfast joint around the corner. They excitedly discussed possibilities for future weekends and agreed that the contest had signaled new beginnings for them all. John even lectured "tha Kid" on his substance abuse. The young DJ promised John that he would curtail his indulgences and think more seriously about his future as a musician.

Finally, after scrambled eggs, toast, coffee, and much conversation, John slowly rose from the table. He was exhausted and needed some rest. The three promised to meet again to sketch out a new plan for the Spotlight. John shook Mickey's hand and hugged "tha Kid" good-bye. To be sure, he drove home a winner.

But John Henry went to sleep that day and never woke up. He died of a massive stroke at 2:59 P.M.

And there wasn't a hammer in sight.

NEED FOR SPEED

I was driving south on Western Avenue in Chicago when I was pulled over for speeding. I realized I'd been going too fast as soon as I saw those little red lights flashing in my rearview mirror, but 20/20 hindsight isn't much of an asset in these situations. I cursed myself as I watched the cop speak into his radio and then amble up to my car. "So, where's the fire, son?" he said sternly.

Feeling desperate and dreading the prospect of another moving violation, I decided the only thing to do was tell the absolute truth. "Maybe this guy will see that I'm sincere and give me a break," I thought.

"I'm sorry, Officer," I said humbly. "I know that I was going way too fast. I just don't know what happened. I was listening to this song on the radio and must have gotten carried away by the music."

The policeman stared at my driver's license and registration as I desperately tried to gain his sympathy. After what seemed like an eternity he said, "Don't tell me. Were you listening to something like 'Radar Love' by Golden Earring?"

My jaw dropped. "W-w-why yes," I stammered. "I was! But how did you know?"

The officer smiled with a hint of pride as he responded, "Oh, I can

usually tell by paying attention to a few details: how old the person is, where they're from, what kind of car they drive, those kind of things."

This intrigued me. For a moment I forgot my predicament and began quizzing the policeman about his theory on cars, cruising, and music. "Hell," he laughed. "If I had a dollar for every person I pulled over for speeding while listening to 'Hot Rod Lincoln' or some other damned car song, I could've taken early retirement and been down in Florida right now."

Feeling encouraged by his now-open demeanor, I tried a little sucking up in hopes of getting a pass for my own indiscretion. "I guess you're right," I said. "There must be a million great car songs that make people put the pedal to the metal. All those old rock 'n' roll tunes from the fifties—it must have started with Chuck Berry's 'Maybelline.' "

The policeman took off his hat for a moment and ran his fingers through his thick, gray pompadour. "No," he sighed in a nostalgic voice. "It was earlier than that. Jackie Brenston & His Delta Cats cut 'Rocket 88' back in 1951, and Johnny 'Guitar' Watson had a song called 'Motorhead Baby' on Federal Records about two years after that. Hank Williams wrote 'Lost Highway' even earlier than those two, but most folks don't care about old country music, R&B, or rockabilly anymore. The real problem started with all that surf and car music that came out of California in the early sixties."

With brazen confidence, I interrupted the officer's reverie to display my own knowledge on this subject. "I remember that—my college roommate was a total custom car fanatic and all he listened to was stuff like Jan & Dean and early Beach Boys records. It seemed like Jan Berry, Brian Wilson, a DJ named Roger Christian, and maybe three or four other guys in L.A. invented the whole musical genre."

The cop looked at me sideways. "True," he said. "Tom Wolfe captured the entire hot rod/custom car scene in his 1965 essay 'The

Kandy-Kolored Tangerine-Flake Streamline Baby.' The only thing Wolfe didn't analyze was the music that those kids listened to. There were countless tunes written about cruising, chop-tops, coupes, dragsters, fuel injection, and the like."

By this time, I was sure that the cop was going to forget the ticket and let me off with a warning. Jokingly, I said, "I can't believe I'm one of those guys who gets pulled over while listening to 'Radar Love,' how embarrassing."

The cop laughed. "Don't feel bad, you could have turned out to be the dork who gets nabbed singing along with the Doobie Brothers' 'Rocking Down the Highway.' "

"Wait!" I shot back. "What about the dudes cruising to War's 'Low Rider' or Canned Heat's 'On the Road Again'?"

"Well," said the cop. "Those types usually aren't speeding, but we sometimes get them for marijuana or open container."

I couldn't believe it. Here I was having this great conversation while other drivers were slowing down, looking at us, and assuming that I was in trouble. In my excitement I began babbling a mile a minute about songs that mentioned highways, Mustangs, Cadillacs, Fords, GTOs, Cameros, Corvettes, and Thunderbirds.

Suddenly, the cop wasn't laughing anymore. I'd gotten carried away again and didn't even realize it. It was obvious to him that I had no self-control.

"I'm going to have to issue you a ticket, sir," he said coldly. "Just remain in your car and I'll be back in a few minutes."

As I sat in stunned silence, Bo Diddley's "Road Runner" came on the radio. The DJ had been doing some theme-oriented programming—and I was just another statistic.

RESPECT DUE

Are you getting the spirit in the dark?

Some works of art are born from inspiration, but even when the agenda of commerce intercedes, the results can still be compelling. It's common knowledge that Aretha Franklin was the most talented daughter of Reverend C. L. Franklin, a popular, charismatic, and influential Detroit preacher who recorded sermons for Chess Records in the 1950s.

Young Aretha toured the country with her father and recorded sacred music well before making her first mainstream gesture. For that, she moved to Manhattan in 1960. There, she took dance lessons, received vocal training, and signed a contract with the great John Hammond at Columbia to make "pop" recordings.

But after nine albums with Columbia, her crossover dreams remained unrealized. John Hammond had produced some artful sessions with Aretha, but his successor, Irving Townsend, seemed unable to tap into Aretha's deep gospel-soul-blues roots. This drove her into the waiting arms of producer Jerry Wexler at rival Atlantic Records in 1967.

Atlantic had a glorious history working with black artists, recording everyone from Professor Longhair to John Coltrane and Ray Charles.

With her earthier side well accommodated at Atlantic, Aretha garnered a number of Top 10 singles and albums on both the R&B and pop charts. Of course, Atlantic was seeking even wider acceptance for Aretha and remained eager to find new ways to increase her record sales.

Considering the "secularization of gospel music" as a commercial enterprise to begin with, Franklin's 1971 performances at the rock-oriented Fillmore West should have been no surprise to anyone. Back then (as now) the record-buying public was youth-based, and this included the teenagers who were drawn to the Fillmore West Auditorium in San Francisco.

But in 1971, white kids, even the hippies, just weren't being exposed to the soul revues of James Brown, Wilson Pickett, or Aretha Franklin. In the weeks before Aretha played at the Fillmore, typical shows featured the countrified jams of the New Riders of the Purple Sage and the hard rock grind of Steppenwolf.

The prospect of winning the hearts and dollars of the love generation outweighed any fears of an audience rejecting Lady Soul. Having enjoyed a bounty of success with songs like "Respect" and "Chain of Fools," Aretha had already ascended to the status of soul diva and was simply looking to expand her fan base. Fillmore impresario Bill Graham maintained a progressive booking policy—he paired Miles Davis with the Grateful Dead that year—and was ready to bring in Aretha.

It was still business as usual when Bill Graham approached Jerry Wexler to have the Queen of Soul perform. For all Graham's enthusiasm, he was unwilling to meet Aretha's hefty performance fees by himself. "Bill Graham proposed that I bring her to Fillmore West," said Wexler. "However, Bill couldn't pay Aretha what she wanted so I made up the difference. Atlantic underwrote the shows but we got our money back because they were so well attended."

With the sum of $20,000 per show promised to Franklin's agent,

Ruth Bowen, Aretha and all of the other Atlantic players convened at the Fillmore West.

To maximize the return on their investment, Atlantic elected to record Aretha's performances, just as they'd done with jazzman Charles Lloyd a few years earlier. *Aretha Live at Fillmore West* is a memento of those concerts, carefully edited by Wexler and coproducer Arif Mardin after three consecutive nights at the hall.

The shows occurred on March 5, 6, and 7 with Bay Area heroes Tower of Power opening up for King Curtis and the Kingpins—who after their own funky set proceeded to back up Aretha in all her soulful glory.

Texas-born saxophonist Curtis Ousley was Atlantic's arranger/in-house bandleader who'd been called upon to recruit musicians that were superior to Franklin's regular touring band. His group, the Kingpins, was well suited to Aretha's expansive musical needs.

On their own, the band played soul-jazz versions of rock tunes like "Whiter Shade of Pale" and "Whole Lotta Love," as well as originals like "Memphis Soul Stew" and "Soul Serenade." Wexler taped Curtis's set those three nights, too, which Atlantic released as—you guessed it—*King Curtis Live at Fillmore West.*

Then, after their set, King Curtis and his Kingpins got down to the business of working it out with "Miss Ree."

Besides King Curtis himself, Aretha enjoyed the core support of guitarist Cornell Dupree, bassist Jerry Jemmott, drummer Bernard "Pretty" Purdie, and Billy Preston on the organ. Add to this pianist Truman Thomas, Pancho Morales on the congas, the Memphis Horns, and three female singers known as the Sweethearts of Soul.

Let's not address the guest appearance of Mr. Ray Charles—not yet.

Although the technology was primitive compared to our current

digital age, Jerry Wexler and Arif Mardin used every trick they knew to document Aretha's concerts. They parked Atlantic's mobile recording unit right outside the Fillmore and worked in tandem for an authentic live sound.

"I had Arif out in the truck while I sat with the sound engineer and mixed the sound inside," Wexler recalled. "When you do a live broadcast, the guy in the truck has to take what he gets. If you depend upon a house amplifying system, you better be there and get it right."

According to the late Arif Mardin, the recordings required a lot of editing, and condensing three live shows into a fifty-minute concert album was no small feat. "My goal was not to make a sterile mix with [just the] music," said Mardin. "I made the audience tracks part of the mix. I believe in the live mix. Usually, live albums sound sterile. I made the audience part of the band."

In the course of her time with Atlantic, Aretha had blossomed into a force of nature—playing piano and writing songs as well as singing up a storm. But Jerry Wexler was still unsure as to how Aretha would be received. "When we got out there, I had trepidation because [Aretha] had never been exposed to the patchouli crowd," said Wexler. "But I was astonished to see the certitude of response by the flower children. They responded to all the right things. They got it and it was tremendous."

After opening with a churning version of her biggest hit, "Respect," Aretha tells the crowd to relax, feel good, and let it all hang out. Then, with the Kingpins vamping away like a Saturday night party turned Sunday morning church service, Aretha promises the audience—and perhaps herself—"that when you leave here, you will have enjoyed this show as much as any that you have had the occasion to see."

Like King Curtis, Aretha wooed the "flower children" with funky renditions of tunes written by pop-rock artists of the day. In short order, she runs through Stephen Stills's "Love the One You're With,"

Paul Simon's "Bridge Over Troubled Water," The Beatles' "Eleanor Rigby," and Bread's "Make It with You."

Infusing soul into songs by Bread may have been questionable, but Franklin had already recorded contemporary material like Elton John's "Border Song" and was looking to connect with a younger/whiter audience. Closing out with Ben E. King's "Don't Play That Song" (her single at the time), the stage was set for the focal point of Aretha's show—some bluesy gospel soul.

Top 40 songs written by white rock artists dominated side one of Aretha's album, and those performances were recorded on the first night of her Fillmore run. The flip side, taken mostly from the final night, emphasized Aretha's own artistry: that of a soulful entertainer skilled at bridging sacred and secular music.

Seated at the piano she asks, "Does anybody feel like hearing the blues?"—and launches into her self-penned classic, "Dr. Feelgood."

"Dr. Feelgood" builds gradually, embracing the basic blues in a languid mood. The song grows in intensity with the Kingpins and the Memphis Horns grooving behind Aretha—all locked in sync. Franklin then begins to moan, scream, and shout in a near-carnal vocal exhibition, all the while encouraged by the Sweethearts of Soul.

Beyond passionate, Aretha's suggestive vocal cut through the Fillmore's hippie haze, drawing the young crowd into the rocking dynamics of some vintage-styled, call-and-response, gospel-inspired R&B.

And then, slowly by way of the rhythm and the blues, Aretha brings her children home with "Spirit in the Dark." Her reverence is palpable, and the sanctifying education of Aretha's grand anthem transforms the audience into a congregation and the Fillmore into church. This song is nearly as sexual as "Dr. Feelgood" and when Aretha sings, "Are you getting the spirit, getting it in the dark?" you know to what she's testifying.

The dramatic performance of "Spirit" was a triumphant climax to Aretha's shows at the venue. "Aretha captured the Fillmore," remembered Arif Mardin. "Bill Graham was a big fan of Aretha, [the Fillmore] was a rock Mecca, and she just captured the audience. It was an incredible, electrifying performance."

How do you top that? Trust Aretha to receive some divine intervention on the road to pop's Promised Land. "I discovered Ray Charles!" she exclaims. In a spontaneous moment, Aretha brought gospel-soul icon Ray Charles onstage for a reprise of "Spirit in the Dark." Their duet is exciting, but according to Wexler, the golden voices were surrounded by chaos.

"Yeah, that was an accident," Wexler recalled. "Nobody knew Ray Charles was there and when he came out onstage it was one big ball of confusion. They started to vamp on the "Spirit in the Dark" and couldn't get it together. Finally it had a semblance of agreement, but it was an unplanned mess and we had to do some very careful editing."

Brother Ray's presence is compelling, but his guest appearance barely made it onto the album. "Because Ray remembered the difficulties [onstage] I had a very difficult job getting his okay to release the record with his voice on it," said Wexler. "It took a lot of persuasion and argument and Ray Charles is not amenable to persuasion once he makes up his mind. So that was a difficult part."

Encoring with Diana Ross's "Reach Out and Touch (Somebody's Hand)," Aretha gives a nod to her old Detroit neighbors at the Motown Hit Factory. And reaching toward a commercially viable song by way of Miss Ross, one wonders what might have been if Aretha had signed her first contract with the budding Motown label rather than Columbia back in 1960.

Even if Aretha had scored with Motown, she would never have received the nurturing that she got from her Atlantic crew. Aided by the

flawless ears of Arif Mardin and engineer Tom Dowd, as well as the intuitive guidance of Jerry Wexler, Franklin matured into one of the greatest singers of her generation. And by turning church music into pop, she became one of the biggest soul stars of all time.

This live album, born from the dealings of an ambitious record executive and a resourceful concert promoter, turned out to be a milestone in Aretha Franklin's career. Credit goes to Aretha, of course, but in terms of taking care of business, you have to hand it to guys like Bill Graham and Jerry Wexler.

Respect goes out to the late Tom Dowd, who engineered so many great Atlantic recordings, but not this one.

Amen.

Jerry Wexler felt there was one more important point about the crafting of Aretha Live at Fillmore West. *He said, "In live gigs, the horns and the background voices almost always sound out of tune, but they're not. That's because certain voices in the group and certain voices in the horns are too prominent and you can't change it on a live broadcast. So we redid the horns and the voices in the studio using the same people. That's what's important; all they did was replicate their parts. We laid it over and it came out perfectly; there were no intonation problems but the trick was to use the Memphis Horns and the Sweethearts of Soul. So we called them back in; that's why it came out as good as it did."*

CLOSER TO HOME

"Grandpa, tell us another story about the old days, will you? Shannon and me were watching another *Behind the Music* on VH1. The episode was about a band called Grand Funk Railroad. They kept talking about how these Railroad dudes were always setting attendance records wherever they performed. We never even heard of them. What's the deal?"

"Grand Funk? You want to know about Grand Funk? Now that's a blast from my Detroit past." The old man smiled as he struggled to sit up in his easy chair.

"I was just a few years older than you when I first heard Grand Funk Railroad in the late '60s," he began. "Your uncle Carl was into Cream and Jimi Hendrix and he wouldn't let me hang around with him when I was a kid. Our other brother Alex liked the MC5 and the Stooges, and Alex was too cool for me as well. I needed my own group to idolize and that's where Grand Funk came in. They weren't as hip as those other bands, but they were what we called a 'power trio' and were really, really loud. They played long, endless songs that sounded great when we were smoking . . . uh . . . our Marlboros."

Grandpa's voice raced with enthusiasm as he continued with his story, "For some reason everyone hated Grand Funk, which made me love the group even more. Eventually, I found some other weirdos like me and we worshipped the band. We went to see them perform at least a dozen times and even called out to them by name—Mark, Don, and Mel. I must have worn out the grooves of their live record from listening to it so much. Hey! Would you believe that in 1970 a double album cost $5.98 and a concert ticket was only four bucks?

"In a lot of ways, I grew up with Grand Funk. They were the first band I knew of that spoke out against the war in Vietnam and Mark Farner was always warning us about hard drugs. Farner had the longest hair I'd ever seen, but as the years wore on he kept cutting it shorter and shorter, just like me."

At this point, Grandpa was trembling as he spoke, "By the mid-'70s, the band had gotten popular and it didn't feel very hip to dig Grand Funk any more. FM radio had become a big deal and hard rock was getting through to all sorts of people. Besides, the band started having hit singles with old R&B tunes like "The Loco-Motion," and "Some Kind of Wonderful," and all these little kids began listening to Grand Funk. The days of plodding, adolescent rock tunes like "Time Machine" and "Mean Mistreater" were over, and I stopped buying the band's records."

The old man paused in midsentence and got an odd, faraway look in his eyes. He muttered something about Mel Schacher's bass playing being "really, really heavy" and began singing the first verse of "I'm Your Captain."

Shannon turned to his older brother and said, "Great, you got Grandpa to have another one of his flashbacks. Are you happy now? It'll take him all day to get it back together and Mom is definitely

going to restrict us from our video games for the rest of the week. We better go out and buy some drugs so we don't die of boredom tonight."

"Grand Funk Railroad—now what kind of name is that for a band?"

DIMINUENDO AND CRESCENDO

I tried calling my good pal Harlan the other day. I needed some help with my computer and if anyone knows about computers, it's Harlan. Unfortunately, or perhaps fortunately, my friend was nowhere to be found. Instead, Harlan's voice-mail greeting confronted me.

"Hi, I'm not home right now," his voice explained. "This is Paul Gonsalves's saxophone solo from 'Diminuendo and Crescendo in Blue.' If you have heard this before, you may press pound now and leave me a message."

I smiled to myself as Paul Gonsalves's tenor blew through the wire into my ear. Harlan had come up with some wild phone greetings in the past, but this one was really too much. Now, you may be asking yourself what makes this bit of music so notable in the first place and I must say, I'm glad you asked.

You see, Paul Gonsalves played this particular saxophone solo with Duke Ellington's orchestra at the American Jazz Festival in Newport, Rhode Island, on July 7, 1956. Ellington, of course, was the undisputed giant of jazz who'd become enormously popular since first performing at Harlem's Cotton Club in the Roaring Twenties.

While immortal compositions like "Mood Indigo," "Sophisticated

172 - MITCH MYERS

Lady" and "Take the 'A' Train" sustained Ellington throughout the '30s and '40s, things had tapered off for Duke's big band, and their appearance at Newport was intended to be a comeback of sorts. Ellington had even written the "Newport Jazz Festival Suite" expressly for the occasion.

Paul Gonsalves was a journeyman musician who had played with Count Basie and Dizzy Gillespie before joining Ellington's caravan. His extroverted saxophone style was solid, coming out of the Coleman Hawkins's school of tenor players. While not nearly as famous as other tenor stars who had worked with the Duke (like the great Ben Webster), Gonsalves was still a well-seasoned jazzman.

That night, Ellington's introduction of "Diminuendo and Crescendo in Blue" was respectfully received by the Newport crowd but not identified as particularly noteworthy. Indeed, the song had been written nineteen years earlier and there was no indication that this performance would contain anything out of the ordinary.

The piece starts out with a few minutes of classic Ellingtonia, that is, Duke setting the stage with four jumping choruses on piano before the ensemble rolls in to fortify the main theme. After two more choruses by the Duke, and with a rollicking beat laid down by bassist Jimmy Woode and drummer Sam Woodyard, Paul Gonsalves stepped forward to perform his most memorable solo.

Gonsalves's segment begins conventionally enough and any number of tenor players could have played his first few choruses. Traditionally, three or four choruses by a notable soloist would be plenty for an Ellington composition, but this was not the case at Newport.

It was somewhere around Gonsalves's sixth steaming chorus that the crowd began to sense something special was occurring: during his seventh go-round a sophisticated lady (a platinum blonde in a black evening dress) jumped up from her box seat and began dancing wildly

to the rocking rhythm. Bear in mind that the festival was a somewhat elegant event and the commotion caused by Gonsalves's tour de force had the Newport security police more than a little concerned.

By this time, most of the crowd (seven thousand strong) was on their feet and cheering. Eight, twelve, fifteen muscular choruses and Gonsalves showed no signs of slowing down. At the very foot of the stage, Jo Jones (former Basie drummer appearing at Newport with Teddy Wilson) was pounding out his unbridled enthusiasm with a rolled-up copy of the *Christian Science Monitor*.

Backed by just bass, drums, and an occasional piano fill by the Duke, Gonsalves reared back even harder and played on. Veteran Ellington bandmates like Johnny Hodges, Cat Anderson, and Harry Carney were shouting their own special encouragement as Gonsalves boldly blew through a grand total of twenty-seven straight, groovin' choruses.

After almost seven minutes worth of a saxophone solo that shook the world (would you believe Rhode Island?), the beep indicating it was time to leave Harlan a message brought me back from a most nostalgic reverie. I had forgotten what I was calling about, and although I tried valiantly to think of something clever to say, I was stumped.

So instead, I sat right down and wrote myself this letter. Yes, Harlan wasn't around to fix my computer, but Paul Gonsalves sure did help out Duke Ellington on that fine day in Newport.

— *For George Avakian*

WORLD'S BIGGEST GONG FAN

I once interviewed musician Daevid Allen at a recording studio in San Francisco. He was an odd sort, with plenty of old stories to tell. Way back in the 1960s, Daevid was (briefly) a member of the wonderfully creative British band Soft Machine. But Daevid didn't stay with the Soft Machine and he ended up forming another psychedelic rock group, called Gong.

In his life, Daevid Allen has hung out with everybody from William Burroughs and Jimi Hendrix to Bud Powell, Paul McCartney, Syd Barrett, Keith Richards, Richard Branson, and a whole bunch of other famous people that he can't remember.

One famous person Daevid does recall spending time with is Sherman Hemsley aka George Jefferson of the '70s sitcom *The Jeffersons*. Sherman had been a jazz keyboardist before portraying George Jefferson on television, and his progressive sensibilities led him to appreciate the offbeat sounds of Daevid Allen and (Planet) Gong. Apparently, cosmic Gong compositions like "Flying Teapot" and "Pot Head Pixies" resonated with the TV star's psyche.

Years after David's encounter with Sherman Hemsley, the actor would go on to collaborate with Jon Anderson—lead singer of the

famous prog-rock group Yes. The Hemsley/Anderson production was called "Festival of Dreams," and supposedly described the spiritual qualities of the number 7.

Anyway, here is Daevid Allen's verbatim account of his sole meeting with certified Gong fanatic Sherman Hemsley:

It was 1978 or 1979 and Sherman Hemsley kept ringing me up, I didn't know him from a bar of soap because we didn't have television in Spain. He called me from Hollywood saying, "I'm one of your biggest fans and I'm going to fly you here and put flying teapots all up and down the Sunset Strip." I thought, "This guy is a lunatic." He kept it up so I said, "Listen, can you get us tickets to L.A. via Jamaica? I want to go there to make a reggae track and have a honeymoon with my new girlfriend." He said, "Sure! I'll get you two tickets."

I thought, "Well, even if he's a nut case at least he's coming up with the goodies." The tickets arrived and we had this great honeymoon in Jamaica. Then we caught the plane across to L.A. We had heard Sherman was a big star, but we didn't know the details.

Coming down the corridor from the plane, I see this black guy with a whole bunch of people running after him trying to get autographs. Anyway, we get into this stretch limousine with Sherman and immediately there's a big joint being passed around. I say, "Sorry man, I don't smoke." Sherman says, "You don't smoke and you're from Gong?"

Inside the front door of Sherman's house was a sign saying, "Don't answer the door because it might be the man." There were two Puerto Ricans that had an LSD laboratory in his basement, so they were really paranoid. They also had little crack/freebase depots on every floor.

Then Sherman says, "C'mon upstairs and I'll show you the Flying Teapot room." Sherman was very sweet, but was surrounded by these really crazy people.

We went up to the top floor and there was this big room with darkened windows and "Flying Teapot" is playing on a tape loop over and over again. There were also three really dumb looking, very voluptuous Southern gals stoned and wobbling around naked. They were obviously there for the guys to play around with.

[My girlfriend] Maggie and I were really tired and went to our room to go to bed. The room had one mattress with an electric blanket and that was it. No bed covering, no pillow, nothing. The next day we came down and Sherman showed us a couple of [The Jeffersons] episodes.

One of our fans came and rescued us, but not before Sherman took us to see these Hollywood PR people. They said, "Well, Mr. Hemsley wants us to get the information we need in order to do these Flying Teapot billboards on Sunset Strip." I looked at them and thought they were the cheesiest, most nasty people that I had ever seen in my life and I gave them the runaround. I just wanted out of there.

I liked Sherman a lot. He was a very personable, charming guy. I just had a lot of trouble with the people around him.

After completing this essay, I ran the finished text through a computerized spell check. Upon encountering Daevid Allen's first name, the "(Word Services) Apple Events Spellswell" instructed me to replace *Daevid* with the word *teapot.*

Somewhere in Silicone Valley, a very clever Gong fan is laughing.

WHAT CAN YOU DO
THAT'S FANTASTIC?

Frank Zappa died on December 4, 1993. He was a relentless com-
poser, guitarist, and bandleader and fashioned one of the most prolific
musical careers of the twentieth century. Since his untimely passing,
recognition of Zappa's cultural contributions has increased exponen-
tially. Besides numerous books, CDs, DVDs, and websites, there have
been tribute bands, repertory groups, and entire festivals dedicated to
Frank. Even his classical compositions are now performed the world
over.

In addition to music, Frank made political inroads, developing a
rapport with the government of Czechoslovakia and reaching out to
businesses in the Soviet Union. At home, his civic-minded commentar-
ies on the First Amendment reached their apex during his notorious
censorship battles with the Parents' Music Resource Center (PMRC)
and the "Washington Wives" (organized by Tipper Gore). He also
promoted voter registration and considered a bid for the presidency in
1991.

Until his final concert tour in 1988, which was cut short due to per-
sonnel problems, Frank was a certified road dog traveling the globe
with different groups and sidemen. While Zappa created solo works

using the Synclavier and even employed entire orchestras upon occasion, the bulk of his music was developed with and for his rock groups—in rehearsals, in the studio, and on the road.

Zappa's accomplishments as a composer and guitarist can't be overemphasized, but his role as a bandleader distinguishes him from other pop artists and invites comparisons to veteran jazz conductors. Much like Miles Davis, Frank oversaw a constant changing of sidemen. Similar to Duke Ellington, he frequently composed ambitious works that showcased the individual strengths of his musicians.

"Frank would pick guys that wouldn't ever naturally work together," recalled bassist Tom Fowler. "You might have a guitarist who's a Hendrix freak and a keyboard player that loves Art Tatum; Frank figured out who should play when and orchestrated the band. He had the ability to figure out what they were good at and would utilize that in the shows. Even in the auditions, the question was 'What can you do that's fantastic?' That meant anything, musically or otherwise."

Zappa was unyielding in his efforts to retain absolute creative freedom. He developed his own production company early in his career, which helped him remain autonomous. He was usually strapped for cash and because of his many legal battles within the recording industry, he was compelled to pour his earnings back into the creative process. Touring was Frank's main source of income—a huge incentive to keep his band together.

Each stage of Frank's career was unique, but there was a bedrock consistency to his approach. Ranging from the satiric-rock-improvisations of the original Mothers of Invention to the passion-meets-precision of his later groups, Zappa composed, conducted, and performed music like no one else on the planet.

In the late 1950s, Frank was a teenaged outsider with a brilliant, profane mind. When he first began making recordings in his hometown

of Lancaster, California, he was already a rabid blues and R&B aficio-
nado who loved doo-wop as well as serious composers, like Igor Stravin-
sky and Edgard Varèse.

Frank started out playing drums, but switched to guitar and joined
a Pomona bar band called the Soul Giants. By that time he'd already
owned and operated a recording studio, written and conducted low-
budget film scores, and appeared on the *Steve Allen Show* playing the
spokes of a bicycle. It wouldn't be long before Zappa remade the Soul
Giants in his own image, that is, the outrageous image of the Mothers
of Invention.

Frank convinced the Soul Giants to abandon their Top 40 cover
tunes in favor of his original material and rechristened the group "The
Mothers" on Mother's Day, 1964. "We began introducing the songs
that we had learned from Frank," said bassist Roy Estrada. "We were
getting mixed reactions but we kept on playing them. Frank became
more of a bandleader later on because only he knew how he wanted his
music played."

Those early songs were satiric commentaries on the precarious
social and political climate of the '60s—breaking sexual taboos and
sporting provocative humor akin to Lenny Bruce—but performed by
coarse-looking long-haired men dressed in full hippie garb.

In an effort to maximize the Mothers' crude talents, Zappa insti-
tuted a schedule of rehearsals that became a template of discipline for
all his future groups. Original drummer Jimmy Carl Black remem-
bered the endless drill of the band's formative days. "We sounded
tight because we practiced all of the time," Black said. "Frank was a
hard bandleader and he demanded perfection whether he got it or not
and he was never totally satisfied."

One early incarnation of the Mothers of Invention consisted of
Zappa, singer Ray Collins, guitarist Elliot Ingber, and the Black/Estrada

rhythm section. This is the band that recorded the Mothers' debut, *Freak Out!* In the studio, Zappa augmented his quintet with two dozen session musicians including Les McCann, Mac Rebennack (Dr. John), and session pro Carol Kaye on 12-string guitar. Inside the double album's surreal gatefold cover, the liner notes included a credit that read, ALL SELECTIONS ARRANGED, ORCHESTRATED AND CONDUCTED BY FRANK ZAPPA.

Rock would never be the same. Devising radical tracks like "Who Are the Brain Police?" and the lengthy avant-garde performance of "The Return of the Son of Monster Magnet," Zappa combined social commentary and psychedelic improvisation in the studio. "How many people do something that's new and different?" Elliot Ingber remarked. "As a bandleader Frank was able to utilize our individual skills toward his vision."

Los Angeles rock denizen Kim Fowley was on hand for *Freak Out!*, reciting the composition "Help I'm a Rock." He remembered Zappa as an enterprising musician who directed the sessions down to the smallest theatrical detail. "Frank was all over the studio," Fowley said. "He was singing, playing, arranging; everybody was multitasking and Frank was conducting. There wasn't one bystander and if there was, they were on the recording, too. Everybody got utilized somehow."

As the '60s progressed, Frank and the Mothers became peripatetic. Looking for work, they moved from Los Angeles to Manhattan and back to L.A. again. In the course of their travels, Zappa pushed the group through a series of expansions and transformations, lending greater sophistication and more outrageous personalities into the mix. The band's theatrical stage show at the Garrick Theater in New York City made them the talk of the hippie/boho underground, resulting in an extended run at the theater before returning to California.

In concert, the band used makeshift props, destroyed household

vegetables, and molested female fans onstage. They fused Frank's biting social commentary with visceral humor, dynamic rock noise, neo-jazz squall, and spontaneous interactions with the audience. While subsequent albums like *Absolutely Free* were poorly marketed and misunderstood by the record-buying public, the group's reputation grew thanks to their provocative live shows.

The Mothers of Invention were one of the first rock groups to use two drummers, a move driven by Zappa's long-standing enthusiasm for percussion and odd time signatures. The additions of keyboardist Don Preston and saxophonist Bunk Gardner gave Zappa incentive to stretch his compositional approach. The new members were more familiar with progressive music: Preston had worked with jazzmen Charlie Haden and Elvin Jones while Gardner had performed with the Cleveland Philharmonic.

Unleashed, Zappa began composing more complex material to suit his expanded group. "At first, Frank couldn't do the far-out stuff because those guys [Roy and Jimmy] didn't have a clue of what he wanted," Don Preston remembered. "By 1967 we were playing things like 'Little House I Used to Live In,' which is a combination of 12/8 against 13/8. Nobody was doing that kind of stuff, especially in that kind of a context."

Putting a greater emphasis on Frank's written scores, the Mothers of Invention entered another rigorous stage of development. "We enabled Frank to open up a lot, being able to read music," Bunk Gardner said. "Everything was by rote for the rhythm section; that's one reason why some of the rehearsals were ten, twelve hours long. But I hadn't encountered that kind of musical challenge in my life and had to spend an awful lot of time practicing and memorizing—like twenty-four hours a day."

Zappa's intrepid experimentalism and countercultural satire led to

the band's landmark recording, *We're Only in It for the Money*. After that, Frank put out the ambitious double LP *Uncle Meat*, which featured his classical-rock-jazz opus, "King Kong." Both collections were unique concept albums that helped redefine the boundaries of underground rock and instrumental music in the 1960s.

Adding more band members, like classically trained percussionist Art Tripp, reed/keyboard whiz Ian Underwood, and untrained sax maniac Jim "Motorhead" Sherwood, the Mothers of Invention reached full flower blending greasy ethnic bar band machismo with progressive jazz chops, classical structures, rhythmic workouts, and free-form freak-outs.

The Mothers even jammed with the blind jazz saxophonist Roland Kirk. Albums like *Weasels Ripped My Flesh* showed a wide-ranging sense of adventure—with scorching pachuco blues and snarling rock guitar set alongside more atonal sound experiments.

In spite of Zappa's references to jazzman Eric Dolphy and classical composers like Debussy and Stravinsky, the Mothers were rarely perceived as a serious group. Guitarist Mike Keneally played with Zappa's band in 1988. He commented on the chronic underassessment of Frank's progressive side.

"Frank never got as many props for that stuff because he would turn around and do a moronic pop song or three minutes of noise," Keneally said. "He didn't see anything wrong with moving from area to area very rapidly. A lot of people got the idea that he was a dilettante but that wasn't it. Frank just wanted to hear all this music."

Besides their creative struggles, the Mothers of Invention suffered through typical group dilemmas, mostly centering on money. Faced with the incompatible chores of recording, touring, and composing new material, Frank made a tough decision to close up shop, and abruptly dismissed the entire group. The original Mothers were very unhappy

with Zappa at the time, but many of them ended up playing with Frank again as the years went on.

After disbanding the original Mothers of Invention, Frank released a solo album, *Hot Rats*, which showcased his guitar playing and Ian Underwood's many musical talents. Mostly an instrumental album, the one vocal track on *Hot Rats* was "Willie the Pimp," an avant-blues tune sung by Frank's infamous high school buddy, Captain Beefheart (Don Van Vliet).

An iconoclast in his own right, Beefheart collaborated with Zappa on several different occasions. For a time, they were empathic musical comrades, but Don and Frank had a stormy personal relationship and the longtime friends were often estranged.

In 1970, Frank assembled a band of interim Mothers to appear with conductor Zubin Mehta and the Los Angeles Symphony. The concert was his first live orchestral performance, and it was expensive to produce and somewhat rushed. These types of problems would inevitably occur with Zappa's symphonic efforts. Lacking adequate rehearsal time and faced with disinterested, bureaucratic orchestras, Frank's perfectionist tendencies were perpetually frustrated. Later recordings with the London Symphony Orchestra and the Ensemble Modern (performing "The Yellow Shark") chart his steady progress in the classical realm.

Frank's rock bands were more easily modified to suit his performance needs. Conducting the ribald stage theatrics of yet another version of the Mothers—with singers Mark Volman and Howard Kaylan and drummer Aynsley Dunbar—Zappa showcased his newest group in the surrealistic road-tour documentary, *200 Motels*. This humorous edition of the Mothers met a premature end when a crazed concertgoer pushed Zappa offstage in London where he fell fifteen feet, breaking several bones and crushing his larynx.

184 ~ MITCH MYERS

During his convalescence, Zappa returned to the safety of the stu-
dio and organized a big band, recording two horn-heavy/quirk-jazz
albums, *Waka Jawaka* and *The Grand Wazoo*. A large touring en-
semble emerged, one that included trombonist Bruce Fowler. A vet-
eran of several Zappa groups, Fowler recalled Frank's more personal
side. "Part of the reason Frank hired different guys or kept someone
in the band was because of their sense of humor and their ability to
mesh with his concepts on a personality basis."

Zappa soon learned that instrumental big bands didn't have much
appeal to the concertgoing masses. A smaller group coalesced around
the recording of *Over-Nite Sensation*, however, and signaled yet an-
other shift in his touring organization. Emphasizing more precision
playing and music reading ability—as well as a sense of the absurd—
players like keyboardist-singer George Duke, percussionist Ruth Un-
derwood, and violinist Jean-Luc Ponty formed the nucleus of a killer
road group.

The strength of his band's chops worked to Zappa's advantage
when enlisting new members. Singer/saxophonist Napoleon Murphy
Brock was performing in a Hawaiian nightclub when Frank asked
him to join up—using the reputation of his other musicians as bait. "I
came to the audition because Frank told me that George Duke and
Jean-Luc Ponty were in his band; that set the standard right there,"
Brock said. "Those were the only two people whose names I recog-
nized because when I first met Frank I hadn't even heard of him."

The Mothers had evolved from outrageous rock philistines to
technique-oriented virtuosos. Showcasing riotous onstage camarade-
rie, stellar musicianship, and complex-yet-comical compositions,
Zappa's proto-rock-jazz-theater resulted in a musical flashpoint, as
exhibited on the 1973 live album, *Roxy & Elsewhere*. "It was jazz-
fusion," George Duke said. "But Frank would never admit it. He was

always focused on presenting challenging, entertaining music that was funny and diverse. The technical aspect was important because he wanted to amaze people."

Bassist Tom Fowler was in his early twenties when he joined the Mothers amid changing lineups and endless rehearsals. "It was an era of discovery," Fowler remembered. "We did a tour with the Mahavishnu Orchestra and Frank started thinking in odd meters a lot more after that. We would rehearse and perfect it and memorize as much as we could—it was amazing and he kept you on your toes. Frank was extremely critical but he could control his anger. He never yelled; he just made the appropriate punishment."

George Duke recalled Zappa's strict nature onstage. "Once I screwed up something on 'Approximate,' which had a strange melodic deviation," said Duke. "Frank stopped everything and announced, 'George made a mistake.' Then he says, 'OK, George, now do it by yourself.' I played the thing by myself and I was OK, but I'll tell you what: I never did it again, I made sure I rehearsed and practiced my part."

Drummer Chester Thompson was hired, extending the band's unbroken string of drum masters. He played Zappa's complex time signatures along with Ruth Underwood and drummer Ralph Humphrey. Chester eventually left to join Weather Report, a move made easier thanks to his tenure with Zappa.

"Playing with Frank's band gave you credibility at a way higher level," Thompson explained. "It said a lot as far as gaining respect from other musicians. Everybody in L.A. was well aware of what Frank was doing. You know how cynical musicians can be, but Frank earned the respect of everyone that crossed his path."

A role in Zappa's band was a prize, and his auditions could accommodate dozens of would-be players. Guitarist Denny Walley knew

Frank growing up in Lancaster but didn't work with him until the '70s. "Playing with Frank, it carried a cachet," Walley recalled. "Some of his cattle-call auditions were wide open. It was almost like *Star Search*, people were just desperate and they wouldn't last thirty seconds. Frank would cut them quick, he didn't waste any time and there was no doubt about it. 'Nope. OK. Thank you.' A lot of those auditions were brutal."

Playing with Zappa wasn't just an artistic accomplishment; it led to professional recognition. Frank gave numerous musicians their careers, plucking them from obscurity and legitimizing their talents on a worldwide level.

"Nobody would know me if it weren't for Frank," said Terry Bozzio. "I was a decent drummer around San Francisco. He took me and in a month I was internationally known. I had credibility because with Zappa, you've got to be really good and able to play anything."

Frank first saw guitarist/singer Adrian Belew playing cover tunes with a bar band in Nashville. Although Adrian couldn't read music, Zappa hired him anyway. Belew stayed with Frank for just one year before leaving to join David Bowie.

"It's truly amazing how many great musicians passed through the school of Frank," Belew said. "He was dedicated to seeking out and encouraging other musicians. I owe everything to Frank in that sense—he gave me my initial start and put me on the international stage."

Frank launched the careers of musicians as disparate as Belew, singer/guitarist Lowell George (of Little Feat), and fret-shredder Steve Vai, who first contacted Zappa while still a student at Berklee College of Music. Vai submitted a detailed transcription of Frank's notoriously difficult composition "The Black Page," and was soon drafted into the group full-time. Dubbed "stunt guitarist," Vai added his daz-

zling needlepoint to the fabric of Zappa's formidable guitar sound.

A new phase of proficient rock ensembles satisfied Zappa's requirements and younger musicians were now joining the band. Bassist Patrick O'Hearn was playing with saxophonist Joe Henderson when he first hooked up with Zappa. He remembered Frank as a flexible bandleader inspired by the skills of his sidemen.

"One thing that struck me about Frank was that he was one of the last composers that operated in a fashion similar to Duke Ellington," O'Hearn said. "A lot of his compositions were adjustable; he'd bring in the charts but we were free to embellish. Frank worked our band like a palette and he wrote for the band."

Meanwhile, the years of independent business practice had finally begun to pay off. Frank's later groups enjoyed superior equipment, huge rehearsal spaces, knowledgeable tour managers, experienced soundmen, and the privacy of his home studio. They played festivals and large arenas, drawing thousands of fans on the strength of Zappa's name.

Perpetually energized by drummers like Terry Bozzio, Vinnie Colaiuta, or Chad Wackerman, Frank's concerts showcased his skills as a guitarist, using swooping dynamics on tunes like "Black Napkins" and "The Torture Never Stops." Zappa's multidisc collection, *Shut Up 'N Play Yer Guitar*, recontextualized his guitar solos, smartly reframing them as spontaneous compositions.

By the late '70s, Zappa needed greater assistance in preparing his band for their massive concert tours. The standard had become three months of full-time training before hitting the road. Daily rehearsals were still eight to ten hours long, but Zappa was so busy that he would only show up for the second half of each day's rehearsal.

Bassist Arthur Barrow served for a time as Zappa's "clonemeister"—a surrogate musical director in charge of rehearsals when the

maestro was absent. "The intensity was ten times more than I expected it to be," said Barrow. "The feeling after his rehearsals—especially when Frank was writing new stuff and throwing ideas at you—was this constant mental exercise. I remember driving home and it felt as if my brain was a muscle physically contorting in my head, it was moving all around."

Besides hiring talented musicians, Zappa made sure to feature expressive vocalists in his group. In the beginning there was the twisted crooning of Ray Collins and Roy Estrada and then the mock-rock ravings of Mark Volman and Howie Kaylan. Zappa had a recognizable voice of his own, but he surrounded himself with singers rooted in black vocal traditions. "It's interesting, his association with soul and R&B," George Duke observed. "Frank liked dichotomy and he would force different things together to see what would happen."

"Frank was inspired by great vocals and he was a big fan of doo-wop and early rhythm and blues," recalled Adrian Belew. "His was one of the few bands that had many good vocalists come through. In any one band there'd be two or three good singers and great harmonies of all types." Over the years, Zappa incorporated the soul-driven vocals of George Duke, Napoleon Murphy Brock, Ray White, Bobby Martin, and Ike Willis.

Singer Bob Harris ("the boy soprano") felt Zappa had made a special place for him just to have those great harmonies. "Instrumentally, I was nowhere near the level of players like Tommy Mars," Harris said. "I ended up playing little keyboard parts but my gig was the falsetto guy. The chemistry of Ike Willis, Ray White, and I was really something special."

Zappa's bands were so well rehearsed that they intuitively knew what to do on stage. Throughout the decades, Frank would spontaneously

jump up in the air and the players had to know what song to go into when he landed. Some on-the-spot changes were directed by mental communication, while other adjustments were commanded via little hand signals.

Singer/guitarist Ike Willis was in college when he first met Zappa, and he ended up playing on albums like *Joe's Garage*. While Frank's music had evolved over time, Willis's onstage responsibilities were very much the same as those followed by the Mothers of Invention years earlier.

"The rules are, keep at least one eye on Frank at all times," Willis said. "Because at any time, anywhere, for any reason or no reason at all, he might decide to change the song or go someplace else, or stop the song, or whatever. Those are your instructions, keep one eye on Frank and watch the finger."

Although his early albums were studio creations with occasional live tracks, Frank came to prefer live performances. During the final era of his commercial output, albums like *Tinseltown Rebellion, Baby Snakes,* and the basic tracks of *Sheik Yerbouti* were all recorded in concert.

On his series of live anthologies, *You Can't Do That on Stage Anymore,* Zappa juxtaposed old performances by the original Mothers alongside music by his later groups. Using concert recordings like building blocks, he edited discrete performances from different eras together, forming new idealized versions of his classic tunes. Those nonlinear productions illustrated Frank's theory regarding the conceptual continuity of his lifework, a systematic view that he called "project/object."

Drummer Vinnie Colaiuta spent a few years playing with Zappa and he strongly related to the metaphysical nature of Frank's concepts.

"Frank loved the idea of being able to manipulate things, bending space and time in the studio," Colaiuta said. "But live performance was the most intriguing thing to him. Who's to say that [those] performances from different time periods aren't supposed to connect with one another in some quantum environment that we don't know about?"

Zappa's final touring band was impressive, boasting a five-man horn section and the percussion team of Ed Mann and Chad Wackerman. Their 1988 performances were documented on several live collections, including *Make a Jazz Noise Here*, *Broadway the Hard Way*, and *The Best Band You Never Heard in Your Life*.

Chad Wackerman was an important part of that 1988 ensemble, and he marveled at the band's stylistic depth. "We had 120 tunes rehearsed so it was completely different every night," said Wackerman. "Frank would change up styles constantly. People might know a tune as reggae, but he might decide to do it as heavy metal. He was very spontaneous but really organized. We rehearsed so much that Frank could change anything and the band could do it with confidence."

From his first group to the last, Frank made sure that the music was imbued with his distinctive personality. There was always humor, politics, sex, satire, social commentary, great musicianship, and a lot of hard work.

Frank's widow, Gail Zappa, commented on the consistency within her husband's many ensembles. "I don't think the quality with which the music was delivered ever really changed," said Gail. "There was always a standard that was maintained—it just comes from a different experience. Frank worked with a lot of musicians and there were very few people who weren't capable and couldn't deliver."

And you still can't do that on stage anymore.

—*MM*

Give Frank's Drummers Some

JIMMY CARL BLACK
(THE MOTHERS OF INVENTION: 1964–1969)

"Frank was originally a drummer before he was a guitar player. He was a big fan of Edgard Varèse who also wrote a lot of percussion pieces. Frank used percussion better than anybody else has ever used it in a 'rock' band, if that's what we were. I didn't read drum music that well, not like Artie Tripp did. We played good together, I played the rhythm and Artie could do whatever he had to. Frank had a way of writing my parts out for me—he knew my limitations."

AYNSLEY DUNBAR
(FRANK ZAPPA/THE MOTHERS: 1969–1972)

"His mind must have been preprogrammed to percussion because his ideas flowed with a drummer's ideas. He liked the drums to get excited behind him and play with his riffs. He wrote music from drums, especially percussion, and knew what it should sound like. I started to feel it wasn't necessary to be in the band anymore because everything was starting to get written out. The only room was behind solos. I'm not one of those guys who like to play the same prearranged thing note-for-note every day."

CHESTER THOMPSON
(FRANK ZAPPA/THE MOTHERS: 1973–1974)

"Frank had great effect on me as far as being able to play with precision. I learned a lot about odd time signatures from Ralph Humphrey and that was great because I had so much to absorb coming into the band. When I joined, it was two drummers and my job to supply a funk side to what was going on. I still had to learn the book,

but between Ralph's way of breaking down time signatures and Frank's understanding of what could and should happen, it was a great education."

TERRY BOZZIO
(FRANK ZAPPA: 1975-1978)

"It was a special connection because Frank understood what drummers were doing and he dug it. [As Frank's drummer] you're in this unique position of being a guy who really has to go all ways. You had to be able to improvise your ass off and you needed to be able to hear and interact with Frank in terms of improvisation to accompany him. Then you had to be able to read because the drummer was always expected to play the classical stuff and all of the more intricate music as well."

VINNIE COLAIUTA
(FRANK ZAPPA: 1978-1980)

" 'The Black Page' is a great piece of music on its own and it did a huge service in terms of legitimizing the role of the drum set in ways that people didn't realize. Frank treated drums like a legitimate instrument. Rhythmically, he wrote structured music for the drum kit that was never done before. 'The Black Page' stands all on its own compositionally— that's what it represents as a piece of music and that's what it did for the drum set as an instrument."

CHAD WACKERMAN
(FRANK ZAPPA: 1981-1988)

"I showed some of my parts to other drummers and they didn't know how to start. But you break things down slowly like you would with any difficult piece. His music demanded fearlessness. That's the only

way you could play it—if you took away the fear then it opens up for you. I worked with Frank and the London Symphony Orchestra playing multiple percussion parts on the drum kit. Frank told me, 'Do you realize that the drum-set has never been used this way, *ever*? We're making history here!'"

A CHANCE ENCOUNTER

I was sitting alone in my favorite coffeehouse, enjoying a cappuccino and reading a fairly good book, when I spied an old friend of mine, Adam Coil, walking through the door.

Adam and I had bonded years earlier, and our affinity was mostly due to a strong mutual interest in what we considered to be good music. I hadn't seen him in months and immediately motioned for him to join me.

As he smiled and headed across the room, I recalled the last time we'd seen each other. It was just before Christmas, and I'd confronted Adam on his obvious depression.

I hadn't spoken to Adam since that day and felt embarrassed that I hadn't been in touch. He sat down and we exchanged pleasantries. He seemed to be in good spirits, and after a bit of small talk and more cappuccino, I cautiously brought up his dark mood of the previous winter.

"I was really worried about you," I told him. "I can't remember ever seeing you so discouraged."

He sat there silently for a long time, apparently deciding whether or not to confide in me. Finally, he said, "You know, I was down. I was so down that I was ready to pull the plug."

"What do you mean?" I asked, dreading the answer.

"You know what I mean," he said quietly. "I was going to kill myself. I'd been depressed for months. I was crying every day and I couldn't bring myself to talk about it. I missed so much work that eventually I lost my job."

Coil's confession left me uneasy; I said something about me being there for him and how glad I was that he was still around. "You seem fine now," I said. "How'd you get through it?"

Adam looked smug as he leaned forward to share his tale.

"It's a funny thing, actually," he said. "It was March and I hadn't left my house in weeks. I couldn't have been more depressed. I was crying so much that my vision was blurry and I couldn't even read or watch TV. Finally, I couldn't take it anymore. It wasn't as if I really wanted to die but I couldn't stand the pain. I'd already bought a gun and was ready to blow my brains out. But I was scared and thought that I should try talking to someone. So, I dialed a crisis intervention number that I'd scribbled down after hearing a Public Service Announcement on the radio.

"Somebody answered the phone and said 'Hotline' and I started spilling my guts. I explained how I had become a total shut-in and couldn't stop thinking about killing myself when the guy stopped me and asked if I was over eighteen. I told him that I was well over eighteen and needed to talk to a professional. I said that I was desperate and if I didn't get to talk to the right person I was likely to shoot myself in the head. There was a short pause and I was transferred to a woman who sounded very experienced and very patient. I started telling her my problems.

"Almost immediately, the woman stopped me and asked if I could give her a credit card number. I was surprised because I thought that I had dialed a free hotline. Here I was in the middle of baring my soul

when all of a sudden she asks for my credit card? I was going to hang up but then I decided, screw it—if this doesn't help me I'm going to kill myself, so who cares what they might charge me?

"I gave the woman my credit card number and then she started asking me some very personal questions. I was amazed by her ability to change gears like that—it was as if there had been no break in our discussion. She was warm, compassionate, and surprisingly reassuring. She listened to me as I cried and she told me not to worry. She promised that she was going to make me feel better. Her soothing voice had me entranced. I don't know exactly how long it took me to realize that I'd misdialed the phone number and had inadvertently called one of those 900-number sex lines."

Adam shrugged his shoulders and grinned. "Damn if I didn't find the will to live after that," he said. "As a matter of fact, I've been talking to the same woman twice a week ever since, and I feel better than I have in ages."

Then he glanced at his watch and said, "Wow, look at the time. I have to run. I just came in to get a cup of coffee before my softball game. Listen, it was great running into you. I'll call you and we'll get together and hang out for sure."

Adam Coil threw a few dollars down on the table and was out the door in a flash. I looked blankly around the coffeehouse, sipped at my cold cappuccino, and tried in vain to resume reading my damn book.

HIGH NOON

The sun hangs high in the Texas sky, and West Fourth Street in Austin is totally deserted. Alejandro Escovedo sits motionless in the back room of La Zona Rosa nightclub. Then, slowly, he stands up and begins to strap on his 6-string guitar.

A pretty young woman rushes in and pleads with the solemn guitar-slinger, "Al, you don't have to go out there! You don't have to prove anything to anyone; all of your albums are great, no matter how little they may have sold! Besides, they've brought in some big names for the South by Southwest music festival this year. It will be suicide! Let's just leave town and go somewhere new and start over."

Alejandro Escovedo smiles ruefully and wipes a tear from the young woman's cheek. "It's too late for a man like me to start over, my dear. I've come too far and seen more miles than money. If this doesn't cut it—well, that's just the way it is."

Outside, the clock tolls twelve and three grizzled men walk down the middle of the street. Neil Young, Elvis Costello, and Bruce Springsteen stare straight ahead—barely aware of the bystanders anxiously watching their every move.

Leaving his woman crying in the back of La Zona Rosa, Alejandro Escovedo steps out into the blinding light to face his fate . . .

Exactly what happened next is hard to confirm.

Some think Alejando's elegant balladry saved his ass. Others insist it was his ear-bleeding version of the Stooges' "I Wanna Be Your Dog." Me? I say it was his finale of "Gravity/Falling Down Again" segueing straight into Lou Reed's "Street Hassle" that made all of the difference.

Anyway, believe what you want to believe. That's the stuff of legends, ain't it?

THIS AMERICAN LIFE

We're among the pastoral foothills of the Sierra Nevada in rural Camptonville, California, at Terry Riley's secluded "Sri Moonshine Ranch." And what does the godfather of modern minimalism have in store for us today? Creating a landmark batch of salsa, of course.

Terry Riley and his wife, Ann, have been cooking up salsa for many a summer and their kitchen tradition remains an industrious-yet-imprecise science. Using hot chilies grown on their farm and peppers received from their friends and neighbors, the Rileys chop, stir, and boil impressive amounts of organic tomatoes, onions, and cilantro into their annual "hot" concoction.

Upstairs, above the kitchen, is where Terry makes an even more vital blend. Two beautiful grand pianos sit side by side in his workspace. Removed from urban distractions, this is where Terry composes music. Riley is a wise and gentle sort, articulate but unassuming, and in the course of his long career he's influenced artists as diverse as composer Philip Glass, rock icon Pete Townsend (remember "Baba O'Riley" from *Who's Next*?), and sound architect Brian Eno.

Terry is one of the most important composers of the twentieth century,

and his timeless composition *In C* duly eliminated the boundaries between classical music, minimalist experimentalism, and trance-improvisation for all who followed.

Born in Colfax, California, in 1935, Terry was a barrelhouse piano prodigy by the time he attended San Francisco State College. One of his early peers was Pauline Oliveros, a groundbreaking composer in her own right. "When we were going to school together, Terry was a really hot pianist," she recalled. "It was quite clear that he was an enormous talent and had music coming out of his pores."

After leaving San Francisco State, Terry enrolled in the University of California at Berkeley in 1959, and became a member of the San Francisco Tape Music Center—a Davisadero Street workshop that became a prime gathering place for northern California's avant-garde community.

Alongside filmmakers, dancers, and artists, Riley forged relationships with musicians whose names now read like a postclassical who's who. Besides Oliveros, Terry exchanged ideas with composers like Morton Subotnick, Steve Reich, and Ramon Sender—even future Grateful Dead bassist Phil Lesh was there.

Most importantly, Riley encountered La Monte Young while at Berkeley. And if Terry Riley is the founding father of modern minimalism, then La Monte Young is the genre's designated granddad.

When the two met in 1960, La Monte had already developed some highly original ideas on extended tones, and how musical time could pass with the smallest amount of sound. These concepts marked the beginning of the school of musical "minimalism."

La Monte moved to New York, and along with his wife, Marian Zazeela; John Cale (future member of the Velvet Underground); and Tony Conrad, Young formed the Theater of Eternal Music, whose droning,

drug-fueled performances would last through the night and into the dawn.

La Monte Young is notorious for a long-standing feud with Cale and Conrad. Their dispute is over the rights to recordings that they made together in the mid-'60s. Terry, who also performed with the ensemble, remained close to La Monte.

"Terry Riley is the most harmonious musician to work with I have ever known," Young said. "I appreciate it more and more over the years, although we don't have as frequent an opportunity to perform and rehearse together. We really were able to capitalize on this in the Theatre of Eternal Music because there was so much cocreativity encouraged in the group."

The 1960s were a period of heady discovery for Terry. Outgrowing honky-tonk piano, he experimented with tape manipulations and employed a tape-delay device called the time-lag accumulator. Some of his music reflected the use of psychedelic drugs, like the mesmerizing tape-loop construction, "Mescalin Mix." "Mescalin Mix" was recorded between 1960 and 1962 and was inspired by musician/engineer Richard Maxfield.

"I went to Europe for a couple of years after I got out of Berkeley," Terry recalled. "That's when I had a big period of bringing my ideas into focus and got to work with Chet Baker in Paris. The Tape Music Center had gotten started, and when I came back, I reconnected with Pauline and Morton Subotnick. There was a lot of work I'd been doing, including [music for the theater production] *The Gift* with Chet Baker. I found, through accident, that tape loops build up this long form. I'd sit there listening as this loop was repeating over and over, creating a whole musical form. The way time passes and the way the mind works when it focuses on an object, it's like a meditation. A tape loop is a kind of mantra."

Riley's collaboration with jazzman Chet Baker accompanied *The Gift*, which was a 1961 theater piece written by Ken Dewey that debuted in Paris. Both the "Mescalin Mix" and *The Gift* involved sonic fragmentation and the stretching and slackening of time using (now) primitive tape recording technology. Terry looped reels of audiotape through one tape player, extended the loops out his window and around a wine bottle, and back into a second tape machine.

All this experimental work, however, paled at the debut of his most memorable composition, *In C*. It is a seminal instrumental work with a nonstop pulse, repetitive themes, and interlocking modal melodies. It was devised by Riley during a bus trip and written out in the space of two days.

In C is a cosmic sound cycle—one that gradually blossoms into a shimmering aural experience via fifty-three recurring figures. The composition took Riley's hypnotic tape-loop concepts and his other motifs of repetition and adapted them, using traditional acoustic instruments.

"In 1964, I'd been working on all these electronic pieces," said Riley. "I'd [also] written *In C*, but it had never been performed. So I took all this stuff down to the Tape Music Center. I met Steve Reich and John Gibson, and they put together this pickup band and *In C* was recorded."

Crediting La Monte Young for the spirit of *In C* but not the content, Terry is proud of the resilient piece, which has been performed all over the world. There have been Canadian and Italian versions, a twenty-fifth anniversary concert recording, and a rendition by the Shanghai Film Orchestra using traditional Chinese instruments. Guitarist Henry Kaiser played on the twenty-fifth anniversary edition of *In C* and he maintained that Riley is the "most significant and influential composer since World War II."

In the '70s, a fifteen-piece rock band performed *In C*; in the '80s, there was an all-guitar performance; and in the late '90s a Lincoln Center Festival featured an electronic version with Robert Moog on synthesizer.

But CBS Records released Riley's most distinguished rendering of *In C* back in 1968, and the clarity and precision of that recording remains unsurpassed.

When I said to Kronos Quartet leader David Harrington that one couldn't write about Riley without discussing *In C*, his response was succinct: "It's the same way you can't talk about Stravinsky without discussing *The Rite of Spring. In C* is an idea about life, about making music together, and about community. It's so simple and yet so profound, it always sounds right and it always sounds different."

La Monte Young had his own high praise for Riley's work. "*In C* is a perfect masterpiece," said Young. "I compare it with the theme from the 'Funeral March' in Mahler's *Fifth Symphony* and Schoenberg's opening theme in *Verklärte Nacht*. Terry not only influenced Steve Reich, Philip Glass, and their protégés, such as John Adams, but his influence spread out to certain European rock groups such as Daevid Allen's Gong, Can, and Tangerine Dream. In the case of these rock groups, I think sometimes Terry was the direct link."

Invigorated by the success of *In C* and hopeful to return to Europe, the Rileys made their way across America in a Volkswagen bus. "I'd been in Mexico living the hippie lifestyle and ended up in New York broke—so we traded our van for money for a loft," Riley recalled. The couple settled in Manhattan, where Ann Riley worked as a schoolteacher and Terry reunited with La Monte Young.

"La Monte was my main contact, so I started going over [to his place]," Riley explained. "Tony [Conrad] and John [Cale] and Marian and La Monte were singing on a very regular basis. John had already

started work with the Velvet Underground. Within a couple of months he left, and I found myself as one of the main members of the group. La Monte, Marian, and I were singing, and Tony was playing an amplified violin. In addition, we used little tank motors for drones and later on, sine-wave generators. We did several concerts. Tony Conrad was brilliant, I really liked working with Tony."

His tenure with La Monte was brief, but Terry had established himself in Manhattan's burgeoning loft scene. "I left the group because I wanted to get back to the work I'd been doing after *In C*," he said. "I got this little harmonium that had a vacuum-cleaner motor. It was primitive, but I started playing keyboard studies on it and doing some of the first loft concerts around New York."

Lengthy, mutable tunes like "Poppy Nogood and the Phantom Band" evolved into mesmerizing solo concerts that incorporated Riley's keyboard studies, tape delays, and his soprano saxophone style—one that borrowed from both La Monte Young *and* John Coltrane.

Tony Conrad was impressed with Riley's metamorphosis and enjoyed his solo shows during this time. "Terry's keyboard work had evolved a conceptual coherence and technical mastery that was on a tier above any musician then playing and was as original and articulate as Bird in the early '40s or Tudor/Cage in the '50s," explained Conrad. "The magic and power of the soundscape that Terry created in concerts defied all explanation or understanding. His proficiency as a performer, combined with the intricacy of his rhythmic and melodic structure, left most listeners dumbfounded, simply able to drink in the endlessly undulating liquidity of his sound."

Riley's hyperbolic solo shows in 1967 and 1968 would often last until morning, predating the tranced-out rave culture by decades. English DJ Mixmaster Morris kept an extensive library of Terry's recordings and considered him one of the great innovators in contemporary

music. "[Riley's] use of electronic modulation in a live context was thirty years ahead of the field," said Morris.

After securing a three-album deal with CBS Records' Masterworks, Riley recorded his classic version of *In C*. His "pickup band" included Stuart Dempster on trombone, Jon Hassell on trumpet, and Margaret Hassell, who played the single, C note "pulse" throughout on piano.

The 1968 recording of *In C* galvanized Terry's reputation as a serious composer, but it was marketed to younger consumers. Indeed, *In C* and his follow-up album, *Rainbow in Curved Air*, were portrayed as psychedelic brain candy—appearing in ads alongside synthesizer oddities like Walter (now Wendy) Carlos's *Switched-On Bach* and Morton Subotnick's *Touch*.

While *In C* was the acoustic precursor to many future-minimalist works, Riley's *Rainbow in Curved Air* was a one-man electric circus geared to re-create the experience of his all-night concerts.

So, besides his accomplishments with *In C*, Terry Riley effected a ground-zero change in the realms of electronic and ambient music. West Coast intellectual Stuart Brand said, "Riley had profound and immediate influence on Brian Eno, evident in his albums *My Life in the Bush of Ghosts* and *Music for Airports*. *In C* persuaded Brian that endlessly original algorithmic music doing permutations on a sound palette designed by the composer could make brilliant listening. This is something Brian and I have talked about a lot."

"There was a sensibility that was changing in the late 1960s," Riley explained. "It would have been hard to create these records five years earlier. The *Curved Air* sessions were the first recordings made on an 8-track machine at CBS. They wheeled it in—it was brand-new and nobody had even used it yet."

During that same time Terry was recording *Rainbow in Curved*

Air as a solo project, he was also in the studio collaborating with John Cale. "I was recording *Church of Anthrax* with John in the afternoon and then I'd go in late at night to record *Rainbow in Curved Air,*" said Riley. "Essentially, John and I just improvised. One thing we share in common is not too much preparation beforehand."

Together, Riley and Cale tried to extend the musical disciplines that they'd practiced with La Monte Young. But the pair was saddled with stubborn rock drummers who insisted on playing in 4/4 time. As a result, the mostly improvised *Church of Anthrax* ended up a cryptic jazz-drone hybrid.

Terry's span of work in New York led to more critical success, and he received many invitations to record with musicians eager to pick up where *In C* had left off. He was poised to cement his position in the East Coast's progressive music community. But life took Terry elsewhere.

"I got involved in Indian classical music because of Pandit Pran Nath," Riley explained. "I met him in 1970. La Monte had arranged to help bring him over to the States to teach. I was powerfully moved. Not just by his music but by him as a person. I was also at a point in my career where I wasn't sure what I wanted to do. So during the next twenty-six years, even though I was composing and giving keyboard concerts, I was trying to learn Indian classical music in the traditional way."

Riley studied with Pran Nath and spent six months living in India until the elder told Terry that he should return to work in America. For Terry, Pran Nath's intensive teachings went well beyond musical training. "It's a very personal relationship when you study under your masters," Riley emphasized. "You don't come for a lesson once a week, you work very closely because it's a responsibility on both persons' part. You have to devote your life to it." Riley's mentor eventually

moved to the Bay Area and their friendship lasted until Pran Nath's death in 1996.

When Terry returned to California, he took an instructor's position at Mills College. There, he practiced the teachings of Pran Nath and improvised music. Up to that time, Terry had never thought to notate his music in written fashion. Instead, he produced more solo-trance classics, including *Happy Endings* and *Persian Surgery Dervishes*. There was also the West-meets-East electro-tone-poem, *Shri Camel*, which used digital delays on a Yamaha organ calibrated to a unique tuning system called "just intonation."

In 1979, Terry met David Harrington and the Kronos Quartet at Mills College. Riley's work had already made an impression on Harrington, and their meeting at Mills resulted in a series of collaborations.

"The first time I ever met Terry he sat in on a rehearsal we were having," said Harrington. "I'd been listening to Riley's music for a long time and after meeting him, it became clear to me that he had to write for Kronos. He was a quartet composer even if he didn't know it yet."

Harrington's assessment was prophetic and Riley has written some of his most significant compositions specifically for the Kronos Quartet. The group's recording of Riley's *Cadenza on the Night Plain* was selected by both *Time* and *Newsweek* as one of the Ten Best Classical Albums of the Year in 1985, and their double disc *Salome Dances for Peace* was nominated for a GRAMMY in 1989.

On their ten-CD retrospective, *25 Years*, the Kronos Quartet devoted an entire disc to Riley's compositions. Here, Terry is set alongside contemporaries like Philip Glass, Steve Reich, and John Adams, as well as more obscure luminaries like Henryk Górecki and Morton Feldman.

"David talked me into writing for the Kronos," Riley admitted.

"They are my most consistent collaborators in music. It brought me out of an isolated solo performance career. I also started writing for other groups and ended up getting orchestral commissions."

One such project had Riley and the Kronos working with the NASA space program. Thanks to David Harrington, Riley was commissioned to compose music based on radio waves collected by the *Voyager* space shuttle.

"This one is based on *Voyager*'s exploration, which flew by all of the planets," Riley explained. "On board *Voyager* was a device called the Plasma Wave Receptor, which was invented by a Dr. Gurnett in Iowa. This [device] is able to receive radio waves the planets themselves broadcast, and each planet has a different sound wave."

Besides cultivating his abilities as a composer, Terry found a passion for piano improvisation and recorded some uniquely contemplative solo pieces. His use of the "just intonation" tuning system is used to great effect on 1986's *The Harp of New Albion*. Terry's conventionally tuned piano meditations, like 1995's *Lisbon Concert*, are especially transcendent.

Whether composing space-age string quartets or singing North Indian ragas, Terry approaches music with focused devotion, reflecting the sum total of his experience and integrating a world of sound. While his peers Philip Glass and Steve Reich record for the prestigious Nonesuch label and vie for commissions and grants in businesslike fashion, Terry resides at his Shri Moonshine Ranch like a venerable music buddha, performing sporadically and recording for small, independent record labels.

Sitting quietly upstairs at the Sri Moonshine Ranch, Riley radiates a sense of inner peace as he looks back at an uncommon career.

"The choices I've made have been for the music and my own soul," said Terry. "When I walked away from New York, I knew fame wouldn't

have given me any happiness if it weren't based on a musical choice. Pran Nath said, 'Just enough fame to keep doing your work is enough,' and I thought that was good advice. I feel terrifically lucky every day I get up and give thanks for what's happened. What really makes me sad is to see young musicians who are hopeless about their situations. My advice is put it all into the music. That's the only thing you can do, because you don't know what kind of hand fate is going to deal you. At least your own soul is going to be getting some feedback."

HOUSE OF THE RISING SON

"Hello, Doris? This is Mrs. Albini from down the street. Did I catch you at a bad time? Good, I appreciate that. Oh, I'm fine, thank you. Listen, I hate to be a bother but I understand you've done a fair share of counseling down at the church and I was hoping to ask your opinion on a family matter.

"Now I know this is going to sound sort of silly, but our son Steven won't eat his cereal. No, he's not a finicky eater. He usually finishes everything I put in front of him. Never gains a bit of weight, either—sometimes I worry because he's so thin, but that's not why I'm calling.

"It's the things he's been saying that have me concerned. Like this cereal thing; Stevie absolutely refuses to eat the Cheerios that I bought at the grocery store. He keeps referring to General Mills as some kind of 'major label' and insists that he'll only eat 'indie-brand' cereal. He says that smaller companies have more integrity and care more about their finished product. Is this any way for a child to talk?

"It's almost like a game with him. Sometimes I can slip a Post brand cereal past him when he's really hungry or tired from staying up too late, but that's it. Then there are the times when he gets angry and bites my head off for no apparent reason. He's so rigid and

uncompromising compared to the other children that I just don't know how to deal with him anymore.

"I shouldn't complain—we're actually quite proud of our little man. I'm especially impressed by the measure of discipline that he exerts when he's working on something, but he can be so cold toward his schoolmates. You see, Stevie is quite gifted—I know you probably think I'm biased because I'm his mother—but he's extremely intelligent and . . . well, sometimes he talks down to some people. It's awkward because he can make an awful lot of sense and is very convincing, especially when he sets his mind to something.

"There are times when he's totally oppositional and rejects people's wishes on principle. He's constantly accusing his friends of 'selling out' and refuses to have anything to do with them. He insists on total honesty, extreme independence, self-determination, and common sense. Hardly any of the kids in the neighborhood can keep up with him. My friend Sally says all he needs is a good shellacking, but we don't want to discourage his creative flair.

"How can you argue with a youngster who adheres to a fully formed moral code with absolutely no room for compromise? I don't know where he got it into his head to pursue such a rigorous work ethic— he hardly ever takes a day for himself. And this totally pure artistic worldview that he's always going on about, it's very intimidating.

"He does enjoy himself when he plays music with his friends, though. They look so cute with their instruments, but I don't understand what they're doing. Stevie plays his guitar so loud that I have to get out of the house when his band rehearses in our basement. I've never known anyone that likes noise as much as he does. It's some sort of release for Stevie, and all this aggression just comes pouring out of him when he plays. He reminds me of a deranged method actor and that scares me. It's like he has a split personality.

212 ~ MITCH MYERS

"Lately, his friends Bobby and Todd have been spending a lot of time in the basement with him and the caterwauling is getting quite intense. Sometimes they play very slowly while other times their pace is accelerated beyond words. I have to say that for just three kids they make quite an imposing and synchronized racket. And I don't know where my son got this idea to scrape and strangle his guitar so viciously—certainly not from anyone here in Missoula, Montana!

"I've tried listening to the lyrics but I can't follow his train of thought at all. Especially while young Todd is pounding on his drums and Bobby is flogging that poor bass. I've even looked in Stevie's school notebook and he's been scrawling strange phrases like 'Big Black' and 'Rapeman.' Should I be concerned about any of this?

"Doris, you've never heard anything like these kids. There's something damaged about the whole thing. No, I don't think they're Satanists, the other two are quite polite when they come over to the house. They just seem to change when they plug in their instruments. I swear, my oldest used to listen to Led Zeppelin, and that was tame compared to this stuff. And their attention to detail—it borders on obsessive! They work out the smallest aspects of all their songs and it makes me feel claustrophobic.

"So, do you think that he's just going through a phase? Do you think he'll calm down and start paying more attention to his homework? Even if he just brought home a nice girl once in a while. Anything! I hate to sound like a worrywart, I'm sure it's just a maturity thing. They say it takes longer with boys.

"Well listen, Doris, thanks. I feel so much better just getting that off my chest. Steven is coming home with his friends soon so I've got to go hurry and put out some milk and cookies. Bye now!"

REQUIEM FOR A COWBELL

Do you remember the *Saturday Night Live* skit spoofing Blue Oyster Cult in the recording studio? It was a send-up of *VH1 Behind the Music* and astutely mocked the inflated sense of self-importance held by so many famous rock groups.

In the *SNL* skit, the "band" is recording their song "Don't Fear the Reaper" and Christopher Walken, who portrays record producer Bruce Dickinson, keeps insisting that the tune needs, well, "more cowbell."

As funny as that skit was, there's something about this cowbell business that rings true for me. When I was a young teenager coming of age in the 1970s, some of my favorite songs contained the distinctive clank of a cowbell.

Of course, those were the glory days of swaggering, super-heavy-rock 'n' roll stars—I'm talking fringe-vested, bare-chested, bell-bottom-wearing hard rockers who used and abused the innocent cowbell to accentuate their macho point of view.

As I recall, no self-respecting drummer of the time could be found without a cowbell perched on top of his bass drum (often wrapped in duct tape to deaden the harsh metallic clank).

Now, I really can't wax nostalgic about the '70s and the collective

thrust of old cowbell tunes without getting more specific, so please forgive this sentimental indulgence—but if you can remember producer Jimmy Miller's historic cowbell intro to the Rolling Stones' "Honky Tonk Women," you already know what I'm talking about.

That's right—for a brief period in the twentieth century the cowbell was an essential component of popular music. And for certain groups, the cowbell was the most identifiable part of their signature sound. Take the once-portly guitarist Leslie West and his band, Mountain, who enjoyed at least fifteen minutes of fame with "Mississippi Queen," a hard-rock classic that begins with drummer Corky Laing whacking the living daylights out of his cowbell—providing an infectious counterpoint to West's throaty wail and crunching power chords.

And the beat goes on. Besides Top 40 breakthroughs for heavy-metal kids like Blue Oyster Cult and Mountain, Grand Funk Railroad's "We're an American Band" showcased big Don Brewer working that poor cowbell to death, all the while singing his blue-collar ode to partying on the road, groupies, and good-time rock 'n' roll.

There's some consensus that the ringing clarion call is the ultimate party signifier. But the history of the cowbell actually goes back to ancient Middle Eastern culture. There, animal tenders placed bells around the necks of their camels. And when it came to keeping track of cattle in the centuries to follow, many farmers put bells around the necks of their smartest animals, the ones most likely to keep the rest of the herd out of trouble.

I could go on listing old-fashioned cowbell songs performed by groups from the days of yore. There's memorable cowbell rock by the likes of Free, Humble Pie, Black Sabbath, Creedence Clearwater Revival, AC/DC, Santana, and even the Beatles.

But I just can't bring myself to talk about the days when cowbells reigned supreme. You see, at some point my cowbell story gets rather

depressing and I have to face the fact that the '70s are ancient history and so is my lost youth. The last time cowbells ruled the radio I was parting my hair down the middle—nowadays I don't even own a comb.

Oh yes, the past is gone, even if some of the groups who played those cowbell songs are still going strong. Hey, I wonder if this means that cowbells aren't just good, but good for you. It's possible, right? *Something* is keeping groups like Aerosmith and ZZ Top alive and well. Who's to say it's not the ding-dang cowbell?

Now please don't let my rueful nostalgia convince you that cowbells have gone the way of the dinosaur. Contemporary groups always seem to keep this great lost art alive, like the White Stripes or the Kings of Leon, whose "California Waiting" stuck some classic cowbell clangor on top of a guitar riff stolen straight from a song by Blondie.

So, instead of mentioning any more cowbell songs, I humbly refer you to "The Cowbell Project" at *geekspeakweekly.com/cowbell/*, a website listing every cowbell tune you can think of and plenty more that you can't. On top of that, the site even dubs Christopher Walken "the patron saint of the cowbell."

And if all of this isn't a perfect example of herd mentality, then I don't know what is.

TIE-DIE!

It was just another lazy Sunday afternoon and Adam Coil was browsing a summer garage sale in his neighborhood. He asked the proprietor, "Any books or records?" That was his mantra when it came to this sort of thing. "Any books or records?"

The owner—an old man—pointed to the back of the garage. "There might be a few things left over there," he answered. "You should have been here yesterday, one guy loaded up his car with all sorts of stuff."

Adam winced and said, "That's what I get for waiting until Sunday." He located a small stack of records, mostly timeworn junk in pretty bad shape and picked out a pair of albums by some forgotten group from San Diego. He also found some science fiction by writer Michael Moorcock and a dog-eared edition of *The Whole Earth Catalog*.

Then Adam noticed a gray-haired woman sitting quietly in the corner. She was surely the owner's wife, but the contrast between the two was striking. While the old man joked and was eager to make a deal on everything in the garage, the woman was silent and distracted. The look in her eyes implied both distress and complete self-absorption.

Adam wondered if she was an acid casualty, or perhaps senile. She

and her husband were once hippies—that much was clear. The garage was littered with pale remnants of a lifestyle from long ago. There were crocheted shawls, a "black light" with posters, a fringed leather vest, peasant blouses, and decrepit sandals. Adam smiled as he noticed the hand-painted Adam-and-Eve coffee mugs, withered headbands, patched-up bell-bottoms, a collection of tarnished incense holders, and some hand-carved Mersham pipes.

He stepped up to pay for his items and the old man began some preemptive haggling—a sporting gesture that Adam appreciated. After a quick back-and-forth, which amounted to a savings of a dollar fifty, the jovial oldster twirled what was left of his graying ponytail and said, "We're at $4.75, why don't you pick out a T-shirt and we'll make it five bucks even?"

"Why not?" Adam replied. He rustled through a carton of musty clothes on the makeshift counter. They were mostly faded concert T-shirts, but when Adam reached into the box, he grabbed something warm and tingly and pulled out a radiant, tie-dyed T-shirt. The shirt was an extra-large and looked like new.

When he placed the shirt on the table and pulled out his wallet, the old woman snapped out of her trance. She began speaking excitedly and Adam had a hard time understanding her. All he could make out was something about "bad karma" and a big mistake with someone named Sam. "Listen," said Adam. "If there's any problem with me taking the T-shirt, just forget it. It's not important."

"No, no, no," insisted the old man. "There's no problem. Take the shirt—it's an original tie-dye and we want you to have it. The shirt is yours. Really, take it with our blessings."

Adam peered at the old woman. She had reverted back to her distracted state looking even sadder than before. "Well, as long as it isn't a big deal," he muttered shyly. "No seller's remorse?"

"Not at all," replied the old hippie. "Here, I'll even throw in some incense . . ."

As he left the garage, Adam looked back to see the elderly couple speaking in hushed tones. But by the time he got home, he'd forgotten the sad look on the old woman's face. He threw the shirt into the washing machine and read a few pages from Michael Moorcock's *An Alien Heat.*

The next day, Adam called his girlfriend, Tina. She was younger than Adam, shared a high-rise apartment with a roommate across town, and worked long hours as a graphic designer. She was a conservative girl and much less spontaneous than Adam.

The couple had a highly structured relationship. For example, Tina never stayed at Adam's during the week, but she would come over every Friday and spend the weekend. It was an established routine and Adam took comfort in the dependable aspects of their relationship.

Adam was happy just to have a girlfriend, especially one as smart and pretty as Tina. She'd plan out their weekends: movies, shopping, and get-togethers with other couples. Adam cooked when they stayed home—she would read and they would watch TV together. They were what you'd call comfortable, but there wasn't much passion in their relationship and they only had sex about once a week, usually on Saturday.

On Friday, as usual, Tina came over after work. Their plan was to stay in that night, go to the mall on Saturday, and hit a museum on Sunday. Adam had cooked dinner, penne pasta with chicken, and Tina had brought an expensive bottle of wine. Afterward, they made love in a somewhat perfunctory fashion. "Well, that's it for the weekend," thought Adam as Tina took her shower.

Just as Adam was drifting off to sleep he heard Tina cursing in the bathroom. "Damn!" she whined. "I forgot my overnight bag. Now

I don't have anything to wear for tomorrow." She stomped around the bedroom, "I need something to wear right now. I can't stand to sleep naked."

Tina opened Adam's bottom dresser drawer and pulled out the tie-dyed T-shirt. "Hey, I've never seen this," she said. "I guess it will fit. How long have you had it?"

Adam was tired and he knew that Tina would never wear something that he'd bought secondhand. So, for the sake of expediency, peace and quiet, he avoided telling her the entire truth.

"It was in a pile of old clothes," he answered. "But don't worry, I just washed it with fabric softener. Besides, the colors will look nice on you. Just put it on and come to bed."

Adam woke abruptly at two in the morning. There was music playing. What roused him, however, was Tina. Her hands were rubbing his back and her tongue was licking his neck. This time, their lovemaking was more passionate. Adam gasped as she straddled him. "Omigod Tina, what's gotten into you?" Her eyes were glazed, and she answered with a burst of pelvic thrusts. "Whatever it is, I'm not complaining!" he moaned.

Later that morning, Adam awoke again, this time to the sounds of Quicksilver Messenger Service's "Who Do You Love." He noticed that the XM radio was set to "Deep Tracks" instead of CNN. Then he smelled breakfast. This was even more unbelievable than the sex, Tina was actually cooking! When he entered the kitchen there were pancakes, sausages, and hot coffee waiting for him. "Good morning, baby," she cooed. "Sleep well?"

It was nearly noon and Tina was still wearing the T-shirt—and nothing else. "I was thinking," she said. "We already slept late, what if we just stayed in today? Let's blow off everything and forget about the mall. Would that be okay?"

Okay? Hell yes, it would be okay.

So, the couple lounged around for the entire weekend. They watched old movies, had Chinese food delivered, listened to music, and had a lot more sex. Adam couldn't have been happier, and Tina seemed to be enjoying herself. She even stayed over on Sunday night, which meant that she'd be wearing the same outfit to work that she'd worn on Friday—yet another first.

There was no denying that Adam was pleased. In his mind, Tina had made some kind of internal shift and was more fun-loving than before. Later that week when folding laundry, he came across the tie-dye. For a moment Adam felt the same tingly warmth that he'd experienced at the garage sale.

For the next month, things proceeded in a similar manner. Then, Tina suggested that they "buy some grass" to smoke before going to bed. Adam wasn't much of a pothead, but he'd blown his share of weed. As far as he knew, Tina had never even smoked a joint all through college. Now, besides the sex—which was getting more frequent and a little kinkier—she wanted to get high.

And—whenever Tina was over at Adam's place, she wore the tie-dye.

There were other changes in Tina. She'd begun going to resale shops and vintage clothing stores, changing her wardrobe in a decidedly retro mode. Adam was enjoying the new, fun-loving Tina—she was more than he could have hoped for—that is, until she started making more willful changes.

Tina had taken to wearing the tie-dye under her clothes when she went to work. It was her shirt now—that much was clear. But wearing it seven days a week was a little too much. When Adam tried to talk about it with Tina, she would either get angry or change the subject by dragging him into the bedroom.

One day, when they were sitting around getting high and listening to Joni Mitchell's album *Clouds*, Tina got a frantic call from her roommate, Andrea. It seemed that Andrea's cat, Herman, had somehow hung himself on a beaded curtain that Tina had installed in their apartment. Herman the cat was dead and Andrea was hysterical. Tina said that she would come home immediately and bring something to calm Andrea down.

When Tina explained to Adam what had happened, he asked her what she was bringing home to calm Andrea's nerves. "Oh, just some Quaaludes that I have in my purse," she replied.

"Quaaludes?" Adam shrieked. "Where did you get Quaaludes? I didn't even know that they still made Quaaludes."

Tina looked wearily at Adam. "If you must know, I got them from this biker named Clem."

Adam snapped in disbelief, "Clem? A biker named Clem? Are you kidding? Where did you meet a biker and what the hell were you doing buying Quaaludes anyway?"

Tina had already pulled her poncho over her head and was headed toward the door. "I don't have time for this crap," she said angrily. "Andrea needs me. And don't *ever* talk to me like that again—you're really bringing me down!"

With that, Tina walked out of Adam's apartment, slamming the door.

Adam didn't know what to make of her behavior and couldn't believe that Tina was using drugs. She was a conservative yuppie who'd grown up in central Iowa. When they first met, Tina was afraid of public transportation—now she was consorting with bikers.

Adam was angry but he was also worried and called Tina's cell phone repeatedly. She didn't call him back for three days, which was the longest time they'd ever gone without speaking since they first started dating.

When Tina finally called back, she was apologetic and humble, "Can I please come over on Friday? I have something special for you." Adam felt a flood of relief as well as a little excitement.

By Friday, Adam had rehearsed his questions about Clem and the Quaaludes. But the moment he saw Tina he forgot everything—she looked so good in her hip-hugger jeans.

After a candlelight dinner, a joint, and a bottle of red wine, Tina took something out of her overnight bag. "This is for you," she whispered. "I embroidered it myself." It was a blue-jean jacket with a yellow sun emblazoned on the back.

He tried on the jacket while Tina lit some patchouli incense. "Now, here's your other gift," she said as she handed him a color-illustrated copy of the *Kama Sutra*. "Isn't it groovy? There's this new position I've been dying to try . . ."

By Monday morning Adam felt completely wiped out, and his apartment was a total mess. The weekend was a blur, and as he stumbled around he found a note from Tina saying that there was another gift for him out on the balcony. He squinted into the sunlight and stepped outside to find a macramé plant holder hanging above the railing with some beautiful trailing begonias in a huge clay pot.

Despite the gift, Adam felt lousy. It took him all afternoon to clean the apartment, and after four cups of coffee he still couldn't clear his head. It was more than a weed and booze (and sex) hangover—he felt as if he'd been drugged. Adam wondered if Tina had slipped him a Quaalude. When he called Tina she was cold and distant. She said that she had to spend more time with her roommate, who was still upset about Herman the cat.

The next Friday, Tina canceled their weekend plans, saying that she had to stay home with Andrea. Adam pressed her to come over

but she refused and said that he was being insensitive. Adam thought he heard a motorcycle revving in the background.

Another week went by before Tina came over to Adam's place. He hardly recognized her. Her hair was now straightened and parted down the middle. She wore a pale shade of lipstick and thick dark eyeliner.

Tina had brought him another gift. "I baked some brownies last night," she giggled. "Want one?"

Adam reached for the plate and then thought better of it. "Maybe later," he replied. "I thought we could have some dinner and talk."

"Well, actually, I can't stay," Tina answered. "Andrea and I are going to the movies. She's still having a really rough time."

Adam barely restrained his frustration and squawked, "What about *our* relationship? I thought we were going to spend some time together. I haven't seen you all week."

Tina responded with a fury Adam had never seen. "Our relationship? I'm tired of you hassling me about our relationship! My life doesn't revolve around you. I have other friends, other interests. You're turning into such a bummer! Maybe we should just take a break. I need some time to sort things out."

So, Tina left quickly and Adam threw her brownies in the garbage. He wondered if there was anything illicit in her recipe. "I bet she's seeing that biker guy," he thought. "Someone has to be responsible for all these changes in her." Adam shuddered as he imagined a burly, tattooed biker screwing Tina from behind.

He decided not to call Tina for a while; she wasn't interested and he wasn't going to beg. But Adam sank into a funk that lasted almost two weeks. The only thing that shook him out of his depression was a freak accident. At least Adam hoped that it was an accident.

He'd been sitting around the house going stir-crazy and decided to go to the corner store to get some groceries. On his way out, he

stopped to chat with the doorman, a nice gentleman named William who loved to talk. That was all it took. Adam immediately blurted out all of the problems that he was having with Tina.

Adam had just gotten to the point in his story where he said, "So I thought—forget the crazy bitch, she's nothing but trouble anyhow," when suddenly, a large object came hurtling down from above, narrowly missing Adam and crashing between the two men.

"Damn! That just missed your head," William shouted. "It could have killed you! It could have killed me! Jesus Christ!"

When they examined the scattered mess Adam realized that it was the trailing begonias from his very own balcony that had fallen. The macramé plant holder had given way somehow and the massive clay pot had nearly decapitated him.

He helped clean up the sidewalk and asked William not to mention anything to the management. He even gave the doorman fifty bucks to keep things quiet. Adam wanted to sort things out before anyone came snooping around.

He felt like calling Tina, but fought off the impulse. It had to have been an accident, he reasoned. Nobody was in the apartment when the plant fell and it was just a coincidence that he was on the sidewalk when it happened.

Adam finally stopped thinking about Tina (all the time) and resumed a normal, if lonely, routine. Then, in the middle of the night, she called him. She couldn't stop crying. He'd been yearning to hear her voice, but all thoughts of romance dissolved when she explained what had happened.

Andrea was dead. She'd killed herself by jumping out of a window in their apartment. They'd been doing Ecstasy for the entire weekend and after Tina left for work on Monday, Andrea made her terrible leap.

"I guess she was still upset about Herman," Tina cried. "The police were over here last night and again this morning. I can't sleep here. Can I please come over?"

Tina arrived at Adam's place and collapsed in his arms. She cried herself to sleep and as Adam lay next to her, his mind traced back the events of the last few months. He saw that she'd stopped shaving her legs and underarms and surmised that she'd stopped bathing as well. And she was still wearing the tie-dye.

Tina stayed at Adam's apartment for weeks. She took time off from work, using all of her remaining vacation days. Not surprisingly, the couple reconciled. With their romance reestablished, Adam got up his nerve and asked her, "Honey, what about that motorcycle guy, are you still in contact with him?"

Tina looked confused and said, "What motorcycle guy?" Adam readied himself for another argument. "You know, Clem, the biker that got you the Quaaludes."

Tina started laughing, "Clem? That kid doesn't have a motorcycle. He's just a bike messenger someone told me about. He gave me two Quaaludes when I copped that weed from him and I haven't seen him since!" Adam was relieved and apologized to Tina for being jealous.

So they settled back into their old routine. Tina began using her own apartment again and stayed at Adam's on the weekends. But things weren't quite the same and a gloom pervaded their time together.

Surprisingly, Tina was *still* wearing the T-shirt under her office clothes every day. Adam kept his concerns to himself, even after she received a work warning regarding her hygiene.

Mostly, Tina just walked around barefoot wearing love beads, a peace-sign pendant, and clunky turquoise jewelry. She'd become a strict vegetarian and was into astrology. She even consulted the *I Ching* for her important decisions.

Despite these idealistic pursuits, Tina's dark side was taking hold again. She was moody and uncommunicative and went out by herself almost every night. Adam tried to give her plenty of space but Tina could be quite cruel and the two argued constantly. He was afraid to bring up anything that might upset her and they rarely had sex at all.

Things became even more unsettling when Adam took a walk in the neighborhood and an old Volkswagen microbus with a psychedelic paint job nearly ran him over. It seemed to come out of nowhere and never even slowed down. He actually had to dive out of the way and the bizarre episode left him reeling.

Then Tina took off more time from work and didn't tell Adam. He didn't know where she was and left several phone messages, pleading for her to let him know that she was okay.

Frustrated and concerned, Adam went over to Tina's apartment. He hadn't been to her place in months but he still had a key. There was no answer when he knocked, so Adam let himself in. Tina wasn't there and her bed didn't look as if it had been slept in.

When he peeked in Andrea's old room, Adam couldn't believe what he saw. Tina had converted her dead roommate's bedroom into a foreboding shrine. One wall was covered with photos of Charles Manson and his followers at the infamous Spahn Ranch.

On a table were books like *Helter Skelter*, *The Family*, and *Till Death Do Us Part*. On the floor, in front of a cracked beanbag chair, was a crude pentagram circled by thirteen black candles. Next to the pentagram, there was a mirror holding a razor blade and traces of white powder.

Adam had seen enough and left Tina's apartment as fast as he could. Then, he had the sad realization that there was one more stop to make before going home.

It took him some time to remember exactly where the garage sale had been, but Adam finally found the house. He rang the bell and the same old man came shuffling to the door. He peered through the screen and said, "Can I help you?"

"Yes, I hope so," said Adam. "I don't know if you remember me, but I bought some things at your garage sale a few months ago."

The old hippie looked cautious. "Sorry, no returns. All sales are final," he said and started to close the door.

"No, no, you don't understand," insisted Adam. "I bought a tie-dyed T-shirt from you. Remember? Your wife got upset but you said I could have it."

The old man stared mournfully at Adam and said in a low voice, "You better come inside."

They sat in the front room and the old man offered Adam some jasmine tea. The place had newspapers stacked everywhere and there was rotting food on the kitchen table. Three huge cats prowled around their feet. "My wife hasn't been feeling well lately," the old man said. "It's been hard to take care of her and keep house, too."

Adam nodded and said, "Please, tell me about the T-shirt."

With some reluctance, the old man explained how forty years earlier, he and his girlfriend—now his wife—had joined a group of hippies who were being *shown the way* by a guru named Sam Hackman.

"Kind of like a commune, but not quite," the old man recalled. "It was fun at first, but then Sam started giving us strange tasks and was always testing our allegiance. There were drugs, too. We were young and naïve and went along with it all. Then Sam chose one of us to jump off the Brooklyn Bridge as an act of loyalty."

"That's crazy," said Adam. "What happened to the guy?"

"Oh, I survived," the old man replied. "But that wasn't the worst

of it. We were still getting along pretty good until members of our group started to die. It always seemed like an accident or a suicide, but it kept getting harder to accept."

"Tell him about the T-shirts, Harold." The old woman was standing in the hallway. She hobbled into the room and sank into an overstuffed easy chair. "Tell him about the tie-dyes."

The old man sighed and explained how Sam, who was supposedly a cousin of Bobby Beausoleil, had made these special tie-dyed T-shirts and handed them out to several "chosen" members of the clan.

"And?" Adam asked. "What happened to the people who wore the tie-dyes?"

The old couple looked at each other. "Let's just say nothing good ever happened to any of them," the old man answered.

"Nothing good at all," the woman added. "I thought the T-shirts were dyed with blood. That's why I never wore mine."

The old man nodded, "That's when we decided to leave the group."

The old woman became silent, clicked on the television, and began staring into space. "I'm going to have to ask you to leave now," the old man said. "There's nothing more to tell."

Adam returned home calm and resolute and began formulating his plan. The first thing he did was clean his apartment. Next, he went to the store and bought some groceries and a few bottles of wine. Then he came back home and waited.

He didn't wait long. The next day was Friday and his phone rang early in the morning. "Baby, it's me," cooed Tina. "I'm sorry I didn't call sooner. I've been in a horrible mood. You know how upset I've been since Andrea died. I've just been staying home. Can I come see you tonight? I miss our weekends together."

When Tina arrived, Adam was cooking up a storm. It was a vegetarian delight with steamed eggplant, couscous, black beans, fried tofu, sautéed vegetables, and a spinach salad. The lights were dim and tall candles were burning on the dining room table. A bottle of red wine was already uncorked and the XM radio was playing classics from the '60s.

"Did you bring any weed?" Adam asked.

The question caught Tina off guard. "What? Oh yeah, I did," she answered. "We, uh, I have a connection for this great homegrown."

Adam laughed and said, "Well, get rolling, honey, we've got a big night ahead."

Their dinner was sweet and gentle, with just a hint of sadness. They each played their own familiar part and it almost felt like old times. After the meal, much wine, and smoke, Adam took Tina into the bedroom and tenderly made love to her.

Through it all, Tina declined to remove her shirt.

Afterward, Adam whispered, "I'm going to take a shower, want to join me?" "No, I don't think so," she sighed. "Come on," he urged. "I'll scrub your back." "I said no!" she snapped. "Just take your shower and quit bugging me!"

In the shower, Adam calculated his next move. He thought he would distract Tina with more sex but when he came out of the bathroom she'd already left the bed. The music was turned up loud, but he could hear her moving their dinner plates into the kitchen. Adam threw on a robe and came out into the living room.

Then Adam realized that he was feeling very strange—kind of lightheaded and queasy but more than just that. He sat down on the couch and stared at the Persian rug under his feet while Tina cleaned off the table and washed the dishes. The music seemed to whirl around

his head and he could almost see the notes as they streamed from the speakers. Finally, it occurred to Adam that Tina had slipped him some sort of hallucinogenic drug.

He wasn't sure how much time had passed, but when he looked up Tina was standing in front of him. She wasn't smiling.

He confronted her—almost without words. "Why?" he asked.

"I thought it would bring us closer together," she answered. "But that's never going to happen. You're too uptight."

With that, Adam's rage came pouring forth. He swore at Tina, insisting that the T-shirt was cursed and demanding that she take it off so that he could destroy it. The dispute degenerated into a tirade of mutual resentments as they screamed and brought up old grudges. Haunting rock music blared as Jim Morrison intoned, *"This is the end, my only friend, the end."*

Adam tried to rip the tie-dye from Tina's body. She picked up an ashtray and swung it at his head. He tackled her and they began rolling around on the floor.

Somewhere in the course of their struggle Adam began to get aroused and Tina started moaning. "Fuck me," she cried, pulling his hair. They toppled over a bookcase as Adam raised Tina's legs over his shoulders. He was seeing vivid colors all around him and the music of the Doors was pounding into his brain.

They were screwing under the dining room table when Tina accidentally called him Clem. Adam locked his hands around her throat and shouted, "Clem? I should have known! I could kill you!" The pair flailed violently, knocking over the candles on the dining room table. Flames shot up around them as they fought.

By the time the fire department arrived, the apartment was consumed in flames. The building had to be evacuated and it took five hours to extinguish the blaze.

A few months later, the old hippie couple opened their garage door for another sale. And while Harold put up a sign on the front lawn, his wife slipped another tie-dyed T-shirt into the bottom of the box on the makeshift counter.

Then she sat down, and began staring into space.

—The End—

ALMOST

Did I ever tell you about my young friend Danny Whitehouse? Danny was a teenaged rock obsessive who listened to all the current music—then he saw the movie *Almost Famous* and it changed his life.

Danny really loved *Almost Famous* and after watching it about a dozen times, he began buying old vinyl from the '70s, specifically albums by the artists featured on the *Almost Famous* soundtrack.

He was a methodical music fanatic and began by getting every old Allman Brothers Band album he could find. He loved Greg Allman's voice and the way Duane Allman's slide guitar burned around Dickey Betts's stinging leads.

From there, Danny moved into the southern rock stylings of Lynyrd Skynyrd and their famous three-guitar attack. Danny thought Skynyrd weren't quite the musicians that the Allmans were, but they rocked a lot harder and singer Ronnie Van Zandt wrote some meaningful songs.

It wasn't long before Danny was scouring the used bins for albums by Led Zeppelin and the Who. *Almost Famous* used an instrumental piece from the Who's rock opera, *Tommy*, and while the tune showcased familiar riffs from Pete Townsend's guitar, it was John Entwhistle's rumbling bass that captured Danny's imagination. And while

Led Zeppelin's dynamic, blues-based music was exhilarating, he actually preferred the softer, more romantic side of Jimmy Page and Robert Plant.

Danny really began picking up speed as he acquired old albums by Simon and Garfunkel and Cat Stevens. While he treasured *Tea for the Tillerman*, Danny found Cat's later recordings less interesting. The same went for Elton John and Rod Stewart—Danny cherished their early stuff but decided that they had lost artistic depth as they aged.

Then Danny immersed himself in the arty eclecticism of early Todd Rundgren and the lighter-than-air psychedelia of midperiod Beach Boys. He loved the fact that Rundgren played all of the instruments by himself in the recording studio. Beach Boys albums like *Holland* and *Surf's Up* convinced Danny that Brian Wilson's orchestral pop harmonies and acid-tinged production were the work of absolute genius.

From there Danny went on to the prog-rock of Yes and the androgynous glam-punk of David Bowie. Danny imagined that the Yesmen had studied classical music and thought that Bowie had gotten a lot of mileage out of imitating Lou Reed.

Danny delved into psychedelic garage-rock and spent a big chunk of change on a pristine copy of the original *Nuggets* collection.

I was impressed when Danny pursued the seductive R&B of the blind soul singer Clarence Carter. Carter's version of "Slip Away" was used in *Almost Famous* as well as the film *Wonder Boys*. I assumed that Danny would begin another acquisition process based on *Wonder Boys*' retro soundtrack, but he never even bothered to see that movie.

Instead, he purchased a copy of Thunderclap Newman's first album, the one with the song "Something in the Air." Danny paid a premium for vinyl with the original cover art and was happy to learn that Pete Townsend had produced the record.

234 - MITCH MYERS

But there was one tune on the *Almost Famous* soundtrack that really turned his world upside down. Stillwater's "Fever Dog" begins with a bone-crushing riff and a hearty wail from the group's lead singer. With the song's sinuous bass line, stratospheric guitar, and Cro-Magnon drumbeats echoing in his ears, Danny was eager to purchase any and all albums by Stillwater—but it was not to be.

You can imagine his disappointment when a clerk at the record store told him that Stillwater was just an imaginary band, created expressly for *Almost Famous*.

At first, Danny couldn't believe it. "But 'Fever Dog' sounds so great," he cried. "If their music is totally contrived, what does that say about all of these other records that I've been buying? They don't sound all that much better than Stillwater!"

So that was it for Danny and his record buying. As a matter of fact, he sold off all of the old albums that he'd been collecting so obsessively.

Danny took that money and bought himself an electric guitar. Nowadays he leads a '70s cover band and plays gigs every once in a while at a club downtown.

Perhaps you've heard of Danny's band. They're called "The Cameron Crowes."

(Hey, what about the Oliver Stones?—ed.)

A TRUE STORY

I believe it was 1981. I was a college student at Southern Illinois University in Carbondale. My sister, her boyfriend, my date, and I were attending a big Jeff Beck concert at the local arena. It was a little bit more than halfway through the show when I turned to my sister's beau and said, "Do you have a comb?"

He acknowledged that he did indeed have a comb and pulled it out of his back pocket to offer it to me. So I said, "Throw it on the stage."

He said, "What?" and I said again, "Throw it on the stage."

Of course, things were pretty noisy with Jeff Beck wailing away on his guitar and my sister's boyfriend wasn't exactly the smartest dude anyway, so he said, "What?"

This time I yelled at him, "Throw it on the stage! Throw the comb on the stage!" The poor guy just looked at me, unable to see any purpose behind my command, and stood there frozen with the comb in his hand.

Finally, I said, "Screw it" and grabbed the comb from him. I hurled it onto the stage where it fell about ten feet from where Jeff Beck was playing his guitar. For the next twenty minutes we watched Jeff Beck with rapt attention.

"He didn't see it," my date said. "Just wait" was my measured response.

Naturally, my sister's boyfriend was kind of angry that I had thrown his nice comb onto the stage, but we were never that close and I wasn't too concerned about how he might have felt.

The show began drawing to a close and Jeff Beck was standing just a few feet away from the stupid comb. As he stalked the stage, Beck seemed to be walking all around the comb but never looked down or gave any indication that he might have noticed it lying there.

"He doesn't see it!" my date shouted. "Just wait!" I yelled.

Then, Jeff Beck was standing right over the gosh-darned comb, his legs splayed in a classic rock guitar-god pose. We were going nuts in anticipation. "He doesn't see it!" my date screamed as she pounded on my shoulder with her fists. "He sees it!" I screamed back.

Suddenly, as if on cue, Jeff Beck reached down, grabbed the comb, and viciously attacked the six strings of his electric guitar making a raucous, buzz-saw squall with the teeth of the plastic utensil.

Then he threw the comb back into the crowd.

After the show was over, everyone kept asking how I'd known that Jeff Beck was going to use the comb I'd thrown his way. I answered then as I do now—with a shrug, and then a wink.

And although I can't ever seem to recall the name of my sister's old boyfriend, you have to admit, it was a night to remember.

SPIRITS, GHOSTS, WITCHES,
AND DEVILS

On July 21, 1967, Albert Ayler was dressed in white and blowing his saxophone up toward the heavens. Ayler often reared back and played with his tenor pointed high, but this time the gesture had a particular spiritual significance; he was performing at John Coltrane's funeral services. At Coltrane's request, only Ornette Coleman's ensemble and Ayler's group played at St. Peter's Lutheran Church in Manhattan that day.

Since Ornette Coleman was considered Coltrane's equal—one who'd contributed greatly to the birth of a new, original music—it was easy to imagine Trane's parting gesture as a passing of the torch to Ayler, the younger saxophone hopeful.

The free-jazz explosion of the 1960s had been instigated years earlier by a few select visionaries: pianist Cecil Taylor, who combined his classical training with a doggedly improvisational approach; altoist Coleman, who brought his exceptional quartet from Los Angeles to New York in 1959 and blew everybody's minds; astral bandleader Sun Ra, who claimed to be from outer space and led the most innovative big band since Duke Ellington's; and the determinedly inventive saxophone giant, John Coltrane.

238 - MITCH MYERS

Albert Ayler arrived on the scene well after those innovators, when New York was teeming with young musicians caught up in the sounds of the changing times. The music they made had many different names: the New Thing, free jazz, energy music, and avant-garde. Later on, it was called Black Classical Music or Great Black Music, though some practitioners were white.

Race could be an issue, but it was the confluence between black and white bohemia—often occurring in the East Village—that allowed for much of the new music to develop. Free jazz wasn't being played in clubs at the time, and the musicians were forced to create their own scene amidst a shifting urban backdrop.

The culture wars had begun and avant-garde jazz coincided with the civil rights movement, the Vietnam War, political assassinations, psychedelic consciousness, white and black radicalism, and the influx of Eastern philosophies. Old beats and young folkies were still cavorting in Greenwich Village cafés near the corners of Bleecker and Mac-Dougal, and rock 'n' roll was rearing its head for the second or third time.

Brandishing its deep black cultural roots, the "New Thing" came to life in Village coffeehouses like the Take 3 and converted performance spaces like the Astor Place Playhouse or the Dom. It thrived in outdoor parks, community centers, lofts, and the sawdust-and-spit confines of Slugs' Saloon on the Lower East Side.

"We were all in New York during the revolution," remembered saxophonist Sonny Simmons. "And all them bad motherfuckers were rebelling against all that old, tired shit. We had Duke Ellington and Count Basie and all them swinging, jamming and jumping off of the rafters. Here comes the Beatles, and here comes James Brown talking about 'Give it up.' Here comes Marvin Gaye, all these people—Smokey Robinson, Janis Joplin, and Big Brother and the Holding Company.

The brothers changed things, but Albert Ayler . . . was the only brother I know, other than Eric Dolphy, who shook Coltrane up. I was there and I witnessed it."

The voices of free jazz converged in Manhattan and then shot out across the world. Besides the groups of Coleman, Taylor, Sun Ra, and Coltrane, other improvisational collectives were emerging and a grand sense of unity pervaded.

"We were all in the same place at the same time," recalled drummer Rashied Ali. "It was so strange how we all were thinking about playing something different as far as the music was concerned. Everybody was so compatible—we were into the same kind of a groove and it was great."

In 1964, the free-jazz scene coalesced into a series of concerts—wryly called the October Revolution—held at the Cellar Café. Many of the renegades who participated in the October Revolution also helped to form the (short-lived) Jazz Composers Guild. Albert performed with them, but he never joined the organization. Ayler was soft-spoken, articulate, and enthusiastic, and he followed his own vision.

"I walked into the Take 3 one night in 1963," said trombonist Roswell Rudd. "I heard something the likes of which I never heard before, which was Albert Ayler—in a green leather suit with a white patch on his beard—and Cecil Taylor and [drummer] Sunny Murray and [bassist] Lewis Worrell playing on the far side of the room. I was just shattered by what they played, so when Albert came to the front to go outside, I introduced myself. I said, 'Who are you?' He said, 'Oh, I'm nobody.' I said, 'Well, it didn't *sound* that way.'"

"Albert was not only original, he was incredibly accessible," maintained pianist/composer Carla Bley. "People who didn't even understand music could get into what he was playing because it was that joyful kind of playing, upbeat and with some very maudlin elements.

It was beautiful and we all just loved it—everyone I knew at that time, which was a bunch of freaks."

Ayler's sonic journey essentially paralleled the emergence of free jazz. Many other free players enjoyed lengthy careers, but his time on Earth was cut short. On November 25, 1970, Albert's body was found floating in the East River.

His death at the age of thirty-four was an unexpected tragedy, mysterious at the time and still shrouded in a little bit of did-he-jump-or-was-he-pushed speculation.

The improvisational scene that he helped to launch continues to evolve, but Ayler's immense sound will always epitomize the free-jazz boom of the 1960s.

Albert died the same year Jimi Hendrix did. Both men were cosmic musicians who spread a universal message before leaving this planet for places unknown to you and me (but not to Sun Ra). There were other similarities: They both enlisted in the armed services and later interpreted "The Star-Spangled Banner" (Albert three years before Jimi). Each used his instrument to create groundbreaking sounds, and both were hip minstrels who spoke in ecstatic terms (remember Hendrix's vision of an electric sky church?). Both experienced undue pressure from the music business and died under abrupt, premature circumstances. Numerous concert recordings by both men have been released posthumously, and the mystique surrounding their deaths—and their cults of personality—endures.

But Albert Ayler's existence has an even greater context that must be considered. "The story really begins in 1899," said Sonny Simmons. "That's the year Duke Ellington was born."

So then, with the entire history of jazz as a guiding light, let's examine the life and times of Albert Ayler lest his spiritualized music and buoyant message be passed over one more time.

On July 13, 1936, in the Cleveland suburb of Shaker Heights, Albert was born into the deeply religious, middle-class household of Edward and Myrtle Ayler. Edward played the saxophone and he gave lessons to Albert and his younger brother, Donald.

The boys performed duets with their father at church, but it was Albert who displayed the prodigious talent. At age ten, under the supervision of jazz enthusiast Benny Miller, he began studying at the Academy of Music.

When Albert was twelve his mother became handicapped, unable to walk, and his father abandoned the Baptist Church for a more fervent Pentecostal congregation. Albert played alto saxophone and oboe and occupied first chair in the high-school band. As captain of the golf team, he brought home several trophies—an unlikely feat for a diminutive black kid growing up in segregated Cleveland during the early '50s.

Intrigued by the big-sounding tenor saxophonists of the time, an underage Albert started sneaking into nightclubs with his friend Lloyd Pearson. Albert also joined his friend's new band, Lloyd Pearson and the Counts of Rhythm.

Albert was at a local jam session when he came to the attention of "Little" Walter Jacobs, a tough harmonica player who'd been a mainstay in Muddy Waters's group. Albert played Cleveland gigs with Jacobs and joined the hard-living bluesman for two summers on the road. He also played (briefly) with the talented R&B singer from New Orleans, Lloyd Price.

Working the bruising bar circuit with these journeymen was difficult for young Albert. He wasn't used to the hard traveling, or playing for rowdy audiences. The older musicians drank heavily, and Walter chastised the young man for not knowing how to hold long notes on his saxophone. Albert eventually mastered that crowd-pleasing technique,

and other aspects of his education in great black music took precedence. He started dressing the part of a hip, downtown slickster and had no trouble meeting women.

Graduating from John Adams High School in 1955, Albert considered college, but like many young men of his generation, he joined the army to improve his lot. A fledgling bebopper with alto in hand, he arrived at Fort Knox, Kentucky, in 1956. There, he met bassist Lewis Worrell and drummer Beaver Harris, both of whom would later "convert" to free jazz and play with Albert (again) in the 1960s.

And just as he shifted from gospel to R&B and finally to jazz, the army moved Albert from Cleveland to Kentucky and then Europe, where he spent most of his time stationed in Orléans, France.

He entered the service a straight-ahead jazz musician, but Albert's army stint pushed him in some unanticipated directions. As part of the U.S Army's 113th Military Band and later the 76th Adjutant General's Army Band, he spent hours practicing martial music and consuming the proximal sounds of the French military bands.

As a member of the 76th, he rehearsed constantly and honed his ability to read music. The army band traveled across France and Germany as Albert played pop, jazz, anthems, and local hits, as well as the requisite military themes.

Ayler was still listening to the newest records by Coltrane, Coleman, and Sonny Rollins, but he was also digesting the European folk forms of France, Sweden, and Finland. Later in his career he would perform circular renderings of the French national anthem, "La Marseillaise." This was before the Beatles used the regal theme to introduce "All You Need Is Love."

More significant was Ayler's sage appropriation of a quaint melody from a 1961 Swedish radio hit called "Torparvisan" ("Little Farmer's

Song"). Ayler's composition, which he titled "Ghosts," only tangentially resembles the Swedish ditty, but its joyful, singsong melody would become an unofficial anthem of the free-jazz movement.

"Most folk music is very simple and not burdened by fancy harmonies," said Copenhagen-born altoist John Tchicai. "It's down to earth and original, and in most cases, it's public property, free for all to use and interpret. If one makes an interpretation of a folk song, it isn't necessary to think of composers' rights; you can thereafter call that piece of music for your arrangement. Albert was looking for simplicity. His approach was to go deep into the music, to look for the roots in the material and to express himself with that through his spirituality."

While he eagerly absorbed contrasting musical disciplines, Ayler's quest for his own sound was an ongoing struggle. He was hip to bebop icon Charlie "Bird" Parker—Ayler was sometimes called "Little Bird" back in Cleveland—but while playing at the USO clubs and the Paris cabarets, Albert took a hard left turn.

Deconstructing well-known standards on the bandstand, his savage sound and fractured sense of time became increasingly aberrant. French audiences howled, and fellow musicians were quick to leave the stage when he heedlessly disrupted the familiar bop melodies.

Still, Ayler cut a sharp figure in Europe, and the little black man, dressed in tailored leather suits and multicolored hats, was by all accounts outgoing and sociable. His new sound was just too freakishly emotional for conventional jazz fans and he was ridiculed to his face, behind his back, and on the bandstand.

Some musicians maliciously called Ayler "The Dwarf," and after making him wait all night to sit in, they'd desert the stage or simply refuse to play. Undaunted, Albert kept searching for new musical allies.

Albert had switched from alto to tenor saxophone, giving him a

more emotive, fundamental sound. Illuminating his great black heritage, Ayler's raw playing traced a lineage from the Baptist church and gospel hymns to blues shouts and jumping, moaning R&B. It connected Albert to previous generations of saxophonists like Lester Young, Illinois Jacquet, and Earl Bostic, as well as progressives like Rollins and Coltrane. His was the lost history of jubilant Dixieland, not to mention boss tenor players like Big Jay McNeely, crowd-pleasing honkers who performed lying on their backs or walking the bar at crowded speakeasies.

In early 1961, Ayler was transferred to Fort Ord, California, near Monterey, to await discharge. He was only in California for a short time, but the jazz community there still managed to reject him, just as they'd snubbed Ornette Coleman years earlier.

When Albert finally returned to Cleveland, he was a changed man. His saxophone style was barely recognizable and he was already planning a return to Sweden, where the women were blond and the music fans more receptive to new ideas.

Sweden wasn't everything that Albert had expected, however, and he ended up playing on conventional tours with unremarkable dance combos. He tried to sit in with musicians whenever he could, but Albert mostly alienated the Scandinavian players, as well as the cash-conscious club owners and their unsuspecting patrons.

Meanwhile, his tenor attack was growing even stronger, his use of vibrato more strident, and Albert was promptly banned from jam sessions in Stockholm.

Ayler met several legendary jazz players in Sweden, as northern Europe was a haven for black musicians with its appreciative audiences, paying gigs, and relief from America's racism. Albert encountered his hero Sonny Rollins, elfin trumpeter Don Cherry, and, most important, pianist Cecil Taylor.

Albert was ecstatic upon hearing Cecil Taylor's group in Stockholm; he'd finally felt the rapport he was searching for and pushed himself onto Taylor's band, playing with them in Copenhagen and extracting a promise of more jobs in New York. He enjoyed a special affinity with Taylor's drummer Sunny Murray and began making his plans to return to the United States. With his own sound emerging, Albert had heard the call of freedom.

"Albert was one of the free medicine men that we had bestowed on us by the creator; John Coltrane, Cecil Taylor, Ornette," explained Sunny Murray. "Albert and I were part of the 1936 baby boom—and we're all medicine men."

Before leaving Europe, Ayler made two recordings as a bandleader. His first album, *Something Different!!!!!!*, was cut at the Stockholm Academy of Arts with an unremarkable Swedish rhythm section and an audience of twenty-five people.

Three months later, just days before returning to America, Albert taped a radio program in Copenhagen with Danish pianist Niels Brønsted, a (phenomenal) sixteen-year-old bassist named Niels-Henning Ørsted Pedersen, and a fellow American expatriate on drums, Ronnie Gardiner. The radio session was subsequently released as *My Name Is Albert Ayler*.

On this recording, after a shy, spoken-word introduction, Albert Ayler abandoned his mild manners and embraced a decidedly ardent sound. He performed four standards and one original tune. You can hear the struggle between the group's bop-conservatism and Albert's new, visceral expressiveness.

He mostly used the tenor on *My Name Is Albert Ayler*, but Albert did play soprano sax on "Bye Bye Blackbird" and another old chestnut, "Summertime." On Ayler's "Summertime," George Gershwin's plaintive tune becomes a bent, musical psychodrama as Albert's

vibrato-laden tones sweep and search, wringing every bit of mawkish emotion from the tune's familiar melody.

So began Ayler's ascension in the new-jazz ranks. But things moved slowly upon his second return to Cleveland and in spite of an opportune jam with Coltrane's quartet, Albert was still treated with confusion and rebuffs. He was spotted hawking *Something Different!!!!!!* on the streets of his hometown, to no great success.

Thanks to the availability of an apartment in a house his aunt Beatrice owned on St. Nicholas Avenue in Harlem, Albert moved to New York and began his revolution in earnest.

Word spread about the forceful young saxophonist and when Albert joined Cecil Taylor's group onstage at Philharmonic Hall on New Year's Eve 1963, the anticipation was high.

"We were all waiting for Albert to come onstage, and all of a sudden we hear this towering tenor sound from the dressing room," remembered pianist Burton Greene. "He just came straight out of the dressing room with this towering sound and walked onstage. The only way I can describe it is 'towering'—and it's kind of an earth-shattering experience to hear that. The power coming out of this little guy, it was just a constant stream of energy."

Albert was gaining a reputation, but he was still hard up for paying work. He frequented clubs like the Half Note and the Cellar Café, where he sat in with Coltrane and other jazz musicians including Canadian pianist Paul Bley and bassist Gary Peacock.

"I met Albert in 1963," recalled Peacock. "Paul Bley and I were working the Take 3 coffeehouse down in the Village. I asked if there were any horn players who might be able to join us. (Sun Ra's) John Gilmore wasn't available for this one gig, but he said, 'Do you know who Albert Ayler is? You might want to check him out.' Albert came

down, and that was the first time I heard him play. As far as shocking me, I had never heard anybody play like that before. One time he stopped by my place in Chelsea and said, 'I have a surprise for you. Around three o'clock this afternoon listen for me.' He had gotten on a ferry to go to Staten Island and from where I lived in Chelsea you could hear the ferry when they blew their horn. I'll be damned if at three o'clock in the afternoon I couldn't hear him on the ferry. He was exceptional that way."

Albert was no longer working as a sideman with Cecil Taylor, but he received new opportunities as a bandleader. And just before a lengthy tour of Scandinavia with Gary Peacock, Sonny Murray, and Don Cherry, he made two cutting-edge recordings, *Witches and Devils* and *Spiritual Unity*.

Spiritual Unity, a trio date with Peacock and Murray, is considered to be Albert's landmark session. It was released on ESP, a record label founded by Bernard Stollman, an entertainment lawyer who'd worked on the estates of Billie Holiday and Charlie Parker. Stollman was enamored with the cultural avant-garde and his label reflected the outer limits of underground taste: no producers, one-shot recording sessions, and psychedelic packaging. "Only the artists decide what you will hear on their ESP-Disc," was their credo. Later on, the label exclaimed, "You never heard such sounds in your life."

ESP—so named for Stollman's support of the contrived universal language Esperanto—released records by fringe jazzmen like Ornette Coleman and Sun Ra. ESP was also the home of beat/rock/folk misfits like the Fugs and Pearls Before Swine. But the very first artist to have his own album released on ESP was Albert Ayler.

Recorded July 10, 1964, *Spiritual Unity* is arguably the first "free" jazz album. While Ornette, Cecil Taylor, and a few others had made

records pioneering the avant-garde, *Spiritual Unity* was the first album that *completely* eliminated the concept of time. That is, the new music wasn't at all dependent on rhythm.

Even the groups of Coltrane and Coleman had relied on conventional rhythm sections. But on *Spiritual Unity*, Peacock and Murray did not play in any sort of lockstep repartee. Instead, the bassist and drummer provided blatantly individualistic responses to Ayler's cathartic improvisations. Their performances did have a certain velocity— a sometimes-wavering momentum that was either fast or slow—but the dialogue between Ayler, Murray, and Peacock came from hard listening and active spontaneity.

Thanks to the dissolution of metric time, solos in the conventional sense were dispensed with and *Spiritual Unity* became a collective exhibition in creative freedom.

But that's not all. "He played beautiful melodies," insisted Carla Bley. "It wasn't just that he could play free or that he invented playing free. He played beautiful melodies and that's just something that people respond to."

Spiritual Unity included two different versions of Albert's classic, "Ghosts," and another tune entitled "Spirits." Names of other Ayler compositions—"Witches and Devils," "Saints," "Prophecy" and "Spirits Rejoice"—give a further indication of his reverent perspective. The ethereal titles betrayed Albert's extreme religiosity and his messianic bent. For just as he experienced his music to an intense degree, so did Albert feel—and see—his religious convictions to an extreme.

Albert had visions; at least that's what he claimed in a 1969 essay penned for jazz journal *The Cricket: Black Music in Evolution*. He wrote, "It was at night when I had this vision. In this vision there was a large object flying around with bright colors in a disc form. Immediately I thought of the flying scorpion that I had read about in the

chapter of Revelation from the Holy Bible, but when the object started turning I saw that first it was flat then it turned sideways and started to shoot radiant colors at first then it would turn back to the same position. I was running with my brother when it aimed at us but it didn't touch us at all. I guess this is what they are calling the flying saucers. Anyway, it was revealed to me that we had the right seal of God almighty in our forehead."

Albert's European tour in the fall of 1964 was successful, and not without positive controversy. But trumpeter Don Cherry, who'd worked as a foil for saxophone legends like Ornette, Trane, Rollins, and Archie Shepp, wasn't interested in staying with Ayler. And even before Cherry left that winter to pursue his wanderlust, Albert had already spoken to his own brother, Donald, in Cleveland, encouraging the younger Ayler to ready himself to join the band.

Donald Ayler had only recently switched from alto sax to trumpet when he got the call from Albert. Less mature than his older brother, Donald had made his own pilgrimage to Sweden and returned claiming to have hitchhiked thousands of miles to the North Pole. The prospect of working with Albert's group demanded rigorous preparation, so Albert enlisted a Cleveland altoist named Charles Tyler to help get Donald up to speed.

But no matter how much practicing Donald might do, he would never be a virtuoso like his brother. Albert's bandmates questioned the logic of bringing Donald into the group; his playing sounded infantile compared to the impassioned spitfire of Don Cherry. What could Donald really contribute? Many say not as much as Cherry. But the kinetic synergy, the harmonic kinship, and musical twinship between Albert and Donald would not be denied.

When the Aylers played together, something occurred that went beyond conventional wisdom. He wasn't technically gifted, but Donald's

energetic trumpet magically resonated with Albert's saxophone style.

So, besides showcasing his ecstatic squawks, guttural honks, rapid-fire delivery, dazzling multiphonics, and a wrenching vibrato, Albert was now playing his high evangelical sound alongside his brother, Donald, echoing the church duets of their youth and evoking the joyous spirits of ragtime.

Together, the brothers embraced the simple melodies of European folk songs and the vintage Americana of Stephen Foster. They played the marching music of military bands and old familiar bugle calls, and when they embraced the revolving themes and shimmering free-jazz anthems like Albert's "Truth Is Marching In," it was a complete, consecrated communion.

"Albert and his brother sounded to me like they were from New Orleans or someplace down South," said bassist Henry Grimes, who met Albert in the early '60s playing with Cecil Taylor. "That's where I thought they came from. Their music was so strong that it went back to roots that nobody ever pronounced."

Although they were gigging in Manhattan and Europe, the brothers were perpetually broke and required frequent relief. And much like writer Jack Kerouac endlessly returning to his mother, Albert and Donald would often seek refuge with their parents in Cleveland.

Besides parents Edward and Myrtle, there was only one other person who acted as a benefactor to the Ayler brothers, and that was John Coltrane. For when it came to Albert, Coltrane was a true believer. The two men were close; they often spoke on the phone and even corresponded via telegrams.

Before succumbing to liver cancer at age forty, John Coltrane was inspired by Albert's intense spirituality and his towering saxophone sound. Late-era Coltrane recordings such as *Ascension* and *Meditations* reflect that direct influence.

Not only did Coltrane endorse Albert in interviews, but he also introduced the Ayler brothers during his portion of a 1966 concert at Lincoln Center called "Titans of the Tenor." Albert again strode on-stage blowing in cacophonous form, and while some spectators were enraptured by the screaming revelations of Coltrane and the Aylers, half the audience walked out.

"Sonny Rollins brought Yusef Lateef to the Titans of the Tenor, and Trane brought Albert because he thought Albert should be mentioned," remembered Rashied Ali, who played drums with Coltrane at that time. "He didn't have to bring Albert to that thing, he could of brought Archie Shepp, he could have brought a lot of different people, but he brought Albert because he respected what he was doing."

"Albert's music challenged all that had come before him," said ESP's Bernard Stollman. "From the first moment Coltrane heard Albert play, he acknowledged that Albert was the new force, that Albert had succeeded him in terms of generations of music."

At Coltrane's urging, his record label, Impulse!, signed Albert to a contract, resulting in 1966's *Albert Ayler in Greenwich Village*. The album cover resembles a psychedelic poster from the Fillmore, and Albert's group included violin and cello. On another Village recording, the string section was expanded to a foursome with two bassists. These larger groups created textured variations on Ayler's hovering, stream-of-consciousness meditations, and they amplified the recurring themes that flowed back and forth between Albert and Donald.

"All of Ayler's music is pretty traditional Americana in one sense," said bassist Alan Silva, who played on some of the *Village* sessions. "It was coming out of a real spiritual development and that rooted the music in the '60s. You can listen to the titles and see where he was going. He had a personalized way of playing, and he set up a whole way of thinking about that particular music, especially on a spiritual plane."

Veteran jazz scribe Nat Hentoff had another perspective on Ayler's sound. "The most significant thing I learned from talking to Donald and Albert," said Hentoff, "is that the ideal listener is the one who doesn't listen clinically or critically, but one that opens himself up to the whole of the music, not just part. This helped me later in listening to John Coltrane."

"Trane touched all of us musicians because he was the king of the avant-garde," said Rashied Ali. "When he embraced the music it got a little more recognition than it would have gotten without him. It was like a godsend for him to embrace our side because Coltrane could have gone in any direction that he wanted to. He just moved in that direction and Albert and all of them, they just moved with him."

When John Coltrane died, free jazz lost one of its guiding lights. Albert and Donald had played at Coltrane's funeral and were confronted with the void that the saxophonist had left. Impulse! was desperate to find its next saxophone star and was promoting three forceful tenor men: Ayler, Archie Shepp, and Pharoah Sanders. The New Thing had arrived, but Albert was drifting away from his brother, and the extraordinary music that they created together.

Toward the end of the '60s, Albert became involved with musician Mary Parks, who was also known as Mary Maria. As his lover, then manager and collaborator, Mary formed a bond with Albert that supplanted his relationship with Donald. Donald's heavy drinking exacerbated his own emotional problems, and the brothers ceased appearing together in interviews.

It was clear to some that Donald was headed toward a nervous breakdown. According to bassist Juini Booth, the breach between the brothers had ominous implications. He said, "Albert needed Donald and Donald needed Albert. When they split, that was the beginning of the end of them both."

Sonny Simmons recalls Donald complaining about suspicious characters hovering around Albert—shadowy figures and record-industry people telling Albert what to do and turning Albert against him. "Donnie was kind of losing it a little bit during that period, which was real sad," said Simmons. "The white boys would come over in their suits and ties like Madison Avenue lawyers and tell Donald, 'Get out. We want to talk to your brother.' I thought it was strange. I wouldn't let those cats talk to my little brother like that. Donald was very upset, and it fucked him up mentally. Here was the big brother Donnie grew up with, and Albert discarded him once they got to New York and he gets a big contract with ABC/Impulse."

Did Albert betray his brother? That's open to interpretation—bandleaders are often compelled to change personnel—but Albert's sense of guilt was very real. The unstable Donald relied on his older brother for work, and Albert was pressured by his parents to look out for his sibling. Albert never really told Donald that he was out, but by the middle of 1968, he was absent from the group's lineup.

Albert played on a couple of Donald's solo gigs, but the brothers would never work together under Albert's direction again.

Albert's later records were strangely commercial endeavors, with the music conforming to popular trends. *Love Cry* (1967) still showcased the patented Ayler sound, but that album had been made while Donald was still playing with the band.

Producer Bob Thiele had pushed Albert to use rock musicians in the studio and while his strident tenor sound remained intact, Ayler and Mary Parks started adding vocal tracks to some of his recordings.

Thiele made wholesale changes on Ayler's next album, *New Grass*. Despite Albert and Mary's objections, he added a horn section, replaced backup singers, and even swapped some of Parks's vocals with those of one Rose Marie McCoy.

On the 1969 album *Music Is the Healing Force of the Universe*, Ayler had Canned Heat axe man Henry Vestine play some Hendrix-styled psychedelic blues guitar. Albert even played the bagpipes, using his extraordinary breathing skills to create a keening, spiritual drone.

It all made sense in the context of the late '60s, but Ayler's cross-over experiments—incorporating modal rock, hard blues, psychedelic soul, mod poetry, and gutbucket R&B—muddled his image as an innovative jazz prophet. Coinciding with Miles Davis's groundbreaking electric fusion, the Ayler/Parks collaborations were stiff and unrealized, containing peace-and-love sentiments and a general softening of Albert's fervent sound.

Albert's music no longer seemed so daring, and his playing felt less free.

By 1969, Albert had basically stopped performing in public. He hadn't returned to Europe for a few years, but still had a good reputation overseas. So, when he was invited to the south of France to perform at a festival sponsored by the Maeght Foundation, there was little reason to refuse. With no advance preparation, Parks and Ayler enlisted his pianist friend Call Cobbs, drummer Allen Blairman, and bassist Steve Tintweiss and sped off to France.

At the 1970 Maeght Foundation concerts—performed under a geodesic dome in St. Paul de Vence—Ayler chose not to play his rock/jazz fusion. Instead, he entertained the European crowds with his old spiritualized style. The pickup group had never played together before but they gamely covered sanctified Ayler tunes like "Spirits" and "Holy Family."

The music at the Maeght Foundation sounded just a little bit melancholy when Ayler began the off-to-the-races melody of "Spirits Rejoice." Maybe it was because of all the time that had passed since Albert's sound first exploded like a solar flare onto the free-jazz scene. Perhaps it

was just the absence of brother Donald's ecstatic bugle-boy counterpoint as Albert toyed with "La Marseillaise" one more time.

The Maeght Foundation gigs reaffirmed Ayler's saxophone prowess, but stresses at home were mounting. Donald's mental health continued to deteriorate and he had to be institutionalized. The pressure from Albert's mother to be responsible for Donald's well-being was a constant harangue. Impulse! became less supportive and the label ultimately released him from his recording contract.

The '60s were catching up with Albert, and just as he was profoundly religious throughout his life, he could also become extremely depressed. He was seen wearing a heavy winter coat and gloves in hot summer weather with Vaseline covering his face, claiming that he had to protect himself.

Still, Albert had some things to look forward to. An upcoming tour of Japan was slated to make him a great deal of money and a new record contract was being negotiated.

That's when Albert wound up dead in the East River.

Although there is nothing conclusive about the circumstances surrounding his death, Albert may have jumped off the Staten Island Ferry. Mary Parks told the police that he had smashed things in their Brooklyn apartment and then rushed out of the house claiming blood had to be spilled to make it right between him and his family regarding the problems with Donald. She reported Albert missing, but weeks passed before his body was found.

According to the New York medical examiner's office, it was a death by drowning. With little evidence of foul play, authorities found no reason to conduct an autopsy. Sunny Murray once maintained that "hoodlums and drugs" were to blame and that Albert was in the "wrong place at the wrong time." Others who knew him said he wasn't likely to take his own life.

After his death, rumors swirled—that Ayler was found at the bottom of the river tied to a jukebox or that he'd been shot in the back. Donald—who has been in and out of group homes for decades and unable to live independently—expressed sentiments that Parks knew more about Albert's death than she revealed.

While Ayler's passing remains a mystery, the important question is this: What kind of music would he be creating had he survived? Of course, that riddle is unanswerable, but clues can be found on *Holy Ghost*, a nine-CD boxed set containing rare Ayler recordings from 1962 to 1970.

The title *Holy Ghost* refers to Ayler's comment, "Trane was the father. Pharoah was the son. I was the holy ghost." The massive CD collection includes early European performances with Cecil Taylor and Don Cherry as well as Albert's groups with Donald and other freedom fighters. There are interviews with Ayler and Cherry, and outtakes from the later Impulse! sessions.

Albert once said that his playing was a reaction to what was going on in America, but that he had found peace and then transformed that peace into a silent scream.

Bassist Steve Tintweiss heard Ayler's love cry during one of their Maeght Foundation performances. "Albert picked up his bagpipes and went to the front of the stage," Tintweiss explained. "He started playing very intensely, but there was no sound coming out. There was some sort of problem, and Albert was trying harder and harder, but there was no sound at all. Instead of doing what almost any other musician would have done—stopped, put it down, and picked up another horn or had someone else solo while they tried to adjust their instrument—Albert didn't do that. He just kept playing and imagining the sound of what he was doing. He was getting more intense, and the audience started applauding and yelling and urging him on, and it

looked like to me that for several seconds he levitated while he was playing. At that point, he looked like he had transformed into some sort of gremlin or a character like the mythological Pan on steroids. The audience was totally captivated and when he stopped there was this huge applause."

Albert Ayler is still at peace. Let his silent scream prevail.

OHM ON THE BRAIN

It was 9:00 A.M. in the year 2058 and Mrs. Abraham's third-grade class had just started their day. "Students," she said brightly. "Today we're going to learn all about electronic music!" The room of young boys and girls let out a low moan.

"There, there," Mrs. Abraham reassured them. "It won't be *that* bad. Now, will everybody please plug the information cable coming from the top of your desks into the receptor slots below your cerebral cortices? And that includes you, too, Billy Fields—no more disruptions."

All forty-five students complied with the instructions and swiftly became silent. Their eyes glazed and a few started to drool as their teacher pushed a button on her control pad and a cool synthetic voice began the three-hour lesson.

"In the latter half of the twentieth century, the union between man and machine manifested itself in a variety of systems, which prompted the advancement of electronic music into our mainstream population," the voice droned. "These were primitive times, however, and progress came quite slowly. While a groundbreaking instrument like the Theremin first appeared in the 1920s, three minutes of electronic

music in 1952 could still take up to six months to program—and all of the work was done *by hand*!"

Mrs. Abraham walked slowly around the room as her students listened to the computerized voice and accompanying sounds inside their heads: "Innovators like John Cage and Karlheinz Stockhausen introduced new conceptual possibilities in music, and experimental composer Edgard Varèse employed tape recorders as authentic music production devices. Certainly, the advent of Robert Moog's synthesizer was an important event in the genesis of modern music, but so were the works of Milton Babbitt, Morton Subotnick, David Tudor, and Luc Ferrari. While performances by composers like Terry Riley and Holger Czukay are now considered to be 'pop music,' they were once thought to be unconventional and appealed only to academics and hippie drug users."

Mrs. Abraham's class was well into the second hour of their music lesson when something went awry. They'd been listening to the excellent chapter on sound-design artists like Klaus Schultze, Jon Hassell, and Brian Eno when thick red smoke suddenly erupted from Billy Fields's ears.

It turned out that young Billy had been secretly manipulating the frequencies of his music lesson by attaching the information cable to his mood regulator instead of his cortex. The brat was getting high on modulated sound until a system overload caused a cerebral hemorrhage and an electric surge to occur simultaneously—which quite naturally fried little Billy's brain.

As a result, Mrs. Abraham's class was sent home early and her lesson on electronic music was removed from the weekly schedule.

ROCK 'N' ROLL HEAVEN

To quote the wisdom of that immortal sage, Tommy James, from his classic foray into psychedelic bubblegum, "Crystal Blue Persuasion," not "Crimson and Clover" . . .

> *Look over yonder.*
> *What do you see?*
> *A new day is coming.*
> *Most definitely.*

Well, I've looked over yonder and the new day has finally come. Telltale signs have been popping up for years. Really, it's as plain as the nose on Ringo Starr's face.

We first saw glimmers of this grand cultural shift with films like *Velvet Goldmine* and *Almost Famous*. Later on, the very same message would be driven home in *School of Rock*.

But wait, I'm getting ahead of myself.

Why do you think I keep mentioning writers like Nick Tosches and Richard Meltzer? Aren't those two just old dudes who scribbled record reviews for magazines like *Creem* and *Rolling Stone* in the late

'60s? Is there much value in the collected works of men who didn't even listen to some of the records that they critiqued? Are the blasphemous musings of Meltzer and the hard-boiled journalism and fiction of Tosches really that important?

The answer to that last question is—yes.

And what of the audacious music journo, Jim DeRogatis, choosing to author *Let It Blurt*, the first published biography of a rock critic in the entire history of mankind? Jim's subject, of course, was the late Lester Bangs. Bangs was a fanatical music scribe who came up the ranks at the same time as his drinking buddies, Meltzer and Tosches, both of whom devote plenty of space to Lester in their respective anthologies. Naturally, Richard and Nick get mentions in the Bangs bio; pictures, too! Lester died in 1982 at the age of thirty-three, but left an indelible mark on rock writing and continues to rouse hard-core fans to this day.

Another telltale clue to this conundrum can be found in the movie *High Fidelity*, which was an adaptation of Nick Hornby's rock novel. *High Fidelity* was filmed and set right here in my hometown of Chicago and starred John Cusack. He plays the owner of a small record shop who has trouble making commitments in his relationships but knows more rock trivia than Rodney Bingenheimer.

What exactly am I getting at with all of this rock 'n' roll nonsense? Okay, I'll spell it out for you. ROCK GEEKS ARE FINALLY COOL! Yes, all of you hepcats that know who played bass with the third edition of King Crimson can rejoice, your time has finally come.

Our hero in *High Fidelity* is cool because the movie star, John Cusack, is portraying him. Actor Jack Black stole the show by being an even cooler geek than Cusack, but Black's character transcended his status as a rock geek in *High Fidelity* (and again in *School of Rock*) by becoming a rock performer—and that goes double for Black's mock-rock pursuits with Tenacious D.

That's what every rock geek really wants deep down inside anyway— to be a performer—which is why rock geeks have always been so UNCOOL to begin with.

Of course, Meltzer and Tosches are totally cool because they turned their backs on music writing years ago. Bangs is cool for one main reason—the guy is dead. All we really have to remember him by are two posthumous collections, the DeRogatis bio, and Philip Seymour Hoffman's strange portrayal of Lester in *Almost Famous*.

Now, I must admit that those old rock writer guys inspired me. I'm pretty sure that they influenced DeRogatis, not to mention his partner on the *Sound Opinions* radio show, critic Greg Kot. Yes, once a week you can hear two white guys sitting around playing records and talking about rockstuff. Cool, huh? And with the rise of satellite radio, this sort of rock 'n' roll discourse is becoming even more plentiful.

Honestly, I think that all geek-speak should be conducted in the privacy of one's own home and then only with consenting adults present. Otherwise it's like going out on a double date and spending the entire evening talking sports trivia with your buddy (sorry—not cool).

Maybe all of this is just wishful thinking. I've been waiting for the day when my rock geek mind would get me laid, and I'm not going to pass up this opportunity no matter how bleak my chances may be. Hey, any of you gals want to come over and see my record collection?

Just one thing, please don't compare me to Cusack's character in *High Fidelity* just because I'm a Chicago guy living alone in an apartment filled with records and CDs. That dude wasted all of his time organizing his collection in some kind of chronological order— everybody knows that you should file your albums by genre.

Are we cool?

THE MIX-TAPE
MURDER MYSTERY

Part One

Ross Melboro was a young detective down at the Third Precinct. He'd only been with the homicide division for six months and had yet to see any action out in the field.

The workday had just begun when the chief walked out of his office and hollered, "Melboro, I want you to get right over to a murder site uptown and give Detective Kowalt a hand!"

Jim Kowalt was a veteran homicide detective, known in the precinct as a real hardnose who preferred to work alone.

Ross jumped up from his desk and said, "Sure thing, Chief, what's the situation?"

"You'll find out when you get there!" barked the chief. "Now move it! It's 1859 W. Center Street, Apartment 3-A; the victim's name was Manning."

Jim Kowalt barely looked up when Ross arrived at the crime scene. "It looks premeditated," he said through clenched teeth. There, face-down in the front room of the spacious apartment was a middle-aged

man sprawled out just a few feet away from an expensive stereo system. He'd been stabbed to death.

"He's been dead for at least eight hours," Kowalt continued. "The upstairs neighbor called it in around three this morning. And whoever the murderer is, he's pretty cute."

"Cute? I don't understand," said Ross.

Kowalt pointed beside the body, "See this? Whoever stabbed him used an icicle or something that melted away, eliminating the possibility of finding the murder weapon or fingerprints. It's the oldest trick in the book."

"It must have been someone he knew," Ross suggested. "I mean, the murderer had to get pretty close to stab him in the back like that."

Jim Kowalt looked disdainfully at the young detective. "Come on, rookie," he said. "Let's go have a chat with that upstairs neighbor."

The two walked up a short flight of stairs. Ross examined the back of Jim Kowalt's crew cut as the elder detective knocked on the door. A small, frightened-looking man answered and let them in. He gave his story to the detectives in a faint, breathy voice.

"I kept calling downstairs because the music was so loud," explained Thomas Wolley. "He's directly below me so I can hear right through the floor. Mr. Manning didn't answer his phone, so I finally went down there and knocked. Nobody answered, but the door was open a crack and I kept yelling, 'Hello! Hello!' I thought he couldn't hear me because of the music being so loud, so I peeked inside. That's when I saw him in the front room. It was horrible."

Since he considered himself part of the investigative team, Ross started in on the questioning, "So, did you know the victim well, Mr. Wolley?"

"Actually, I'd only spoken with him once before," the neighbor replied. "That was about the loud music, too. He was always blasting

his stereo in the middle of the night. But Mr. Manning worked very strange hours and he usually left the house by four every morning, so I never actually saw him face-to-face."

"Well, tell me, Mr. Wolley," said Kowalt. "Did you hear anything else before you went downstairs, perhaps an argument or a struggle of some sort?"

"No, Detective," Wolley replied.

Unsatisfied, Kowalt prodded further. "I thought you said that you could hear right through the floor."

The upstairs neighbor was clearly upset. "I didn't hear anything like that," he insisted. "The music was awfully loud, that's all—I couldn't hear myself think. The whole experience was a nightmare!"

Detective Kowalt stood up abruptly and handed the man his card. "Well, thank you for your time, Mr. Wolley. I'm sure this all was very traumatic for you. If anything else comes to mind please give us a call."

As they walked back down the stairs Ross turned to Jim Kowalt and said, "Hey, why'd you cut it off up there? That guy knew more than he was saying."

Kowalt sneered, "Listen, golden boy, you follow my lead. Understand? I got everything I need from our Mr. Wolley. Besides, the chief didn't send you down here to ask questions."

Ross was already resenting his new partner. "So, why did he send me down here?" he asked.

"Well, you're still in your twenties," Kowalt answered.

"So, what does that have to do with it?" Ross said defensively.

"Well," said Kowalt. "The victim was a semifamous, financially successful, and not always well-loved radio personality—a shock-jock. Supposedly, he made guys like Howard Stern sound tame."

The detectives reentered the victim's front room and sat down on the couch not far from the body.

"But why did I get assigned to this case?" Ross asked again, averting his eyes from the corpse.

Jim Kowalt seemed embarrassed as he answered, "Well, the victim was holding a CD box in his hand, and the corresponding CD was in his stereo system."

"A jewel case," Ross said quietly.

"What? No, nothing like that," Kowalt snapped. "Nothing seems to be missing from the apartment and the guy didn't have any jewelry."

"No," Ross said with more authority. "A jewel case, that's what the plastic CD boxes are called."

"Well, that's why you got assigned to this case," Kowalt said. "I've already had the CD and the 'jewel case' sent downtown for fingerprints and DNA samples."

Ross was eager to hear more. "So, what CD was it?" he asked.

"Well, that's another thing," Kowalt answered, "apparently it was a custom-made job comprised of different songs by different artists."

"A mix-tape," said Ross.

"A tape? No!" Kowalt growled, "I said it was a CD, not a tape."

"No, that's what you call it," Ross insisted. "A mix-tape. That's what people call custom-made collections. I guess you'll need to show me the track listing. Was it written by hand?"

Kowalt squinted at Ross and hissed, "The what listing?"

Ross blurted back, "The track listing—the song list, whatever! I just want to know if there were songs listed on the CD box and if so, were they written by hand?"

"I thought you said it was a jewel case," said Kowalt.

Ross was frustrated with his senior partner. He tried again, "Okay, yes, the song list that came with the jewel case. Now, please tell me, was there a track listing and was it handwritten or not?"

Detective Kowalt looked out the window, sighed, and said, "Well,

yes and no. There was a 'track listing' but it wasn't handwritten and it wasn't typewritten either. It looked more like a CD that you would buy in the store."

"Probably computer generated," Ross muttered.

"What? The music?" Kowalt asked.

"No, the graphics," Ross said.

The two men sat in stony silence as Alex Manning's body was taken down to the police ambulance. After a few uncomfortable minutes, Ross tried to resume the discussion, "So, is there anything else on the CD box besides a list of the songs?"

The older detective smiled. "Jewel case," he whispered. "It's a jewel case, right?"

Ross Melboro's neck flushed crimson as he spoke deferentially, "Right, a jewel case. But is there anything else printed on it or not?"

Detective Kowalt leaned back on the couch and stretched. He put his feet up on the coffee table and answered, "Well, yes. In two places— on the front and on the spine. It says, '4-AM.'"

"So," asked Ross, "do you think this was a CD that the victim listened to early in the morning?"

"Well, maybe. But I wish it was that simple," said Kowalt. "You see, the victim's name was Alex Manning. His initials are AM. This complicates matters and we have to eliminate several possibilities."

"You don't think the murderer gave Manning the mix-tape as some kind of message or threat!" Ross exclaimed.

"Well, it's possible," answered Kowalt. "But there are other considerations."

Ross looked warily at the older detective and said, "Such as?"

Kowalt's sarcastic voice took on a singsong quality, "Such as, the victim's radio show was on the AM band during the morning drive time. So, besides representing Alex Manning's initials or a home listening

schedule, '4-AM.' could also mean 'For AM,' or maybe 'For A.M.,' as well as 'Four A.M.,' get it?"

"Got it," said Ross.

"Good," said Kowalt. "Because there's also the possibility that the victim may have made the mix-tape for somebody else. And if that's true, then there's an entirely different set of clues in the 'track listing' as to who the murderer might be. That's where you come in. But any way that you look at the mix-tape murder mystery, we already have several suspects."

"Whom," said Ross. "It's not who the murderer might be, it's whom."

Jim Kowalt stared incredulously at his young partner. "I don't think so," he replied. "Anyway, we have to talk to the victim's son this afternoon—he'd just started living with the victim before this happened. The son is twenty-two years old and the product of a marriage long lost to divorce. Of course, he claims that he slept at his girlfriend's house last night. And guess what his name is—Alex Manning Jr.—another AM! The kid had a stormy relationship with his old man, but he's the only heir and in line to inherit a small fortune."

"So, that's a motive," Ross said.

"Well, maybe, but it gets better," replied Kowalt. "Manning had a sidekick on the radio, this ethnic chick that always laughed it up when he insulted his guests or came on to the bimbos. Her name is Alesha Martinez—AM again. Haven't you heard of these people? They were a radio team for nearly ten years. Interestingly, they had a fight about a month ago. It was their first on-air dispute and apparently it sounded real and quite bitter. The station got hundreds of calls and e-mails, mostly begging for them to kiss and make up. And get this, they didn't speak to each other on the air for almost three weeks."

"So, what was the argument about?" Ross asked.

"Well," said Kowalt, "our victim was sleeping with one of the girls at the station who worked in advertising or sales or something like that. Manning would call her up and talk to her as part of the show. Sometimes their conversations would get pretty suggestive. They were a big item around town for a few months."

"And then?" Ross inquired.

"And then Manning dumped her," said Kowalt. "He broke up with her right on the show and started putting her down pretty bad. This seemed to set off his co-host—Alesha Martinez literally raged at Manning, confronting him on the program for being a self-centered misogynist who didn't know how to treat a woman, et cetera. They eventually worked out their differences and everyone had supposedly moved on."

Ross felt voyeuristic when he asked, "Did they have a relationship?"

Kowalt snorted, "You mean were they fucking? Well, there was always some speculation but they never acknowledged it one way or the other. Good for the ratings I suppose. They were tight though— that much is for sure."

Ross Melboro began brainstorming with his new partner, "You know, Alesha Martinez could have been jealous of Manning's girlfriend, but maybe she was jealous of Manning. I mean—maybe this Martinez likes girls."

Then Ross asked, "Hey, the ex-girlfriend in sales at the radio station, what's her name?"

Jim Kowalt smiled and said, "You won't believe it."

"Try me," Ross insisted.

"Her name is Angie Madison," said Kowalt.

"Damn," said Ross.

Jim Kowalt let a few moments pass and then muttered, "Well, there is one more thing."

Ross looked wearily at the veteran detective and said, "So, what's that?"

Kowalt pulled his reading glasses down from the top of his head, examined a few pages in his small green notebook, and said, "Well, Manning had a rival at another radio station. They would harass each other with elaborate pranks on the air. Last month, they ran into each other, twice at public functions. Both times things got physical between them. Supposedly they really hated each other and had taken to calling it a blood feud."

"Okay," Ross sighed, "what's the rival's name?"

Kowalt closed the green notebook, pushed his glasses back onto the top of his head, massaged his crew cut, and said, "John MacKay, of 'Mac in the Morning' fame."

"Well, at least he's not another AM—that's something," Ross laughed.

"Not exactly," said Kowalt.

"What does that mean?" groaned Ross.

The older detective bolted to his feet and said, "His nickname is Ace, Ace MacKay. Now let's get something to eat before we talk to Manning's son, I'm starved."

Part Two

The detectives visited Alex Manning Jr. at his girlfriend's apartment. It was only a short drive from the victim's neighborhood. The son answered the door unshaven with watery eyes and a sluggish manner. Ross thought that the guy looked like he was on drugs.

Jim Kowalt was already on the hunt and began, "We're sorry for

your loss, Mr. Manning. But you didn't really like your father very much, did you?"

Alex Jr. seemed unsettled by this comment as they sat down at the kitchen table. But he admitted that it was true, he hadn't gotten along with his father at all.

"I only moved in with him because my mom finally remarried and moved out to the suburbs," he explained. "I wanted to be closer to my girlfriend here in the city and my dad said that he didn't care. So I gave it a shot."

Kowalt continued to push the younger Manning, "The two of you argued quite a bit, didn't you?"

"Yes, but that's the way he was with everybody," the son said sadly. "My father was always arguing. He loved to pick fights so I started staying over here and would only go by his place to get some money or raid the refrigerator."

The young man became visibly angry as he spoke. "Besides, it was impossible to get any sleep over there because he would be up at night before going to work and played his music incredibly loud. I guess the neighbors complained because the police came several times when I was staying there. The only thing that we ever agreed on was that we both liked Frank Zappa."

Then Ross asked, "Did your father have any enemies? Ever receive any threats?"

Alex Manning Jr. snorted and said, "Haven't you ever heard my father's show? Half of the people who called in despised him. He was incredibly vindictive and cruel and didn't respect anyone. If he knew that you didn't like something, then he would do it incessantly. He was only happy when he was making someone else miserable."

Jim Kowalt squinted at the younger Manning and said, "Well, our examination of the phone records indicate that you spoke to your

father twice last night before he was killed. You called him at home around seven that evening and he called you about an hour later. What was that all about?"

"To be honest, we'd been fighting all week," Alex Jr. said. "But I was going to visit him last night and we were on the phone making plans for dinner. Then he called me back and said not to bother, that he was expecting company and was too busy to see me."

"Was he expecting a woman?" Ross asked.

Kowalt interrupted before the son could answer and said, "What my partner meant is, do you know who your father was expecting to see last night when he canceled his plans with you?"

Alex Jr. looked back and forth between the two detectives. He shook his head, and said, "No, I don't know. He was up to something though. The weird thing was that he sounded kind of upbeat. As far as women were concerned, the only ones I ever saw over at the house were his partner Alesha and that girl Angie. But they both had been pissed at him lately and were staying away as far as I know."

Jim Kowalt made a snide comment about the son's inheritance. Then he jumped up, handed Alex Jr. his business card, and thanked him for his cooperation.

As Alex Jr. escorted the detectives to the door, he tentatively asked, "Don't you even want to know where I was at the time of my father's murder?"

Kowalt barely turned his head toward Alex and replied, "Here with your girlfriend, watching TV?"

Alex Manning Jr. grinned and said, "You got that right." Then he closed the door.

Outside, Jim Kowalt turned to Ross and said, "Well, let's head down to the radio station and kill two birds with one stone. We have appointments with Angie Madison and Alesha Martinez and it's im-

portant that we meet both of them before the media blows this thing out of proportion. Supposedly Martinez struggled through this morning's show because Manning was missing in action. Now the word is out about his murder, so she and the radio staff are probably trying to figure out what to do next."

The detectives arrived at the radio station, which had already doubled security because of the Manning murder. There was a lot of activity out in front of the station and plenty of action inside, too. Ross noticed a cluster of mourning guests milling around one hallway. They were mostly strippers and porn stars, all dressed provocatively in black. Jim Kowalt observed that the station's employees were fretfully busy and the office management appeared extremely stressed out. No one looked very sad.

An intern escorted the detectives into Alesha Martinez's small office. Snoop Dogg was on the stereo. Martinez was wearing a short skirt and a sweatshirt bearing the radio station's logo. She had dark eyes and dark skin and a beauty mark on her left cheek. Her hair was long and straight and tied back in a ponytail. Her skin was smooth and so was her voice. She explained to the detectives that she was supposed to pick up Alex Manning and give him a ride to work the previous night. They occasionally did this to get a jump on things when they had a lot to discuss.

Ross can't get over how unbelievably hot she is.

Martinez also claimed that she called Alex Manning from her car, but he never answered the phone so she drove to work without him. She maintained that Manning was always erratic and him canceling plans didn't particularly concern her—until Manning didn't show up for their radio show.

"Alex never missed a show in all the years that I knew him," said Alesha Martinez.

"But you do have a key to his apartment, don't you?" Kowalt said bluntly.

The question seemed to bother Alesha and her eyes narrowed. "Yes, I do," she snapped, "and I don't like the implication of your question. Do you think I'm enjoying any of this? Don't you know what is happening? There are all sorts of conspiracy theories and that's all anyone can talk about around here. Some people think I killed Alex and others are blaming Angie Madison. It's all crazy!"

Martinez continued her rant, "We're not even sure if we should do the broadcast tomorrow, but what else can we do? Alex and I had a decade's worth of history here, but I can't do my job right now without looking like a bitch. The ironic thing is, Alex was the most malicious person of us all and he's not here to take advantage of this mess. I've got to be ruthless or the sharks are going to eat me alive. Our show is a multimillion-dollar enterprise and it's in total jeopardy— Detective, I did not kill Alex Manning!"

Ross kept his head down and took notes. He was trying not to stare at Alesha.

"Did Alex Manning have any enemies, Ms. Martinez?" asked Kowalt.

Alesha sighed disdainfully. "I hope you're not going to ask me to do your police work for you," she said. "Alex and I were here for ten years and we dealt with the public almost every day. We made promo appearances and went to parties and hosted events all over the city. There are a ton of kooks out there—we even had stalkers and had to put out restraining orders. Alex had affairs and dumped people, invested in dubious ventures, and screwed over business associates. Sure, he had enemies; just look at the show's transcripts."

Jim Kowalt responded without a hint of empathy, "Our records show that only two individuals ever threatened Alex Manning's life

and had restraining orders established as a result of those threats. These individuals now reside in other states and have been eliminated as suspects in this case. We believe the person who killed Alex Manning was a little closer in proximity. How well do you know Angie Madison?"

"Not very well," answered Martinez. "We all went out socially a few times when she was dating Alex. But anyone who listened to our show knows about Angie."

"S-s-so, Ms. Martinez," stammered Ross. "Were you romantically involved with Mr. Manning?"

"Detective," she said curtly, "there was nothing romantic about my relationship with Alex Manning."

"Yes, but were you having sex with him?" countered Jim Kowalt.

"Why is that always the million-dollar question?" Martinez spat back. "There are plenty of other reasons why somebody would want to kill Alex, I assure you. What's the difference if we did or did not have sex? Can't you guys ever get past the jealous lover thing?"

"Well," said Kowalt. "Isn't it true that in the last few months you were trying to renegotiate your contract with this radio station, but that any change from your current arrangement required a written release from Alex Manning—a release that he hadn't provided to you despite your repeated requests for him to do so?

"Yes, that's true," she said indifferently.

"Well," continued Kowalt, "wasn't this dispute one of the factors that had led to the tension between you and Mr. Manning prior to his murder? The tension that led to you confronting him on the air for his numerous character flaws, including but not restricted to his treatment of women in general, his treatment of Angie Madison in particular, and his temperament toward you, his longtime pal and loyal cohost?"

"Yes, that was one of the factors," she said less indifferently.

"Well, where were you last night between ten o'clock and four in the morning?" asked Jim Kowalt.

"With a friend," she said defiantly.

"Man, she's hot," thought Ross.

Kowalt persisted, "Well, Ms. Martinez, will you please provide us with that person's name and contact information so that we might confirm your whereabouts on the night of Alex Manning's murder?"

Alesha Martinez looked alarmed and her voice became shrill, "I'd really rather not."

Ross suddenly came to life. Smiling, he leaned forward and cooed, "Please, Miss Martinez, Alesha. I guarantee you that this information will not be made available to anyone else. All we want to do is eliminate you as a suspect as soon as possible, and that's it. I promise. We'll respect your privacy."

Alesha Martinez looked unimpressed and said, "Don't you understand that if my reputation gets any worse I could lose my job? There's no real guarantee here, just your damn promise. I'm supposed to trust you? Why don't you just put your tongue back in your mouth and give me a goddamn break."

Jim Kowalt leaned forward, softened his voice as best he could, and said, "You have my guarantee as well, Ms. Martinez. We're just trying to solve this case and if you're innocent, then you have nothing to worry about."

The woman gazed up at the ceiling for several moments. She blinked back some tears and said in a choked whisper, "Okay."

"Well," repeated Detective Jim Kowalt, "who were you with last night between ten in the evening and four in the morning?"

"Ace MacKay," said Alesha Martinez.

"Damn," said Ross.

Part Three

Angie Madison didn't have her own office; she worked out of a cubicle in the sales department. For privacy, the detectives met with her in one of the executive conference rooms. Madison was a leggy blonde, originally from Terre Haute, Indiana. She gave off a youthful, midwestern sort of innocence and looked Jim Kowalt straight in the eye. She was quite intelligent and possessed a rock-hard body with a flat stomach and well-defined thighs.

Ross can't get over how hot she is.

Angie explained to the detectives that she had been working at the station as an ad salesperson for about eighteen months before dating Alex Manning. "He was the least likely person for me to ever have gone out with," she said.

"In what way?" asked Ross.

Angie looked Ross straight in the eye and said, "He was a lot like my father, an overwhelming personality. Alex was very aggressive and his mind was very sharp. He sought out other people's weaknesses and then exposed them."

"Well, why did you start having personal dialogues with Mr. Manning on the radio?" Kowalt asked.

"The first time it happened it was just twenty or thirty seconds of him asking me out on a date," she explained. "I didn't even realize we were on the air until my girlfriend told me afterward."

Angie Madison blushed and said, "Discussing more personal things happened gradually. He'd call me on my cell phone while I was on the way to a meeting or something. I've always had this weird sense of humor and the audience liked me. It became like a game for Alex, he tried to catch me off guard or talk provocatively like he did with

his other guests. That's where I drew the line, but Alex was incorrigible."

"We understand that Mr. Manning broke up with you on the show and you took it pretty hard," said Kowalt.

"That's not true, I broke up with him!" Angie Madison objected. "Then he called me the next day while he was doing the show and said that he didn't want to see me anymore. It was like Paul McCartney claiming he was the one to quit the Beatles when it was really John Lennon! I was upset because he made it look like he was dumping me and it just wasn't true."

"And Mr. Manning continued to disparage your reputation on his show after you'd stopped seeing each other," added Kowalt.

"That's right," said Angie. "I'd never been so hurt and angered by a person in my life."

"Is that when you called up the show and told him to 'fuck off' on the air?" asked Kowalt.

"Yes, that's when I called him and said that," Madison answered.

"And you told him that if he embarrassed you again that he'd regret it," Kowalt reminded.

"Yes, but he never said anything after I confronted him," she said defensively. "He finally left me alone and that was the end of it."

Kowalt pressed further, "Well, didn't your confrontation on the radio directly precede an even bigger argument between Mr. Manning and his cohost Alesha Martinez?"

"Yes, that's true," said Madison. "But what does that have to do with anything? Alesha was just standing up for all women everywhere and I respect her for it."

Ross jumped in again, "Do you know Alesha very well?"

"No, not very well," she replied. "We all went out socially a few times when I was dating Alex."

Jim Kowalt remained focused and terse. "Did you continue to communicate with Alex Manning after your breakup?"

"Not really," she answered. "I was very angry with Alex and didn't want to have anything to do with him."

Jim Kowalt frowned and said, "Well, the phone records show that Alex Manning called you at home last night around six-thirty and that the two of you were on the line for about twenty minutes."

"He called me!" Angie Madison screeched. "I just answered my phone, is that a crime?"

"Well, what did the two of you discuss on the phone for twenty minutes?" asked Kowalt.

"Alex wanted to reconcile, he said he wanted me back!" she shouted. "I didn't say yes but I didn't hang up on him, either. He kept asking me to come over to his place. Finally, I told him I had to get off the phone and would call him back but I didn't. I turned off the ringer, took a Xanax, and watched TV until I fell asleep."

"Well, tell me, Ms. Madison," Kowalt said. "Do you have a key to Mr. Manning's apartment in your possession?"

Angie Madison started crying, "Yes! Yes! I still have the key; I was going to mail it back to him. So I forgot! Is that a crime?" She looked imploringly at Ross and said, "That doesn't mean that I would kill anybody. You don't think I killed Alex—do you?"

But Jim Kowalt sprang to his feet, handed Angie Madison his card, thanked her for her time, and hustled Ross out of the conference room before he could say a word.

The two detectives went directly over to Ace MacKay's radio station. Upon arriving, they were escorted to a large waiting room outside of his office.

Ace had tousled hair, a small goatee, and was wearing a Velvet Underground T-shirt underneath a worn-looking leather jacket. Ace

gave the impression that he was very busy and that there were several projects demanding his immediate attention. He seemed to have a very short attention span.

Ace MacKay also seemed to be in a very good mood, apparently due to the publicity he'd been getting since Manning's demise became public.

"Let's make it quick, gentlemen," he said boisterously. "I have several interviews after this. I guess everyone wants to know what old Ace Murphy thinks about poor Alex Manning getting whacked."

Jim Kowalt got straight down to business and said, "Mr. MacKay, we understand that you and the deceased had a strong dislike for each other."

Ace didn't even blink and answered, "What was there about him not to dislike? Alex was an on-air asshole, same as me. But he was an asshole off the air, too. My listeners always enjoyed it when I made Alex look bad, which was easy to do. Gentlemen, it was both my professional and personal pleasure to hate Alex Manning."

"Well," Kowalt observed, "your feud with Mr. Manning has certainly been good for your career and now his murder has brought you into the national spotlight."

"You bet," Ace said gleefully, "and tomorrow we're going to do 'The Worst of Alex Manning' and play all of the low-down nasty things that jerk ever said to me."

"We understand that you were with Alesha Martinez at the time of the murder," offered Ross.

"That's coming out now, huh?" Ace said in an unconcerned voice. "I've only been sleeping with her for a couple months and told her that it would be impossible to keep it a secret. The woman's obsessed with her public image but as far as I'm concerned there's nothing wrong with a little extra notoriety."

Ace began chuckling and paced his office excitedly. "Hey, I guess I don't have to worry about keeping our secret if you guys know about it," he said. "This just keeps getting better. Now I can really spice up my interviews tonight."

"But we promised Ms. Martinez our complete discretion on this matter," Ross said. "So don't start making this part of your media spiel. Okay, Ace?"

MacKay's eyes got wide and he said, "What, are you threatening me, Detective? Are you telling me that I can't talk about my personal life if I feel like it? So what if our affair becomes common knowledge before Alesha is ready to deal with it?"

"You're pretty nonchalant about this whole thing, aren't you, Mr. MacKay?" said Jim Kowalt.

"Why shouldn't I be?" Ace responded. "I didn't murder anyone. Besides, everybody knows what a hateful person Alex Manning was. Do we all have to act sad just because someone finally got around to killing him?"

"Well, Ms. Martinez claims that you were together at her house on the night of the murder," said Kowalt. "This would provide both of you with an alibi, for now. Care to confirm her story?"

"Of course," he answered. "I was there, and that's a fact. But I can't say for certain if the same goes for Alesha."

"What do you mean by that?" asked Ross.

Ace seemed pleased as he explained, "What I mean is that I was at her house, yes. But I was sleeping very soundly from eleven at night until three-thirty in the morning and can't say with any certainty that Alesha was in bed next to me. I mean, who knows where she was? I was dead asleep and all I can say is that I can't vouch for her."

"Damn," thought Ross as Jim Kowalt jumped up and handed Ace MacKay his card.

Part Four

The two detectives drove back to the precinct. Again there was silence. Ross didn't know what to say about the strange unfolding of the murder mystery. He waited for some direction to come from his partner.

Jim Kowalt pulled his unmarked squad car up to the precinct HQ. He turned to Ross and said firmly, "Well, rookie, now comes the hard part so don't screw this up. It's 7:45, which means that you have just about two hours to examine the 'jewel case' and the 'track listing.' Forensics says that there were no fingerprints or DNA on the disc besides those of Manning himself.

"So what I want you to do is this," Kowalt continued. "You need to analyze the evidence from a musical perspective. See if there were any messages in the songs or anything else that you can come up with. I need you to develop at least a couple different hypotheses as to the identity of the murderer. Then I want you to meet me at the scene of the crime tonight at 10:00."

Jim Kowalt conveyed a covert attitude as he described the next stage of his plan. "After we're set up in the victim's home, I'm going to have the 'four AMs' all brought there, by themselves. We may need to stall them once they arrive, so be ready to discuss the clues from the CD in some detail."

Ross became nervous at the prospect of confronting the four suspects again, especially so soon and all together. "Are you sure we're really ready for this?" he asked. "It feels rushed to me. Besides, how are you even going to get them all to show up, let alone without counsel?"

"Don't you worry about that," Kowalt said. "Just be ready to do some fast talking. It'll be a surprise and there will probably be some panicking when everyone arrives. But we can't wait until tomorrow—we have to gather all of the suspects together at the scene of the crime tonight."

Ross got out of the car and started walking toward the police station. Kowalt opened the window on the passenger side, leaned over, and shouted, "Don't screw this up, rookie! And remember—be there by ten o'clock sharp!"

Ross was frantic when he finally sat down at his desk with the CD and jewel case. He checked the clock on the wall and became anxious about his deadline. "This is crazy," he thought. "What does he expect me to do in just two hours?"

It was then that Ross finally looked at the track listing on the back of the jewel case. He gasped at what he saw.

Part Five

Ross returned to the scene of the crime just five minutes before ten o'clock. He'd rushed like hell to get there and his heart was pounding as he tapped on the front door of Alex Manning's apartment.

Jim Kowalt cracked open the door and literally pulled Ross inside.

"You just made it, rookie," he said. "Well, how did you do with your 'mix-tape'? Any leads?"

"Actually, I—" Ross was cut off in midsentence by the senior detective.

"No time for that now," Kowalt exclaimed. "The 'four AMs' will be here any minute! Just get yourself ready to confront the suspects. All hell is going to break loose if we don't handle things right."

"But, I—" Ross floundered.

Kowalt interrupted again, "Don't worry about a thing, rookie. I'll be backing you up the whole time. Just keep talking until I give you the signal."

"What signal?" Ross asked.

Jim Kowalt had already turned his back on the young detective

and was tinkering with the stereo in the victim's front room. "Crap," he muttered. "Where's the auto-repeat on this damn CD player?"

Before Ross could volunteer to help there was a knock on the front door. Ross stood there while Kowalt quickly pressed some buttons on the disc player and then calmly opened the door.

The suspects had been escorted separately to Alex Manning's apartment but they all arrived at the exact same time. As Kowalt predicted, there was a great deal of confusion when the "four AMs" were herded into the front room.

"What is the meaning of this, Detective?" Alesha Martinez demanded. "And what in the hell is *he* doing here?"

"Aren't you glad to see me, baby?" Ace MacKay said sarcastically. "Hey, why don't you introduce me to your friend here? I'm Ace, pleased to meet you."

"I know who you are, Mr. MacKay," Angie Madison said coldly. "So spare me the pleasantries." Then Angie turned to the younger Manning and said, "Hello, Alex, I'm so sorry about your father."

"Thanks, Angie," said Alex Jr. as he looked quizzically around the room. "But this is getting creepy. What are we here for? Is someone under arrest?"

Jim Kowalt spoke in a loud voice over the music, which was playing at a fairly high volume. "Not yet," he answered. "But that could change. Everyone just sit down and we'll get this over with as soon as possible. I'm going to let my associate, Detective Ross Melboro, explain . . ."

So, with the music building behind him, Ross stood in front of the four suspects and began solemnly. "Well," said Ross. "One of you in this room is a murderer!"

Immediately there was a howl of angry denials from the "four AMs."

"Quiet, please!" Ross demanded. "Thanks to evidence found in

this apartment, we believe the initials of Alex Manning's murderer are A.M."

Meanwhile, the music in the apartment grew louder.

"And you, Alex Jr.," Ross continued, "you hated your father, didn't you? Besides that, you're the only one mentioned in his will."

"This is bullshit, man," said Alex Manning Jr.

"If it's bullshit, then how do you explain the Frank Zappa song, 'My Guitar Wants to Kill Your Mama,' which was on a mix-tape CD found in your father's stereo? We know that the only thing that you and your father agreed on was Zappa."

The music was blasting and Frank Zappa's voice snarled through the speakers.

"A mix-tape?" yelled Alex. "Is it a mix-tape or is it a CD? I don't understand."

"It's a CD, dipshit," hollered Ace MacKay. "That's just what they call them, mix-tapes!"

"Aha! I didn't say it was a CD," said Ross.

"Yes, you did," said Ace.

"That may be true," countered Ross. "But what are we to make of the fact that this 'mix-tape' also contained a Velvet Underground song called 'The Murder Mystery,' Mr. MacKay?"

"'The murder mystery, Mr. MacKay.' That's good," said Ace. "But what does it have to do with me?"

"Well, isn't that a Velvet Underground T-shirt you're wearing?" challenged Ross.

"Yes," answered Ace. "So?"

Ross paused awkwardly, looking self-conscious as the music continued to blare. Then he turned his attention to Angie Madison and said, "Certainly you, Ms. Madison, cannot deny being a Beatles fan. Can you?"

"No," said Angie. "I like the Beatles. Doesn't everybody?"

"Yes," said Ross. "But not everybody was jilted and humiliated by Alex Manning. You even threatened him publicly. Isn't that why the Beatles' song 'Helter Skelter' is on the murderous mix-tape?"

Angie Madison started to cry. "I don't know. I'm really more of a John Lennon fan than a Beatles fan," she wailed. "Is that a crime?"

Then Ross whirled around, pointed with his finger, and said, "And you, Alesha Martinez. How do you explain your professional clashes with Alex Manning and your secret personal relationship with his rival, Ace MacKay? Even Ace can't vouch for you. Perhaps that's why the Snoop Dogg tune 'Murder Was the Case' is on the mix-tape."

The "four AMs" began protesting and arguing among themselves. Slightly overwhelmed, Ross thought that he had heard a phone ringing. Then he felt a wave of panic as he noticed that Detective Kowalt had disappeared from the room.

"This whole thing is completely insane," screamed Alesha Martinez.

"Is it?" Ross continued desperately. "Is it insane to imagine a conspiracy to kill Alex Manning? Is it insane to envision a kinky ménage à trois between you, Ace MacKay, and Angie Madison—a twisted tryst of hot sex and revenge that turned deadly?"

All four suspects jumped to their feet. They began yelling at Ross and hurling wild accusations at one another. The mix-tape murder music had reached a fever pitch and it felt like utter pandemonium as Ross searched for a sign of Jim Kowalt.

Suddenly, the lights went out in the apartment. It was pitch-black in the front room, but the music was still blaring. Then there was a struggle with even more yelling and screaming and somebody finally being slammed to the floor.

When the lights came back on Detective Jim Kowalt was in the

middle of the room, sitting on top of the struggling form of Thomas Wolley.

"The upstairs neighbor!" Ross exclaimed. "What's he doing here?"

"Well, it's quite simple," Kowalt said triumphantly. "The phone records show that old Tom here had been constantly calling his downstairs neighbor every night for months. I assume it had something to do with the noise and the repeated playing of a certain mix-tape. Isn't that right, Mr. Wolley?"

"Yes, yes! That's it!" blubbered Wolley. "I couldn't stand it anymore. He kept playing the same four songs over and over at top volume from ten at night until four in the morning! It was driving me crazy! I begged him to stop but he just laughed at me. So I killed him! I'm glad I did it! He was like the devil!"

"But all of your evidence was circumstantial. How did you know for sure that you could lure Wolley back down here with the loud music?" Ross asked.

"Well, it was the mix-tape," answered Kowalt, "and the clue on the 'jewel case.' "

"So, what clue was that?" Ross asked impatiently.

"Well, the '4-AM,' " said Kowalt. "Manning lived in apartment 3-A, remember? Mr. Wolley lived right above him in 4-A."

"But that's just '4-A,' not '4-AM,' " insisted Ross. "What does the 'M' stand for?"

Jim Kowalt squinted at Ross Melboro, looked around the room slowly, and said, "Don't you know your Alfred Hitchcock, kid? 'M' is for Murder, of course."

WAITING ON A TRAIN

Once I was in New York City attending a jazz conference. On the second morning of the conference I walked over to the subway station on Fourteenth Street and Sixth Avenue to take the F train up to Rockefeller Center.

Although I had no appointments, I was still in a hurry. And as I stood down in the subway waiting for a train, I became preoccupied with getting to where the action was. I wanted to be among my peers. I wanted to know what was going on.

For some reason, I felt that I was missing out on something. I kept shifting my weight from one foot to the other and staring into the dark tunnel, eager for any sign of an oncoming train that would take me where I wanted to go.

It took awhile, but I slowly became aware of a musician performing on the subway platform. The first thing I noticed was a distinctive guitar sound—the crisp acoustic picking reminded me of Neil Young in his early days. Then I focused on the voice and realized that it was a woman singing. I listened to the lyrics of her song, which mirrored the feelings I'd been having that morning.

She was singing about being in a rush and waiting on a train.

I was transfixed. The singer's words expressed my experience to a T. Her rich voice cut through the subway sounds and I forgot about my imagined lateness. I was caught up in the moment and walked closer, throwing a dollar into her guitar case.

Right then, I felt the F train approaching. There was the sudden draft, a distant rumble, and a light down in the tunnel—just as she had described in her song.

The train came to a stop and opened its doors. I boarded, hesitating for a moment before stepping onto the subway car. The doors closed sharply behind me and I turned to face the musician, who was still singing as she gave me a smile.

But the train didn't pull out of the station right away and I just stood there in the subway car, looking at her through the glass and listening to her sing.

As soon as we finally started moving, I realized that I was completely haunted by the troubadour's song. And as the train hurtled uptown, I got more depressed with every stop. Here I'd been in such a hurry to attend some music conference that I'd abandoned a real live experience that actually touched my soul.

When we arrived at the Fiftieth Street stop in Rockefeller Plaza, I got out. Then I ran up the stairs, crossed over the platform, ran down the stairs, took an F train all the way back to Fourteenth Street, got out, ran up the stairs, crossed over again, and ran back down to where I had begun.

She was still there, singing and playing her guitar.

So, I stood there for a good long while watching other people listen to the singer while they waited for *their* trains. I saw all sorts of different folks respond to her. One woman with a mink coat dropped a few dollars into her guitar case. A fellow street musician approached the singer, lingered a bit, and threw her some change.

When she finished her set, I introduced myself and told her how much I enjoyed her performance. I said that I hoped that her music would find an audience someday.

"I play for thousands of people every day," she answered. Her name was Kathleen Mock.

That's all I can tell you. In the course of a New York minute I heard a song that should have stopped me in my tracks. Luckily, I was able to return to the source of my inspiration.

Maybe something like that will happen to you someday—when you're waiting on a train.

HOW TO SUCCEED
IN THE MUSIC BUSINESS
WITHOUT REALLY TRYING

A few years ago I was in Chicago sorting through my late uncle's belongings. My uncle, Shel Silverstein, was quite the Renaissance man, and among his many drawings, poems, songs, plays, scripts, notebooks, and ideas scrawled on napkins were hundreds of old audiotapes.

Aside from Shel's personal library of home recordings and studio demos, there was an odd batch of quarter-inch tapes on seven-inch reels. These tapes had no apparent link to his own musical works—it was just an arbitrary assortment of pop recordings collected by a friendly music publisher that Shel had once worked with.

Anyway, I was examining each box to note the contents and see if there were any stray recordings made by Shel, when a couple of reels grabbed my attention. They had the words *Graham Parsons—Demos* scrawled on them.

You see, Graham sounds similar to Gram. Gram is short for Ingram. And Ingram Cecil Parsons is one of my favorite country-rock artists.

Ah yes, Gram Parsons. Gram cut a romantic figure in the late 1960s and for a time he played with the Byrds. Parsons helped push the Byrds toward country music, and he was a prime mover on the band's Nashville album, *Sweetheart of the Rodeo*. After that, Gram

and fellow Byrd Chris Hillman formed the Flying Burrito Brothers. Gram even hung out with the Rolling Stones. He also introduced the world to a gifted young singer named Emmylou Harris.

Parsons ultimately gained attention as a solo artist, but he died in 1973 at the age of twenty-six. That's when his popularity really began to soar. Ironically, Gram's rock-star mystique was enhanced when friend and road manager Phil Kaufman fulfilled a drunken promise and absconded with his dead body—cremating Parsons out in the desert of Joshua Tree, California.

Since his death several biographies have been written about Gram, and several of his early recordings were released posthumously. There've been tribute concerts, lavish CD anthologies, a documentary, and even a feature film called *Grand Theft Parsons,* which dramatized Kaufman's startling epilogue to Gram's short life.

If I had any doubts as to the identity of the "Graham" Parsons listed on the tapes, they vanished when I noticed the listing of a track entitled "Brass Buttons," which is a classic Gram Parsons song if ever there was one.

I was definitely onto something.

So, I wrote down the song titles and took the list home. But even with all of my resources I was only able to identify about half of the songs. It soon occurred to me that these tapes might contain some extremely rare performances by Gram Parsons.

Looking for help, I started calling people in the music business, ones who knew Gram's story far better than I. And for the first time in my life, important record industry people actually took my calls.

I confirmed that several of the songs were previously unknown to the Parsons discography. It was also ventured that the tapes might have been from the summer of 1964 when Gram and one of his earliest groups, the Shilohs, spent a month in New York City.

The Shilohs had met folksinger Dick Weissman in Manhattan, and they all did some recordings together in a midtown studio. Supposedly, no one knew the whereabouts of the Weissman-Parsons tapes and the demos had never been heard or seen again.

Would you believe that there was a Dick Weissman listed on the Gram Parsons tapes that I'd found?

Now, I still hadn't listened to the recordings. The reels were at least forty years old and extremely fragile. The proper thing to do was find a professional studio to transfer the music onto a more durable, digitized format.

But I began negotiating with a small, independent record label that had released some other old Parsons recordings. The label's owner was very interested, and if the tapes turned out to be authentic, he had the connections to release the music commercially.

This was an exciting prospect. If the record guy released these recordings on his label, then I'd get a credit—like "Executive Producer." Visions of writing the CD liner notes danced in my head and my future in the music business seemed bright.

Even my NPR producer was interested. He wanted to follow me into the studio and document the unveiling of these old recordings. Somebody on his production team thought it would be funny if the tapes turned out to be blank—kind of like Geraldo Rivera's much-hyped entry into Al Capone's vaults—which was a huge bust for Geraldo.

I declined my producer's offer.

Meanwhile, I *was* ready to visit the record label guy's home studio on the East Coast. We were going to examine the tapes together and take up the business end after that. Then, the label guy heard a rumor that I'd been shopping the tapes around to other record label guys. He felt insulted and cut off all communication with me.

I tried to explain to him that a friend of mine had merely mentioned

the tapes to a few other folks in the music industry. The label guy ignored my plea. I wrote him a long, rambling letter apologizing for the mistake and imploring him to resume our excavation of these historic recordings.

The record label guy never answered my rambling letter. I was back on my own.

With my ascent in the record business disrupted, I decided to book some time at a local studio and find out exactly what was on these tapes. There'd be plenty of time for a cool record deal after I determined the nature of the music I was dealing with.

I told my friend Ben Hunter that I was finally going to play the tapes. He insisted on documenting the event with his camcorder. I agreed, since by this time I was feeling certain that I alone possessed the lost 1964 recordings of Gram Parsons.

Besides the old tapes marked "Graham Parsons—Demos," I'd dug up two other important reels from the same batch of tapes. These two reels actually had Shel Silverstein's name written on them. I figured that we could just digitize everything and I'd have enough rare recordings to keep me in the music business for quite some time.

So, Ben and I finally went into the recording studio. We watched the sound engineer examine the tapes and connect an old reel-to-reel tape player to his digital recording console.

As the engineer threaded the Parsons reel into the old tape machine, Ben turned on his camcorder. Then the engineer pressed play, the tape started to roll—and music filled the air.

But it wasn't Gram Parsons; it was just old generic Muzak and some bad, forgotten pop.

The engineer fast-forwarded the tape a bit. Still, no Gram. Soon, it became clear to me. Whoever had received the Parsons's demos at the publishing company had simply recorded over the tapes.

It was all too devastating. The engineer kept fast-forwarding and playing more Muzak and I was just sick about the whole thing. Meanwhile, Ben was recording the entire incident on video.

"Dude, turn that off," I said. "You're killing me."

The engineer flipped the tape over, just in case. Nothing. Then he put the second "Parsons" demo on the old tape machine. The results were the same and Ben kept on filming.

"Dude," I pleaded. "Get that camera out of my face! I'm going down here."

Finally, I conceded that there was absolutely no Gram Parsons on either of the two reels. In hopes of salvaging our studio time, we turned our attention to the other two tapes, the ones with Shel Silverstein's name marked on them.

Did I mention that those two reels were from the same batch as the Parsons stuff? Well, guess what? The same thing happened. Shel's demos had been taped over, too. There was just more of these common, boring pop tunes.

I was totally dejected.

Then, right near the end of our last reel, a voice emerged from the studio speakers that we recognized. It was a thin, reedy singing voice backed by a lone acoustic guitar.

No, it wasn't Shel Silverstein, and it wasn't Gram Parsons, either. It was the godfather of American folk music—Woody Guthrie.

Woody Guthrie, the outspoken singer-songwriter from Oklahoma whose dustbowl ballads and working-class anthems gave voice to so many local and national concerns and inspired the careers of countless musicians.

It's true; we had actually stumbled onto four forgotten performances by the great Woody Guthrie. The first two compositions were entitled "Rollin' Ocean" and "Roll on Waters." The third song was

an end-of-the-war tune called "Wear My Ribbon," which dates back to at least 1951 and may have been cowritten by Woody and his old running buddy, Cisco Houston.

The fourth song, which we found at the very end of our last reel of tape, was a version of "This Land Is Your Land."

Now, history tells us that Woody Guthrie wrote "This Land Is Your Land" as a populist response to Irving Berlin's "God Bless America." While there is certainly a standard version of this iconic folk song, Woody had been known to add an extra verse or two as he sang the tune repeatedly over the years.

So, as our newfound recording of "This Land Is Your Land" played that day in the studio, good old Ben wondered aloud if the tape might contain one of those mythical, unknown verses that Woody occasionally sang.

We listened and held our breath.

But the tape ran out before Woody finished singing. And although we *did* find a few different lyrics in the first part of the song, we'll never know if there was yet another, never-before-heard verse to Mr. Guthrie's most enduring composition.

Still, the tapes had provided us with some extremely rare Woody Guthrie performances, which we gladly donated to Nora Guthrie and the Woody Guthrie Archives in Manhattan, where they are now safe and sound.

Our friends at the Guthrie Archive think that Woody's performances may have been recorded by the legendary record label guy, Moe Asch—perhaps *even before* Moe had started the Folkways Records label back in 1948.

Anyway, no rare Gram Parsons demos and no cool record deal.

But . . . Smithsonian Institute—here we come!

Acknowledgments

Undying thanks to Peg (editor in chief), Liz (for the photo idea and squeezing into the jeans), Rick, Tsipora, Lulu and Twinkie, Sarah, Matt, and Gino.

Special thanks to Hap Mansfield. Extra thanks to Michael Dorr for instigating the project and to the late David Walley for his unwavering support. Gracious thanks to Maureen O'Brien for believing, Stephanie Fraser for the awesome list, and everyone else at HarperCollins.

Thanks to Harvey Kubernick, Colin Berry, John Draper and Laura Sandlin, Ben and Tina Hunter, Holly George-Warren and Robert Burke Warren, Shirley Halperin and Thom Monahan, Cecille Kramer and Kevin Calaguiro, Jerry Goldner, Mike Rowe, Felicia Kelly, Scott and Debbie Cohen, Pat Thomas and Sonia Clerc, Bob Boilen, Steven Bernstein and the Sex Mob, Betsy Palmer, Billy Martin, Paul S. Williams, Richard Meltzer, Dave Marsh, Jaan Uhelzski and Matthew Kaufman, Scott and Ali Giampino, John Humphrey, Michael and Paula Fracasso, Al Rose and Rhonda Welbel, Harlan and Rachel Wallach, Michael Carr and Linda Fiore, Tom Asch, Martin Northway,

Dave Segal, Chris Handyside, Dave Chamberlain, Frank Sennett, Eric Miller and Kim Merritt, Matt Fritch, Hugh Hefner, Mary O'Connor, Randy Haecker, Michael Bloom, Tom Welch, Scott Vingren, Meredith Ochs, David Siegfried and Donna Seaman, Dennis Morgan, John Morthland, Bill Bentley, the late Scott Morrow, Eddie Jemison, Rich Sparks, Ellen Philips, Tim Ford, Paul and Laura Milne, Claude Solnik, Mars Williams, Susan Nadler, Victor Pashuku, Geoff Osbourne, Ben Neill, Michelle Mercer, the late Stew Albert, Noel Olken, Brian Coleman and Margot Edwards, Howard Mandel, Scott Crawford, Blaise Barton, Joel and Adam Dorn, Billy Altman, Michelle Engert, Steve Bloom, John Strausbaugh, Duane and Denise Jarvis, Susan Katz, Kate Jackson, Dennis Locorriere, Martha Wayman and Jim Arndt, John and Nancy Flannery, Jason Koransky, Susan Schiffman, Kim and Rainer Turim, Jim Carlton, the late Al Aronowitz, Sharon and J. R. Zumwelt, Dave Zaworkski, Dean Blackwood, Mark Kemp, Steve Duda, Irwin Chusid, Hal Wilner, Greg B. Johnson, Stuart Brand, Chet Flippo, Kevin Grizzard, Andy Gilbert, Ian Gilchrist, Joy Kingsolver, Jerry Foust, Ric Addy, Bruce Dinsmor, Laura Grover, Steve Dollar, Jim O'Rourke, Richard Henderson, Dave Cirilli, Neil and Dawn Reshen, Bobbi Cowan, Jerry Wexler, Chris Nickson, John Swenson, Carol Kaye, Bob Sarles, Nora Guthrie, Judy Bell, Larry Richmond, Joe D'Angelo, Jeff Braun and Sachi Enochty, Jorey and Beth Schallcross, Lou Reed, Skip Taylor, Shawn Sahm, Alecks Ignjatovic and Mila Troytsky, Mike Saunders, Ashley Kahn, Vince Kamin, Ben Schafer, Paul Bresnick, Kathryn Frazier, Gary Lucas, Edite Kroll, Juan Rodriguez, Daevid Allen, Mike Chamberlain, Bob Blumenthal, Ali Benis, Miles Harvey, Legs McNeil, Jeff Rougvie, J. C. Gabel, Michael Simmons, Paul Krassner, Donald Hamburg and Jan Prokop, Jeff McCord, Michelle Ferguson, Paula Batson and Bob Neuwirth, Terry Riley, Mick and Diane Aryman, Matt Groening, Brad Rempert,

Chuck Prophet, Charles Hiatt, the late John and Marie Hartford, Liam Hayes, Bill Milkowski, Jim Fouratt, Ray Pride, Lee Nagin, Terri Hinte, Tina Pelikan, Theresa Norman (for the jeans!), Brian Hieggelke, Josh Mills, Chuck Eddy, Bill Meyer, James Kahle, Eric Ward, Bill McKeen, Scott Harding, Bobby and Jeannie Bare, Shannon Bare and Bare Jr., Cathy McGinley, Victor McCombe, Gil Kaufman, Van Dyke Parks, Denny Bruce, Jimmy and Nancy Margolis, Paula Gremley, Glen and Cheryl Majewski, Jon Langford, Jim Fanizza, Cem Kurosman, Adam Korn, Terry Ware, Leo Kottke, Melvin Van Peebles, the late Arif Mardin, Kelly Hogan, Pete Kastis, J. J. Jackson, Karen Gullo, Michael Fremer, Auntie Joyce and Cousin Fran, Rob Bleetseen, Tim Anderson, Dave Dunton, Mary Jones, Sarah Apfel, James Porter, Nat Hentoff, Eric Amble, Peter Blackstock, Susan Jasica, Ann Hornaday, Toni Markiet, Marcia Resnick, Tad Henrickson, Versa Manos, Jason Fine, Kevin Calabro, Victor Bockris, Tony Conrad, Greg Kot and Jim DeRogatis, Steve Albini, Elizabeth Derczo, Rick Reger, Deb Stern, Tracey and Laura Dear, Paul D. Miller, Al Cronin, Roy Nathanson, Filippo Salvadori, Bob Gulla, Michael Jackson, David Gans, Tom Rapp, Paul Shapiro, Steve and Sally Parker, Mary Huhn, Aaron Cohen, Nick Baily, La Monte Young, Felice Ecker, Kathleen Mock, Tim and Katie Tuten, J. R. Jones, Kim Smith, Steve Wynn, Barney Hoskyns, Doug Wolk, Dave Royko, Margaret Davis, David Billing, Juini Booth, Royce and Mary Racinowski, Kristin Sherman, Lida Husik, Matt Hanks, Ernie Medeiros, Michael Cuscuna, Charles Lloyd, Chip Porter, Brian Carpenter, Alejandro Escovedo, John Feins, Ben Young, Jim and Betty Kramer, Fred Simon and Sarah Allen, Patty Natalie, Richard Gehr, R. U. Sirius, Stanley Booth, Mark Rakstang, Fred Mills, Billy James, Nile Southern, Gail Zappa, Kurt Kellison, Joe Travers, Kim Fowley, Ken Vandermark, Bobby Reed, Michael Cameron, Jeremy Tepper,

Anthony DeCurtis, John S. Hall, John Corbett, Elizabeth Hardwick, Paul Schutze, Bill Laswell, Mike Lach, Howard Reich, Byron Coley, Lee Froelich, Mike Watt, Willie Flower, Bob Irwin, Roz Calvert, Sam Andrew, Paul Cox, Bob Palmieri, Nick Tosches, Heather Mount and Matthew Covey, David Peel, Harold Platt, Bill Murphy, Dave Razowsky, Neil Tesser, and Robert Wyatt.

~ *Credits* ~

The Introduction used a quote from the lyrics of "Do You Believe in Magic?" by John Sebastian, Trio Music/Alley Music.

Prelude: "A Rock & Roll Fable" is fiction. Portions of this essay originally appeared in *Newcity*, November 1998, and were performed on National Public Radio, *All Things Considered*, August 2002.

"River Deep" benefited from the author's discourse with Harvey Kubernik. Resources include *He's a Rebel: Phil Spector—Rock and Roll's Legendary Producer*, by Mark Ribowsky; *I, Tina: My Life Story* by Tina Turner with Kurt Loder; and *Phil Spector: Back to Mono (1958–1969)* on ABKCO Records. Inspiration gained from listening to the song, "River Deep Mountain High" by Ike and Tina Turner. Thanks to Musicians Local Union 47 in Hollywood, California. Portions of this essay were performed on National Public Radio, *All Things Considered*, June 2002.

"Hellhound on My Trail" benefited from the listening of *Robert Johnson: The Complete Recordings* on Columbia Records. Portions of this

essay appeared in *Newcity*, May 1999, and in comic-strip form in *Crawdaddy!*, June 2001. Portions of this essay were also performed on National Public Radio, *All Things Considered*, Halloween 2001.

"Nuggets" benefited from the listening of *Nuggets: Original Artyfacts from the First Psychedelic Era 1965–1968* on Rhino Entertainment. Portions of this essay appeared in *Smug Magazine*, October 1998.

"The Sound and the Fury" included quotes from the author's discussions, interviews, and correspondence with John Holmstrom, Richard Henderson, Steve Albini, Jim O'Rourke, Jon Langford, Bob Neuwirth, the late Robert Quine, Bill Bentley, Glen Branca, David Thomas, Steve Wynn, Sylvia Reed, Kramer, Penn Jillette, Paul Williams, Lee Ranaldo, and Paul Schutze. There is also a quote from Lou Reed's liner notes in *Metal Machine Music*. Inspiration was gained from the book *Psychotic Reactions and Carburetor Dung* by Lester Bangs. References include *Lou Reed* by Peter Doggett and *Transformer* by Victor Bockris. Portions of this essay appeared in *Magnet Magazine*, April/May 2000.

"Endless Boogie" includes a quote from *Hellfire* by Nick Tosches, and a quote from the lyrics of "Boogie Chillun" by John Lee Hooker and Bernard Bessman, BMG Music Publishing. The essay also references *The Rolling Stone Encyclopedia of Rock & Roll* and *Forbidden American English* by Richard A. Spears. Portions of this essay appeared in *Harp Magazine*, December 2004.

"When Harry Met Allen" included quotes from the author's discussions, interviews, and correspondence with Hal Wilner, Ed Sanders, Tuli Kupferberg, Steven Taylor, John Feins, Bob Rosenthal, and Harvey Kubernik. There are quotes from Allen Ginsberg, found in *This Is*

Rebel Music by Harvey Kubernik. The essay also used a quote from the lyrics of "Nothing" by Tuli Kupferberg, Heavy Metal Music. References include *American Magus Harry Smith: A Modern Alchemist* by Paola Igliori and *Think of the Self Speaking: Harry Smith, Selected Interviews* by Harry Everett Smith, Daniel Darrin, Steve Creson, and Rani Singh. Portions of this essay appeared in the liner notes for the CD reissue of *First Blues: Rags, Ballads & Harmonium Songs* by Allen Ginsberg, on Locust Music, 2002.

"The Power of Tower" benefited from the listening of *Goodbye 20th Century* by Sonic Youth on SYR Records. Portions of this essay appeared in *Smug Magazine*, June 2000.

"Who Will Save the World?" is fiction.

"Something Freaky This Way Comes" benefited from the listening of "Songs in the Key of Z" on Which? Records, and the reading of "Songs in the Key of Z: The Curious Universe of Outsider Music" by Irwin Chusid. Portions of this essay appeared in *Smug Magazine,* September/October 2000, and in a comic-strip version in *Newcity,* October 2000.

"The Monk and the Messenger" benefited from the listening of *Art Blakey's Jazz Messengers with Thelonious Monk* on Atlantic Records. Portions of this essay appeared in the liner notes for the LP reissue of *Art Blakey's Jazz Messengers with Thelonious Monk*, on Four Men with Beards, 2002.

"Captain's Orders" benefited from the listening of the music of Captain Beefheart. Portions of this essay appeared in *Smug Magazine*, October/November 1999.

"It's How You Play the Game" benefited from the listening of *Live at Max's Kansas City '79* by Johnny Thunders and the Heartbreakers on Reachout International Records. Portions of this essay appeared in *Tracking Angle*, Fall 1998.

"Back to the Fillmore" is fiction and used a quote from the lyrics to "The Eleven" by Robert Hunter, copyright Ice Nine Publishing. Used with permission.

"The Steel-String Trilogy"

(a) "A Man Out of Time" used quotes from the author's discussions, interviews, and correspondence with Denny Bruce and Dean Blackwood. Additional insight gained from the reading of *How Bluegrass Destroyed My Life* by John Fahey. Rigorous editing courtesy of Chuck Eddy and Michelle Mercer. Portions of this essay appeared in the *Village Voice*, May 2003.

(b) "The Strength of Strings" benefited from the author's discussions and interviews with Leo Kottke and Denny Bruce. Inspiration was gained from the listening of *6- and 12-String Guitar* by Leo Kottke.

(c) "Bundy K. Blue's Dance with Death" is fiction. Portions of this essay appeared in *Newcity*, August 1998.

"Roundabout" is fiction.

"War All the Time" used quotes from the author's discussions, interviews, and correspondence with Richard Meltzer, Paul Williams, Marty Balin, Mike Watt, Dave Alvin, Robert Christgau, Greil Marcus, Dave Marsh, David Walley, and Nick Tosches. It also used a quote from the essay "As I Lay Dead" by Richard Meltzer, which is in-

cluded in *A Whore Just Like the Rest: The Music Writings of Richard Meltzer*. Portions of this essay appeared in *Magnet Magazine*, November/December 2000.

"Erector Set" benefited from the listening of the music of the Mekons. Portions of this essay appeared in *Tracking Angle*, Summer 1998.

"Classics Vs. Anthems" used a reference from *The Concise Oxford Dictionary* (9th edition). Portions of this essay appeared in *Newcity*, October 1999, and were performed on National Public Radio, *All Things Considered*, January 2002.

"Oh Happy Day" benefited from discussions and correspondence with Paul Williams and the reading of his book, *The 20th Century's Greatest Hits*. Inspiration gained from the listening of "Oh Happy Day" by the Edwin Hawkins Singers. Portions of this essay were performed on National Public Radio, *All Things Considered*, Christmas Day 2002.

"A Lone Star State of Mind" used quotes from the author's discussions, interviews, and correspondence with Eugene Chadbourne, Brian Henneman, Ernie Durawa, Johnny Perez, Jack Barber, Augie Meyers, Steve Earle, Denny Bruce, George Rains, Jay Farrar, Bill Bentley, Jerry Wexler, Shawn Sahm, Shandon Sahm, Flaco Jimenez, Kevin Russell, Chet Flippo, and Joe "King" Carassco. It also used a quote from the lyrics of "At the Crossroads" by Doug Sahm, Southern Love Music. Portions of this essay appeared in *Magnet Magazine*, October/November 2002, which was reprinted in *Da Capo Best Music Writing 2003*.

"Taking Tiger Mountain" benefited from the listening of *Music for Airports* by Bang on a Can, on Point Music. The essay included a quote from Edgard Varèse.

"The Sweltering Guy" is fiction.

"The Ballad of John Henry and the Wheels of Steel" is fiction. It includes a quote from the lyrics of "John Henry" (traditional). This piece was performed on National Public Radio, *All Things Considered*, March 2004, and deemed a "Driveway Moment" by its listeners.

"Need for Speed" benefited from the listening of *Hot Rods & Custom Classics: Cruisin' Songs and Highway Hits* on Rhino Entertainment. Portions of this essay appeared in *Newcity*, March 1999, and were performed on National Public Radio, *All Things Considered*, October 2001.

"Respect Due" benefited from the author's correspondence with Dave Marsh and the late Al Aronowitz and used quotes from the author's interviews with Jerry Wexler and the late Arif Mardin. Portions of this essay appeared in the liner notes of the LP reissue of *Aretha Franklin Live at Fillmore West* on Four Men with Beards, 2003.

"Closer to Home" benefited from the listening of the music of Grand Funk Railroad. Portions of this essay appeared in *Smug Magazine*, January 2000, and in a comic-strip version in *Stop Smiling*, 2001.

"Diminuendo and Crescendo" benefited from the listening of *Ellington at Newport* by Duke Ellington on Columbia/Legacy Records. Por-

tions of this essay appeared in *Tracking Angle*, Fall 1998, and *Strong Coffee*, September 2000. The piece was also performed on National Public Radio, *All Things Considered*, November 2001, and deemed a "Driveway Moment" by its listeners.

"World's Biggest Gong Fan" used quotes from the author's interview with Daevid Allen. Thanks to (Word Services) Apple Events Spellswell7. Portions of this essay appeared in *Magnet Magazine*, October/November 1999.

"What Can You Do That's Fantastic?" used quotes from the author's discussions, interviews, and correspondence with Tom Fowler, Roy Estrada, Jimmy Carl Black, Elliot Ingber, Carol Kaye, Kim Fowley, Don Preston, Bunk Gardner, Mike Keneally, Bruce Fowler, Napolean Murphy Brock, George Duke, Chester Thompson, Denny Walley, Terry Bozzio, Adrian Belew, Patrick O'Hearn, Arthur Barrow, Bob Harris, Ike Willis, Vinnie Colaiuta, Chad Wackerman, Gail Zappa, and Aynsley Dunbar. Additional insights were gained from discussions with David Walley and Matt Groenig. Special assistance from Billy James. Portions of this essay appeared in *DownBeat Magazine*, January 2004.

"A Chance Encounter" is fiction. Portions of this essay appeared in *Strong Coffee*.

"High Noon" benefited from the listening of the music of Alejandro Escovedo and visiting Austin, Texas, repeatedly.

"This American Life" used quotes from the author's discussions, interviews, and correspondence with Pauline Oliveros, La Monte

Young, Henry Kaiser, Terry Riley, David Harrington, Tony Conrad, Mixmaster Morris, and Stuart Brand. Key assistance was received from Tom Welch. Portions of this essay appeared in *Magnet Magazine*, April/May 2001.

"House of the Rising Son" is satire. Portions of this essay appeared in *Tracking Angle*, Fall 1998.

"Requiem for a Cowbell": Portions of this essay appeared in *Harp Magazine*, March 2004. The piece was also performed on National Public Radio, *All Things Considered,* deemed a "Driveway Moment" by its listeners, and included on NPR's 2-CD set, *Driveway Moments 3*, 2005.

"Tie-Die!" is fiction and included a quote from the lyrics of "The End" by the Doors, Nipper Music.

"Almost" benefited from the listening of the *Almost Famous* soundtrack on DreamWorks.

"A True Story" benefited from the listening of the music of Jeff Beck. Portions of this essay appeared in *Newcity*, October 1999, and were performed on National Public Radio, *All Things Considered*, December 2001.

"Spirits, Ghosts, Witches, and Devils" used quotes from the author's interviews with Sonny Simmons, Rashied Ali, Roswell Rudd, Carla Bley, John Tchicai, Sunny Murray, Burton Green, Gary Peacock, Henry Grimes, Bernard Stollman, Alan Silva, Nat Hentoff, Juini Booth, and Steve Tintweiss. The essay also benefited from the author's discussions

and correspondence with Ben Young and Brian Carpenter. Albert Ayler is quoted from his 1969 essay in *The Cricket: Black Music in Evolution*. References include Ayler's *Holy Ghost* on Revenant Records, *As Serious As Your Life* by Valerie Wilmer and *The Autobiography* by Leroi Jones/Amiri Baraka. Portions of this essay appeared in *Magnet Magazine*, October/November 2004.

"Ohm on the Brain" benefited from the listening of *OHM+: The Early Gurus of Electronic Music* on Ellipsis Arts.

"Rock 'n' Roll Heaven" included a quote from the lyrics of "Crystal Blue Persuasion" by Tommy James, Ed Gray, and Mike Vale, Big Seven Music. Portions of this essay appeared in *Newcity*, June 2000.

"The Mix-Tape Murder Mystery" is fiction.

"Waiting on a Train" was inspired by Kathleen Mock's performance of her song, "Waiting on a Train." Portions of this essay were performed on National Public Radio, *All Things Considered*, April 2005.

"Afterword: How to Succeed in the Music Business Without Really Trying" is true.

Index

Harrison, George, 8, 123
Hart, Mickey, 74
Hassell, Jon, 205, 259
Hassell, Margaret, 205
Hawkins, Coleman, 57, 58, 172
Hayes, Isaac, 122
Heartbreakers, 68–70
Hell, Richard, 68
Helms, Chet, 133
"Help I'm a Rock," 180
"Helter Skelter," 286
Henderson, Fletcher, 56
Henderson, Joe, 187
Hendrix, Jimi, 19, 86, 107, 122, 168,
 174, 178, 240, 254
Hentoff, Nat, 252
"He's a Rebel," 6
"Hillbilly Boogie," 31
Hillman, Chris, 292
Hines, Earl "Fatha," 57
Hite, Bob "The Bear," 30–31
Hodges, Johnny, 173
Hoffman, Philip Seymour, 262
Holiday, Billie, 247
Holly, Buddy, 126
Holmstrom, John, 21
"Holy Family," 254
"Honky Tonk Women," 214
Hooker, John Lee, 30, 31, 32
Hopper, Dennis, 7
"Hot Rod Lincoln," 159
Houston, Cisco, 296
Hubbard, Freddie, 62
Huerta, Baldemar, see Fender, Freddy
Humble Pie, 214
Humphrey, Ralph, 185, 191–192
"Hungry Heart," 121

"Imagine," 122
"I Mean You," 63
"I'm Going Home," 31, 32

"I'm Your Captain," 169
"In-A-Gadda-Da-Vida," 155
Ingber, Elliot, 179, 180
"In Walked Bud," 63
Iommi, Tony, 45, 49
Iron Maiden, 3
"I Wanna Be Your Dog," 198
"I Want a New Drug," 122

Jackie Brenston & His Delta Cats,
 159
Jackson, Michael, 48
Jacobs, "Little" Walter, 241
Jacquet, Illinois, 244
Jagger, Mick, 7
James, Skip, 92
James, Tommy, 260
Jan & Dean, 159
Jarrett, Keith, 2
Jefferson, Blind Lemon, 30
Jefferson Airplane, 19, 107
Jemmott, Jerry, 163
Jennings, Waylon, 127, 136
Jimenez, Flaco, 136, 138
John, Elton, 165, 233
Johnson, Pete, 29
Johnson, Robert, 10–14
Johnston, Daniel, 55
Jones, Elvin, 181
Jones, Jo, 173
Jones, John Paul, 49
Jones, Papa Jo, 56
Joplin, Janis, 86, 133, 238
Jordan, Louis, 31
"Jumping Jack Flash," 120
"Jumpin' Punkins," 155

Kaufman, Phil, 292
Kaye, Lenny, 17, 107
Kaylan, Howard, 183, 188
Keneally, Mike, 182

Pere Ubu, 2, 26
Petty, Tom, 121
Pickett, Wilson, 162
Pierce, Webb, 128
"Pinetop's Boggie-Woogie," 29
Pink Floyd, 122
"Planet Rock," 155
Plant, Robert, 49, 233
Pogues, 118
Ponty, Jean-Luc, 184
"Poppy Nogood and the Phantom
 Band," 204
Powell, Bud, 57, 58, 59, 174
Pran Nath, Pandit, 206–207, 209
Presley, Elvis, 31, 126, 154
Preston, Billy, 163
Preston, Don, 181
Price, Lloyd, 241
Prince, 121
"Prophecy," 248
Purdie, Bernard "Pretty," 163

Queen, 121
Quicksilver Messenger Service, 133,
 219

"Radar Love," 158, 160
Rainey, Gertrude P. "Ma," 38
Rains, George, 133, 135, 139
"Rains Came, The," 132
Ramone, Dee Dee, 68
Rapeman, 212
Rath, Billy, 68, 70
"Reach Out and Touch (Somebody's
 Hand)," 166
Rebennack, Mac, see Dr. John
"Red Cross, Disciple of Christ Today,"
 94
Redding, Otis, 131
"Red Temple Prayer (Two-Headed
 Dog)," 135–136

Reed, Lou, 18–28, 69, 198, 233
Reich, Steve, 43, 200, 202, 203, 207,
 208
"Respect," 162, 164
"Return of the Son of Monster
 Magnet, The," 180
"Rhythm-A-Ning," 63
Rich, Buddy, 157
Righteous Brothers, 6
Riley, Terry, 199–209, 259
"River Deep, Mountain High," 5–9
Roach, Max, 58
"Road Runner," 160
Robbins, Ira, 21
Robertson, Pat, 47
Robinson, Smokey, 238
"Rock and Roll Pt. 2," 121
"Rocket 88," 159
"Rocking Down the Highway," 160
"Rock Island Line," 154
Rolling Stones, 15, 120, 126, 130, 131,
 214, 292
"Rollin' Ocean," 295
Rollins, Sonny, 58, 242, 244, 249, 251
"Roll on Waters," 295
Ronettes, 6
Rooks, Conrad, 36
Rosenthal, Bob, 38
Ross, Diana, 166
"Round Midnight," 59
Rouse, Charlie, 62
"Ruby, My Dear," 59
Rudd, Roswell, 239
Rundgren, Todd, 233
Russell, Leon, 7, 135

Sahm, Douglas Wayne, 127–140
"Saints," 248
"Saint Stephen," 74, 89
Sanders, Ed, 37–38
Sanders, Pharaoh, 252, 256